W9-BLD-198

AN AMERICAN CELEBRATION
The Art of
CHARLES WYSOCKI

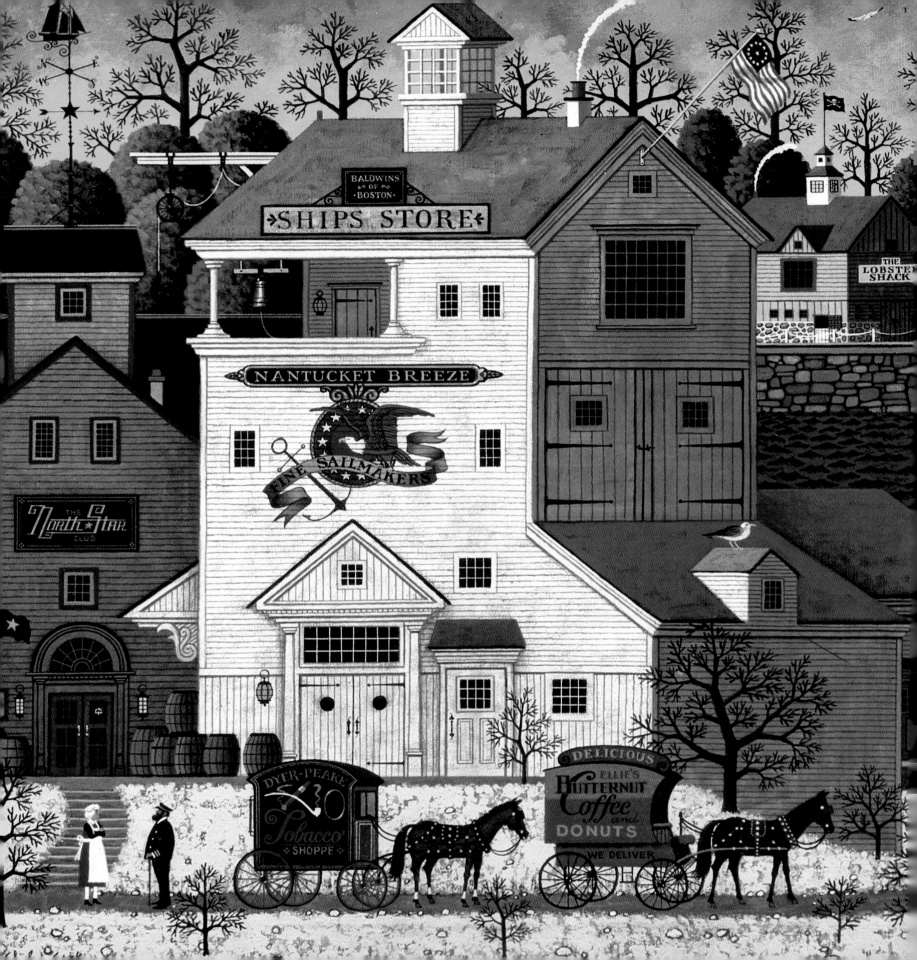

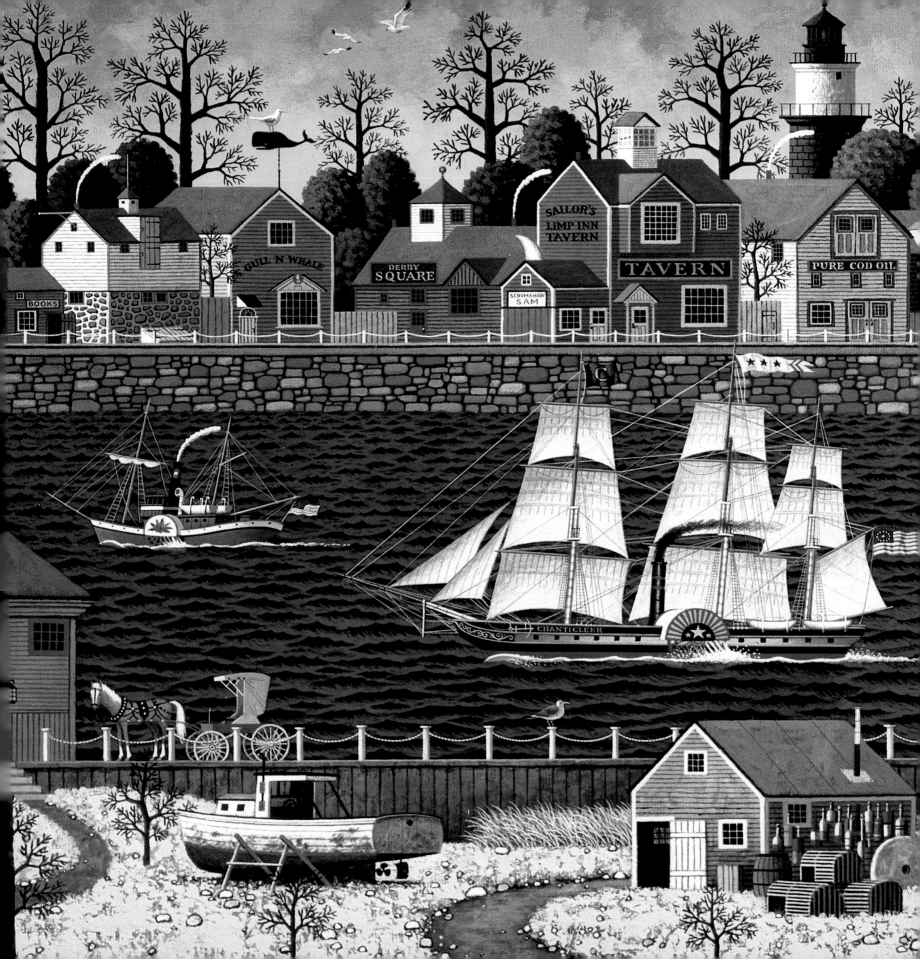

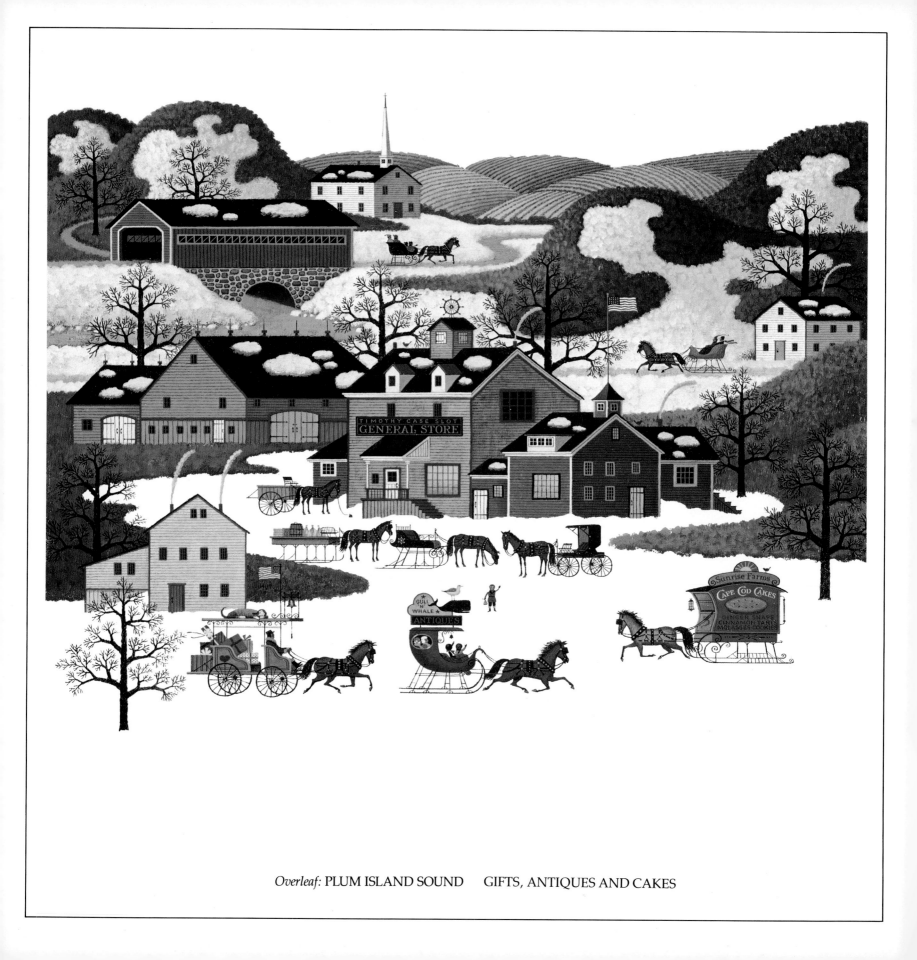

Overleaf: PLUM ISLAND SOUND GIFTS, ANTIQUES AND CAKES

TEXT BY BETTY BALLANTINE

AN AMERICAN CELEBRATION

The Art of

CHARLES WYSOCKI

GREENWICH PRESS LTD.

WORKMAN PUBLISHING, NEW YORK

TO MY LOVING WIFE ELIZABETH, AND MY NEAT KIDS, DAVID, MILLIE, AND MATT

For me this book represents the third plateau in steps I had planned and hoped for in my career. First, I always wanted to showcase my art in the form of a calendar. This has been successfully done for fifteen years now, through my AMERICANA® CALENDARS published by Amcal. My next move was in the limited edition fine print market, and here I achieved my goal through the generosity and with the guidance of my friends at the Greenwich Workshop.

This book, the third step, sees the culmination of my ambitions to date. I am deeply and sincerely grateful to all of the many talented and trusting people who have compiled this volume. Their confidence and this tribute to me and my painting is a marvelously fulfilling experience. Please, all of you concerned, accept my deepest "Thank you."

Copyright © 1985 by Greenwich Press, Ltd.

All rights reserved.

No portion of this book may be reproduced – mechanically, electronically, or by any other means, including photocopying – without written permission from the publisher. Published simultaneously in Canada by Saunders of Toronto, Inc.

LIBRARY OF CONGRESS CATALOGING IN PUBLICATION DATA

Wysocki, Charles.
 An American celebration.

 1. Wysocki, Charles—Catalogs. 2. Americana in art—Catalogs. 3. Primitivism in art—United States—Catalogs.
 I. Ballantine, Betty. II. Title.
ND237.W97A4 1985 759.13 85–40521
ISBN 0–89480–942–3

Greenwich Press, Ltd.
30 Lindeman Drive
Trumbull, CT 06611

Workman Publishing Co., Inc.
1 West 39 Street
New York, NY 10018

Design by Peter Landa
Manufactured in Japan
First printing October 1985
10 9 8 7 6 5 4 3 2 1

CONTENTS

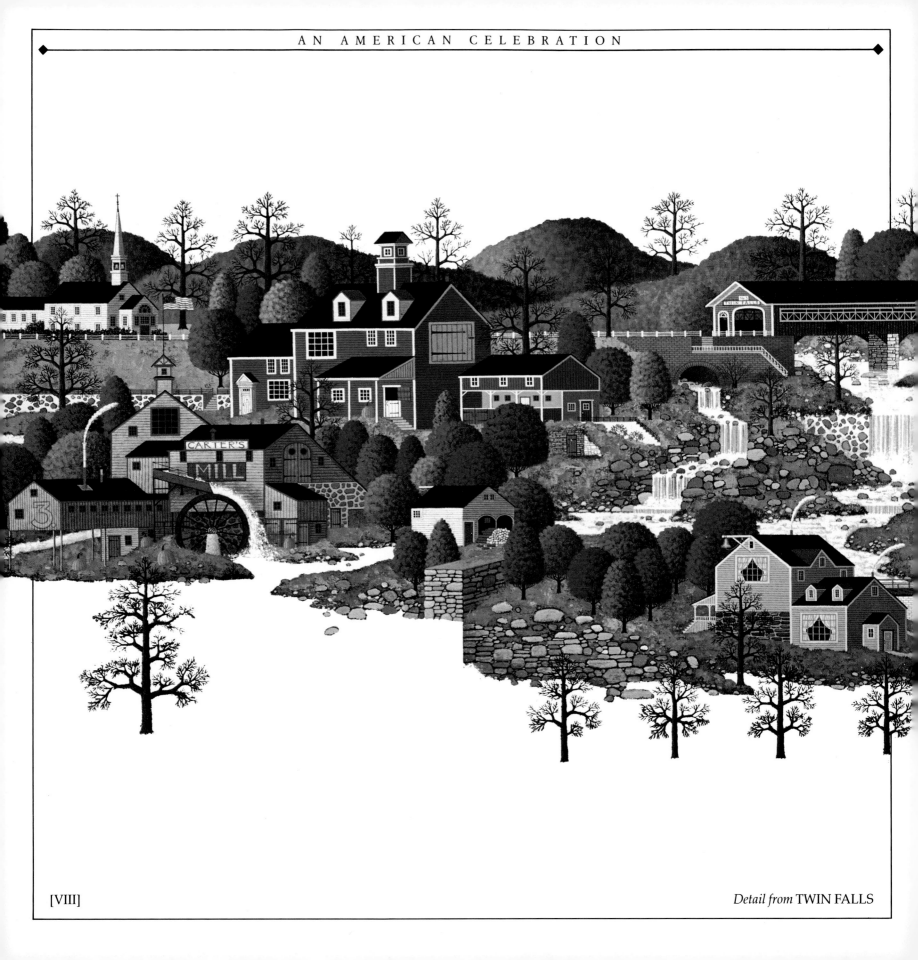

Detail from TWIN FALLS

ARTIST'S NOTE

It is my habit to plan and work for attainable goals. And if I think and fantasize a lot about my future, it is because having definite objectives makes my artistic life constantly challenging.

I am a proud American and my desire is to stress the positive images of our country and its people. The American flag flies high in most of my paintings. To me, the quality of life in average, everyday America seems to be the best in the world—which makes painting this country a pleasure, a joyful thing to do. In particular, portraying the charm of scenes in New England gives me double pleasure as that is the area which most appeals to me. I love the terrain, the architecture, the peace: using the special "feel" of New England as a basis, I construct landscapes, townscapes, seascapes; I try to show life as it once was, and often as it still is.

Living in the west and painting my impressions of the east is somewhat mystifying to some people. I am more comfortable keeping my main subject material at bay or a little bit out of immediate reach. Being closely surrounded by your subject material on a day-to-day basis brings repetitious familiarity that can dull the senses, the eye and the brain. One can overlook potential paintings and concepts. When I take a trip back east my mind lights up, my soul is refreshed and I see things that tell stories and plant patterns for future paintings.

I especially like to inject a touch of humor into my work. So much of art today tries to reach for the profound or is painted for shock value. I see life on the lighter side, in much simpler and more basic forms. I personally feel that art should be fun for the artist as well as the viewer. But I work hard at doing my very best to make each painting both as simple and as interesting as possible. It's difficult. I try. Children, bless their clear eyes, enjoy the simplicity in my work and this really thrills me each time. Art appreciation is not exclusively for adults. I am constantly surprised at how articulate youngsters are in expressing themselves, how clearly they see connections, both within the paintings and to life.

I am deeply concerned with life. I live in today's world but find great strength in what the past has given me. It is from the past that my memory creates lines, streets, houses and people that constitute the fundamental qualities in my work. I live *with* the past, not *in* it. I know I am deeply nostalgic, but my roots, which are entwined in the world of yesterday, are also a natural bridge to the world of today.

It pleases me to depict cleanliness, neatness, order. The essence of nostalgia is a yearning toward remembered joys. There is a place for the neat and tidy, the pristine version of yesterday's scenes and values. I love to let my mind wander and collect past experiences and put them into concepts that can emerge in my drawing and painting, communicated in simple, basic statements. No interpreter or psychiatrist is needed to explain my work. Stimulating the viewer's emotions is paramount in my mind, and I will always endeavor to achieve a natural strength through clarity and simplicity.

The "happy accident" has no importance and no place in my paintings. I plan each canvas carefully and my involvement with content keeps me specifically confined to placing objects within the given area into firmly locked-in compositions, where one cannot move an object in any direction without upsetting the whole. Ultimately, the only statement that really matters is the visible one of the work itself.

I think that design in all of its aspects is the basis of all art. Design is organization and perfection. Perfec-

tion is this artist's desired goal in life and possibly that of all truly creative people. Its ultimate impossibility does not matter, as long as one can enjoy small perfections along the way.

There are pieces of art that dazzle the eye but leave the heart untouched. I do not even aspire to this form of creation. My paintings are personal statements. There is a simple message in my work and it is love—

of country, people and the arts. Having been for a long time happily married, home and family mean a great deal to me. These joyously comfortable virtues frequently emerge in my paintings.

Using our country and all its splendid assets as a basis, I love to create situations that are typically American. I see in America a cornucopia of endless subjects that will last me all my days.

Charles Wysocki

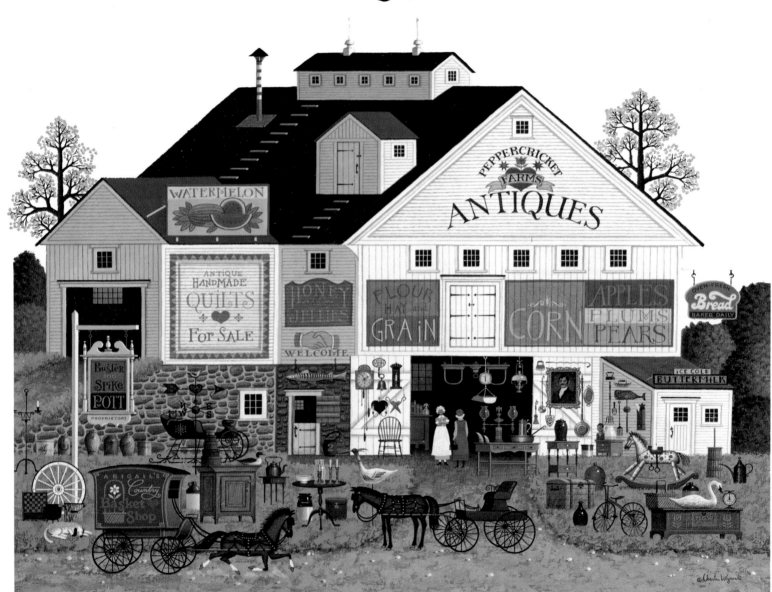

PEPPERCRICKET FARMS

AN AMERICAN CELEBRATION

The Art of

CHARLES WYSOCKI

DO-SI-DO YOUR PARTNER

The celebration of dance got off to a slow start in the New World. The first intrepid Mayflowerites, and those who most immediately followed them, were deeply religious and frowned on such gaieties as dancing. The colonists who came after the Pilgrims were still very much under the influence of their British king, and their dancing was elegant, decorous, even staid—figured measures carefully stepped out.

Satin knee breeches and long skirts did not make for much rowdiness.

It wasn't until America threw off the yoke of the old country, bust loose and broke out for the West, that rambunctious spirits adapted the country dances of several other old countries to the leaping, stamping, jigging, jolly exertions of the richly varied square dances developed by the settlers. The new America

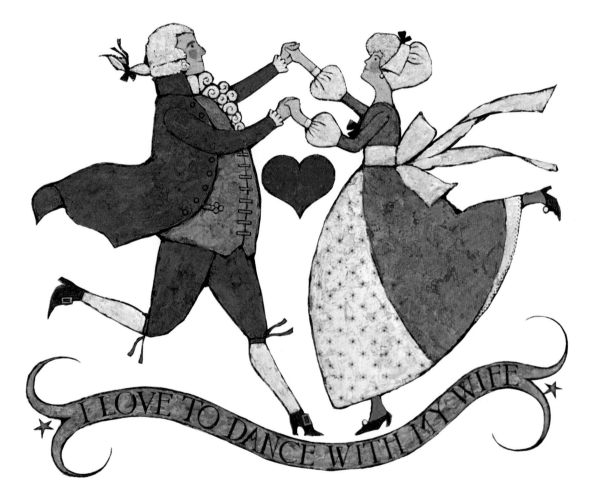

I LOVE TO DANCE WITH MY WIFE

THE DANCERS

invented the barn dance, the turkey trot, the Virginia reel, the cakewalk, and many another joyous expression of rugged individualism. Folk often danced to nothing more than the clapping of hands, but sometimes they do-si-do'd to the merry squawk of a busy fiddle with the beat strummed out on a banjo.

And they danced everywhere—around campfires, at military balls, in barns, on the beaten earth floors of frontier cabins and in elegant eastern homes. In a joyful burst of dust and flying skirts and thumping, tapping feet, dance declared itself an ebullient part of the new land.

Dances, of course, were great occasions for new neighbors to meet one another and for old friends to exchange advice and gossip. Even better, dancing provided splendid opportunities for courtship.

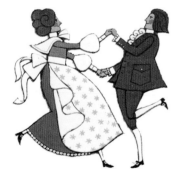

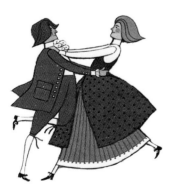

I had a guest on *Cape Cod*
Who visited for chess each day
After years as peas in a pod
we did more than just play
So now i fill a pipe or two
rock my chair and enjoy the view
Our pleasures are many and varied
on Cape Cod together and married

SWEETHEART CHESSMATE

Valentine's Day, one of the oldest of celebrations, was especially dear to the heart of a time unabashedly sentimental and dedicated to genteel declarations of love cast in the most meltingly romantic terms. What better time to celebrate such sentiments than on the traditional feast of Saint Valentine, patron saint of lovers?

The fourteenth of February became giggle day—when swooning maids and languishing lads could declare themselves without fear, amid a pastel blizzard of cards and missives decorated with cupids, lover's knots, flowers, lace and, of course, hearts of every description. And gifts of chocolates, beribboned bouquets, tiny porcelain boxes inscribed with lines of undying love and delicate heart-shaped vials of perfume avowed devotion.

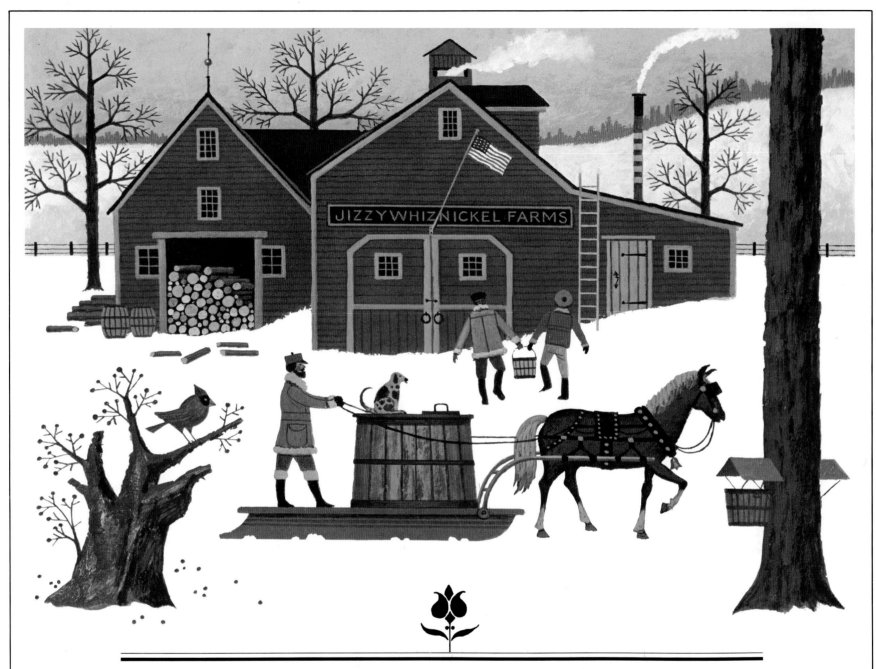

MAPLE SUGARING

American Indians introduced the pioneers to the delights of maple sugar. In fact, the Indians used the then plentiful trees rather wastefully, often destroying those they tapped. Yankee ingenuity eventually devised the method that kept the sugar maple trees alive and the sap coming year after year.

Early spring, while snow is still on the ground and the nights are freezing but the days beneficently mild, is the time of the "maple moon"—the best time to collect the sap.

While the sap is running sweet, make a small incision in the tree, tap in a tube at about a 140° angle,

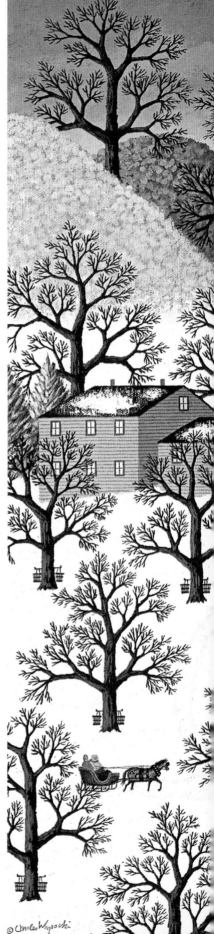

hang a bucket on it and come back day after day to empty the bucket into a vast, steaming cauldron that is kept simmering for several days. When the water-thin sap is reduced to a bubbling syrup, thin streams can be ladled out onto the snow so that it can be tasted to see if it is thick enough. It is necessary to keep "trying" the syrup, at intervals, until you are sure the consistency is right. When this happy moment arrives, what remains in the cauldron becomes the amount of syrup you have for the rest of the year. This accounts for the scarcity of maple syrup.

Incidentally, the Indian method of reducing the syrup by repeatedly dropping red-hot stones into log troughs full of sap is not recommended. This way, even less syrup is left and has to be sorted out from bits of bark, dried grass, insects and old leaves.

Uses for the sweet, subtle, unique flavor of maple syrup far exceed its availability. Combined with water it makes a cooling drink in summer; pristine, it can be a topping for ice cream or a sweetener for cakes, cookies and muffins. In winter, it is supreme with pancakes or hot cereal or French toast, and marvelous with baked apple. It can glaze a ham or sweet potatoes, make turnips acceptable and rice pudding a nectar.

FAWN DELL

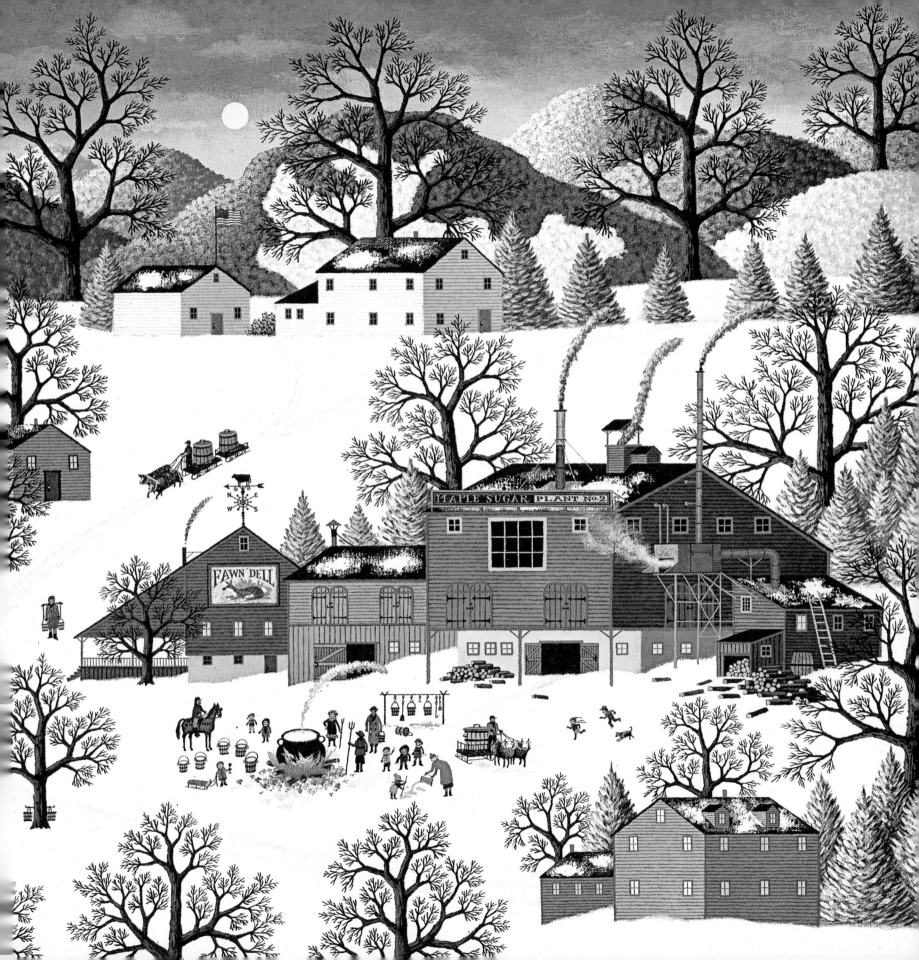

MAPLE MOUSSE

INGREDIENTS

2 cups heavy cream
6 egg yolks
Tiny pinch of salt

²/₃ cup hot maple syrup
¹/₄ cup sliced almonds or other
 chopped nuts

METHOD

Whip the cream and set it aside. Beat the egg yolks with the salt in the top of a double boiler set over medium heat. Keep the syrup hot in another pan.

When the yolks are creamy, mix a little into the hot syrup. Then add this mixture to the rest of the beaten yolks and cook slowly in the top of the double boiler until thick.

Remove from the heat and cool while stirring gently; then fold in the whipped cream. Pour the mousse into parfait glasses or dessert dishes and sprinkle with nuts. Freeze for four hours or overnight. Sounds tricky and it is, but even a mushy or lumpy result tastes delicious.

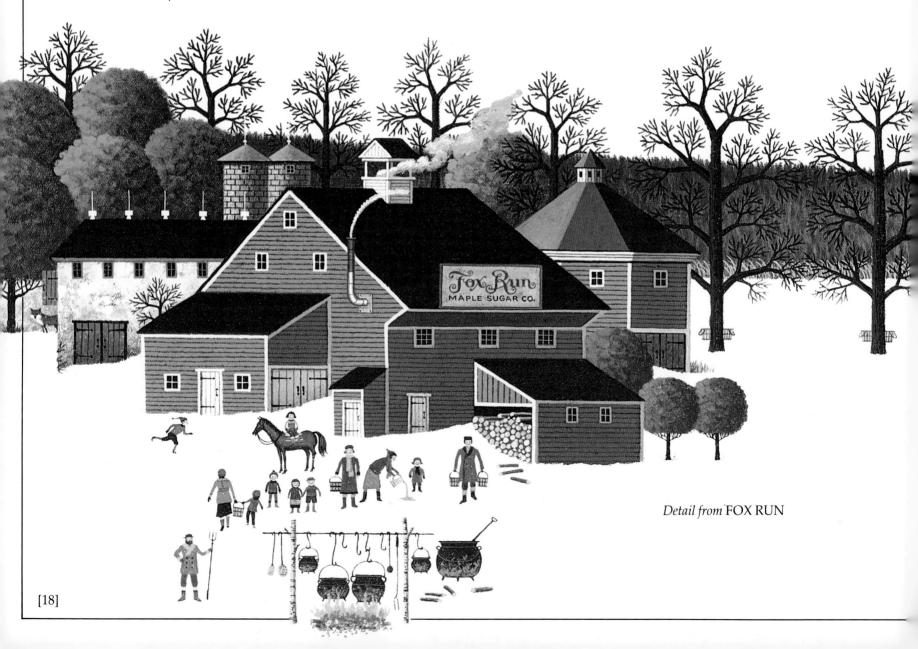

Detail from FOX RUN

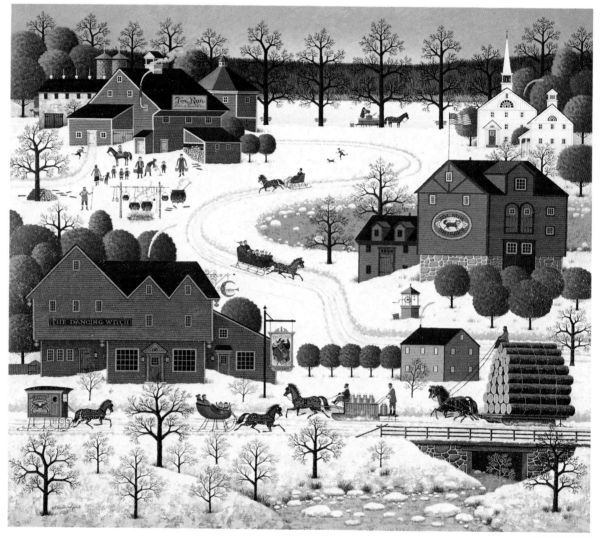

FOX RUN

Candymaking in America remained simple as long as maple sugar and honey were the main sweetening ingredients. Indeed, real candy was a luxury, generally reserved for special occasions, and America's sweet tooth had to be satisfied with an assortment of dried fruits, puddings, pies and baked goodies in which the precious syrup or honey could be stretched to its maximum use.

But the value of sugar as a preservative for delectable conserves, jams and jellies (to say nothing of its use in putting up fruits for the winter) eventually made cane sugar more generally available. The making of a wide variety of delicious

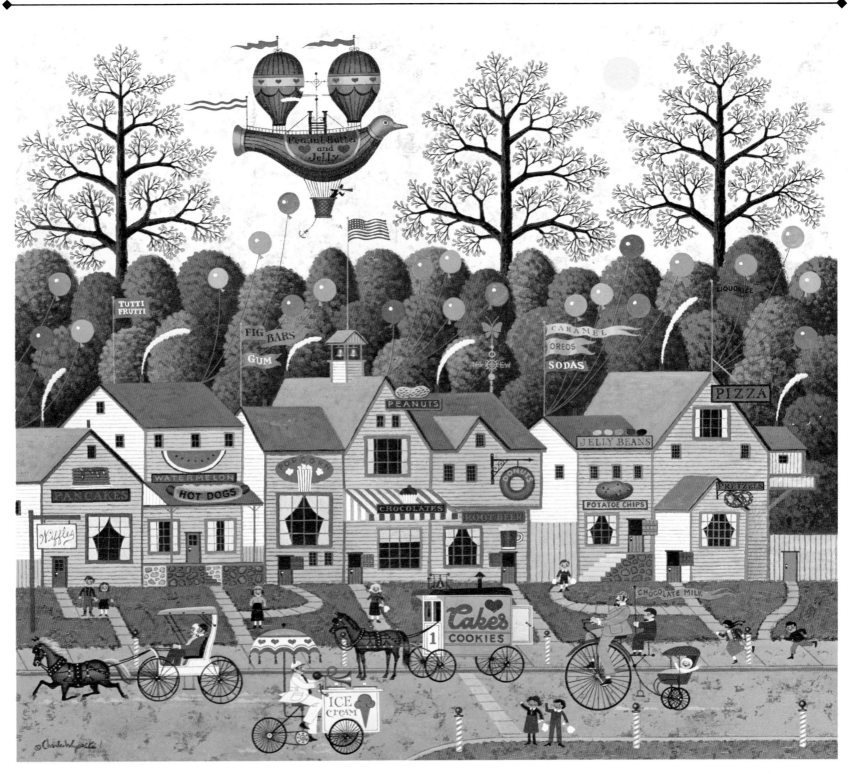

candies blossomed. Confectioners' stores became a mecca of mouth-watering traps in the form of varicolored boiled sweets displayed in huge glass jars, alongside sticks of horehound and strings of licorice, surrounded by creamy pink, white and chocolate fudge, nut-laden toffees, rich caramels, crunchy pralines, airy confections such as divinity, and many more devastating delights of the candymaker's art, while penny candy, in an astonishing array of colors and flavors, became a regular Saturday treat.

CONFECTION STREET

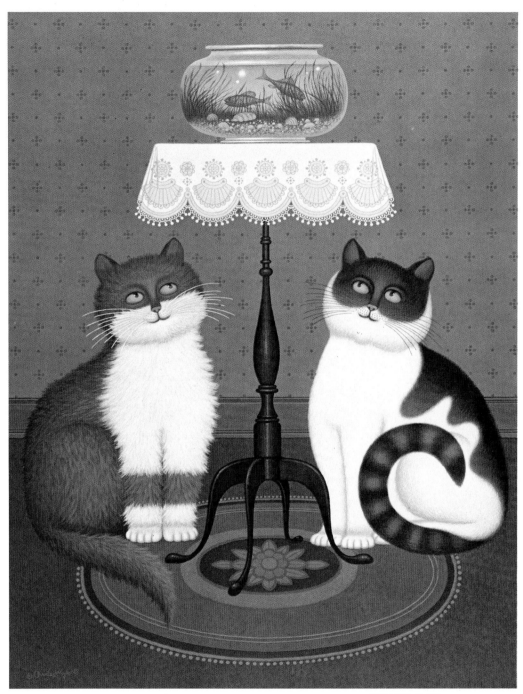

SHALL WE?

HERKYMER

CATS ARE CATS

For centuries, cats have maintained an aura of magic. Man may try to gain control by classifying the species into forty-eight breeds of domestic cat, but the very term "domestic" is laughable–no cat has ever been truly domesticated. Cats choose. Part of the secret awe in which humans hold felines lies in their unassailable aloofness, their total self-sufficiency, their unconcerned assumption of superiority in any situation. Farm cats, for instance, are important functionaries. Alley cats prefer to live a racier life, daring all for the independence by which they live. Egyptian cats chose to be deities. House cats have selected a life of comfort. None of these cats, of course, has anything to do with the forty-eight "recognized" breeds.

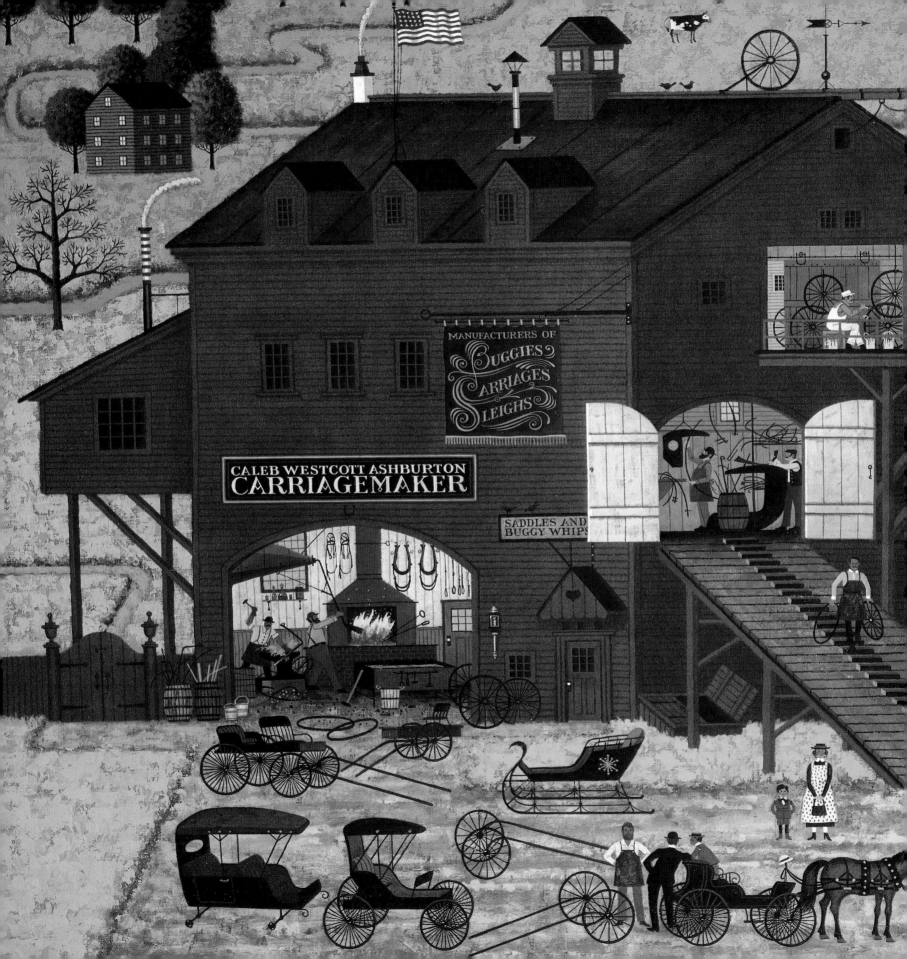

BUSY BUGGIES

America, the new land, ran on wheels right from the start. The old countries had reinvented the wheel—after a mysterious hiatus during which transport was accomplished by shanks' mare, litter and pack animal—so there were skilled wheelwrights and builders among the new colonists. Their value quickly became apparent, and as soon as anything resembling a road system appeared the variety of wheeled vehicles positively exploded.

There was a closed carriage with one seat (oddly called a chariot), the more dignified landau, the barouche with conveniently folding hood, the gracefully fast high phaeton, the low-sided, open carriage in which ladies could display their summer costumes—and many, many more. The most common, because it was in fact the most practical, was a light, four-wheeled buggy with a folding top.

Even in winter, with the aid of hot bricks, furs and blankets, the buggy was a practical means of transport. And in summer, nothing could beat the fresh smell of leather warmed by the sun, the cool breeze when riding at a spanking pace in the open, parasols aflutter for all the world to see, or the delightful intimacy while clopping slowly along in a closed surrey.

The buggy was a comfortable, sensible and altogether civilized way to get around.

Wysocki's paintings abound with the rich array of coaches, wagons, broughams, barouches and carriages of all varieties and descriptions and shapes that ferried Americans from one place to another. The buggy was the core of a way of life. Gracious, elegant and romantic, or simply sturdy and practical, its gentle pace permitted the leisure to see the beauty of a rewarding world.

CALEB'S BUGGY BARN

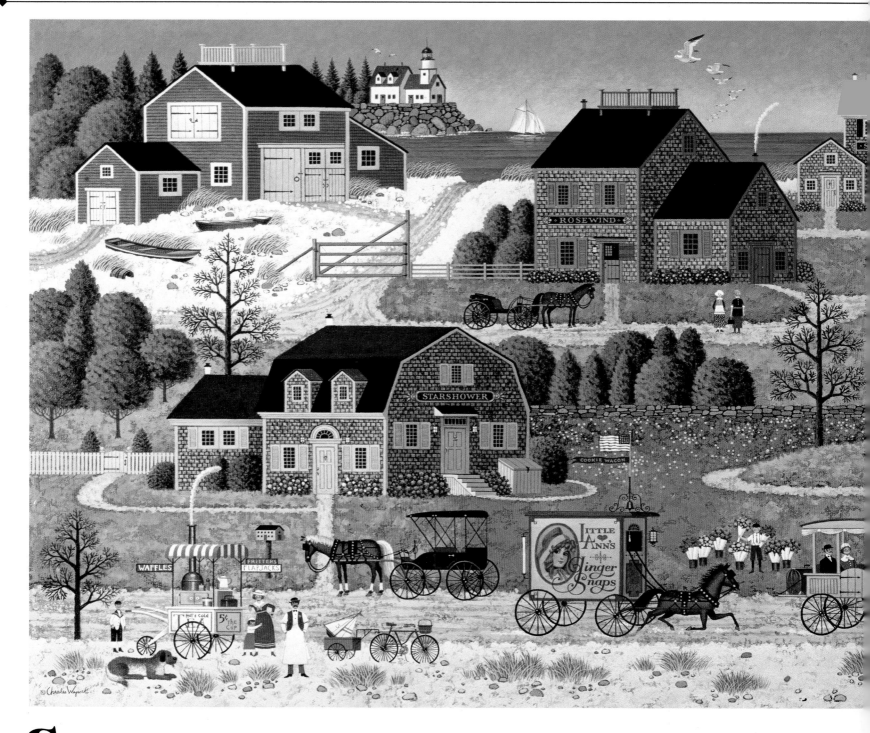

Seaport towns needed the ubiquitous horse-drawn vehicle as much as their inland neighbors. The big wagons brought in produce and the spruced-up delivery vans made their courteous rounds, often every day, bringing milk and fish, meat and groceries, coal and bread. And there was always time to chat with someone pretty. Nowadays, the buggy is an absent friend, but perhaps because of the changeless sea, the leisurely feeling of New England's coastal towns remains. The neat houses, the capacious barns, the pretty gardens—all speak of a gentler time, relaxed and welcoming.

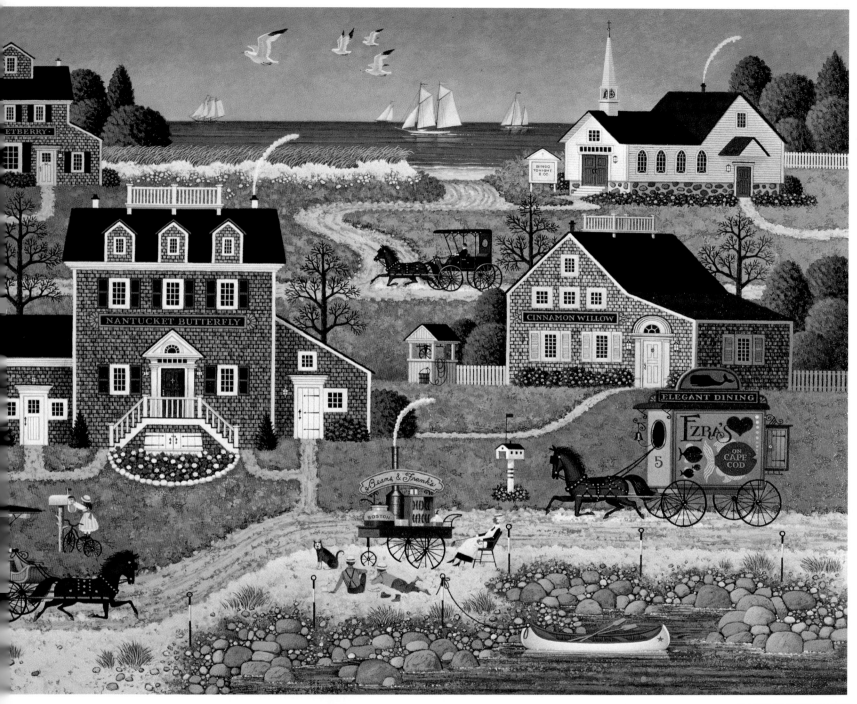

SALTY WITCH BAY

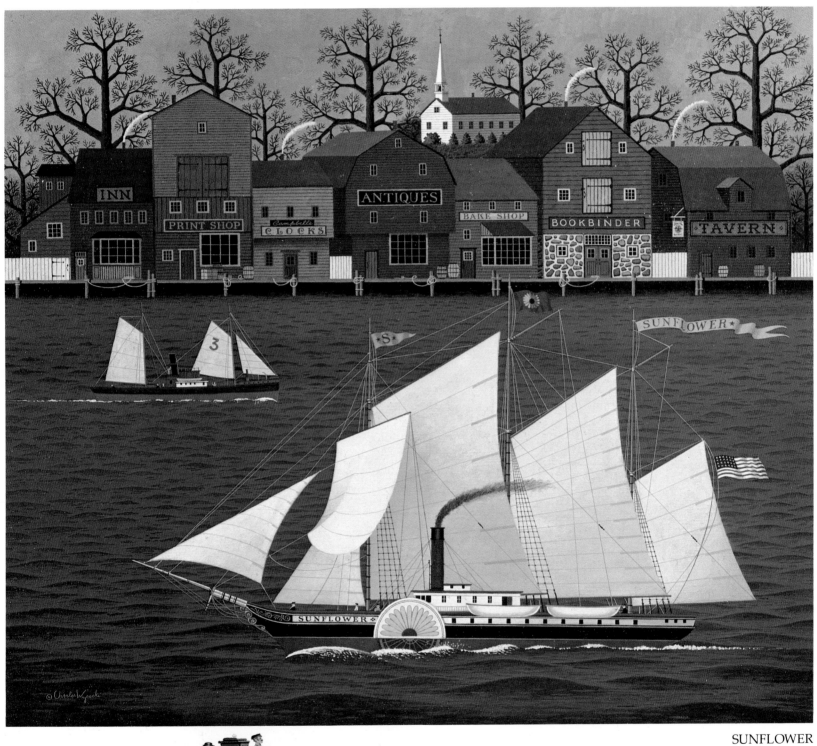

SUNFLOWER

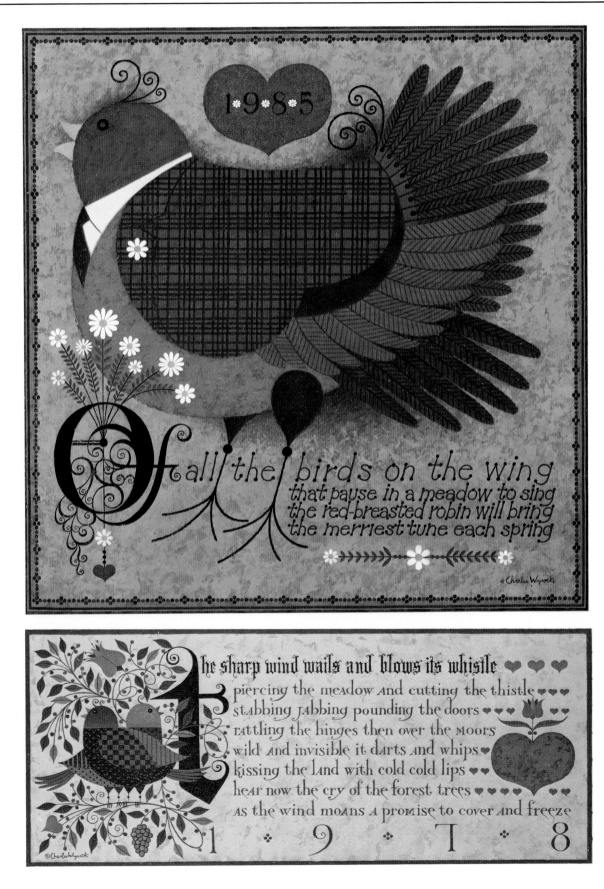

1·9·8·5

Of all the birds on the wing
that pause in a meadow to sing
the red-breasted robin will bring
the merriest tune each spring

© Charles Wysocki

The sharp wind wails and blows its whistle
piercing the meadow and cutting the thistle
stabbing jabbing pounding the doors
rattling the hinges then over the moors
wild and invisible it darts and whips
kissing the land with cold cold lips
hear now the cry of the forest trees
as the wind moans a promise to cover and freeze

1 · 9 · T · 8

© Charles Wysocki

HEARTH & HOME

From the beginning, hearth and home—shelter, warmth and food—were the heart of America. Without this at the core, nothing could have been built. Getting successfully through winter was a triumph that had to be repeated each year, and spring was always more than welcome—often it came as a lifesaver. Once the last frost was past, the young year came with a rush: feathery green in the woods; the warm, lush earth pushing up new growth and life; wise birds heading north to start new families.

Above: 1985 SPRING
COMMEMORATIVE PRINT
Detail from THE WIND

[27]

FAMILY &
FRIENDS

The earliest pioneers depended heavily on the natural bounty of land, sea and shore. Shellfish—several varieties of clams and mussels—were plentiful and easy to dig for. Even the children could bring in enough bucket-loads to feed the family.

Like the Indians from whom the pilgrims learned, their descendants are gathering food for the table. What was a necessity in the early days became a happy chore for family and friends, a scene that would eventually be repeated on all the beaches of America's lakes and coasts where the luscious mollusks are found. The dog may be bored, but the cat is having a fine time, and the diners are going to thoroughly enjoy the fruits of their labors at what has become a grand old American custom—the clambake.

CLAMMERS AT HODGE'S HORN

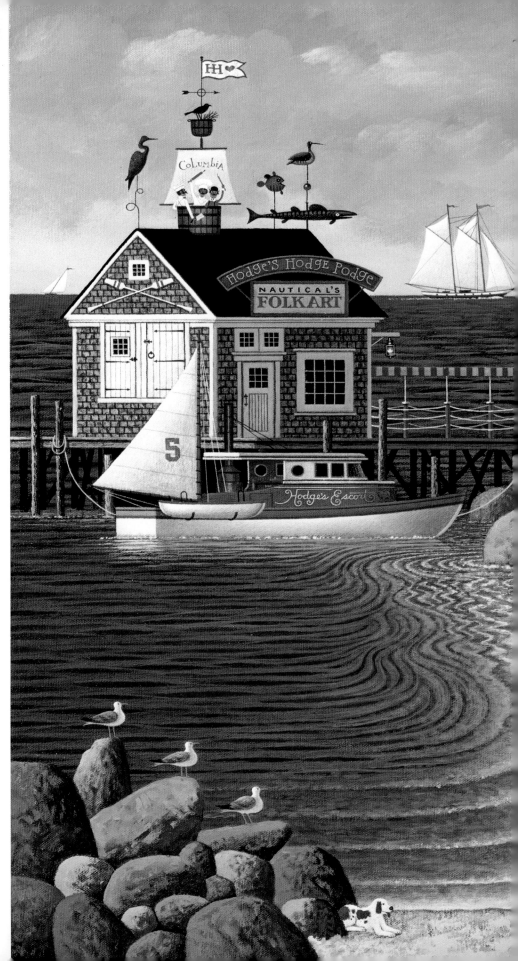

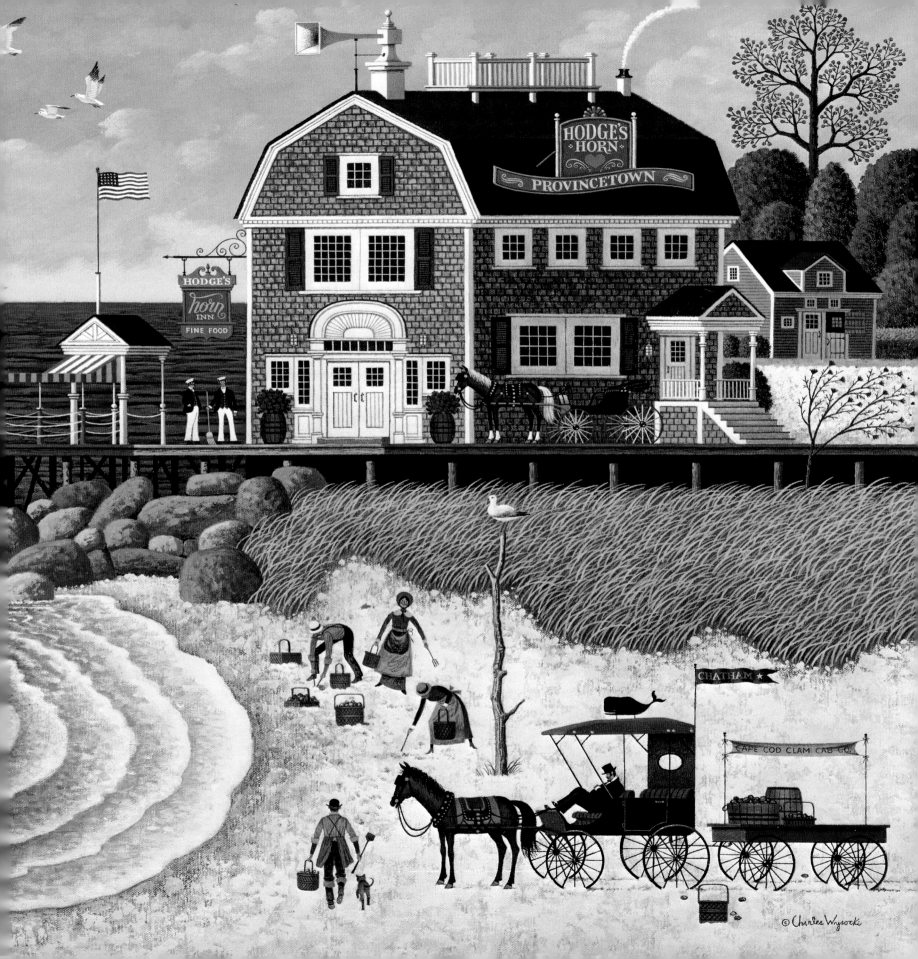

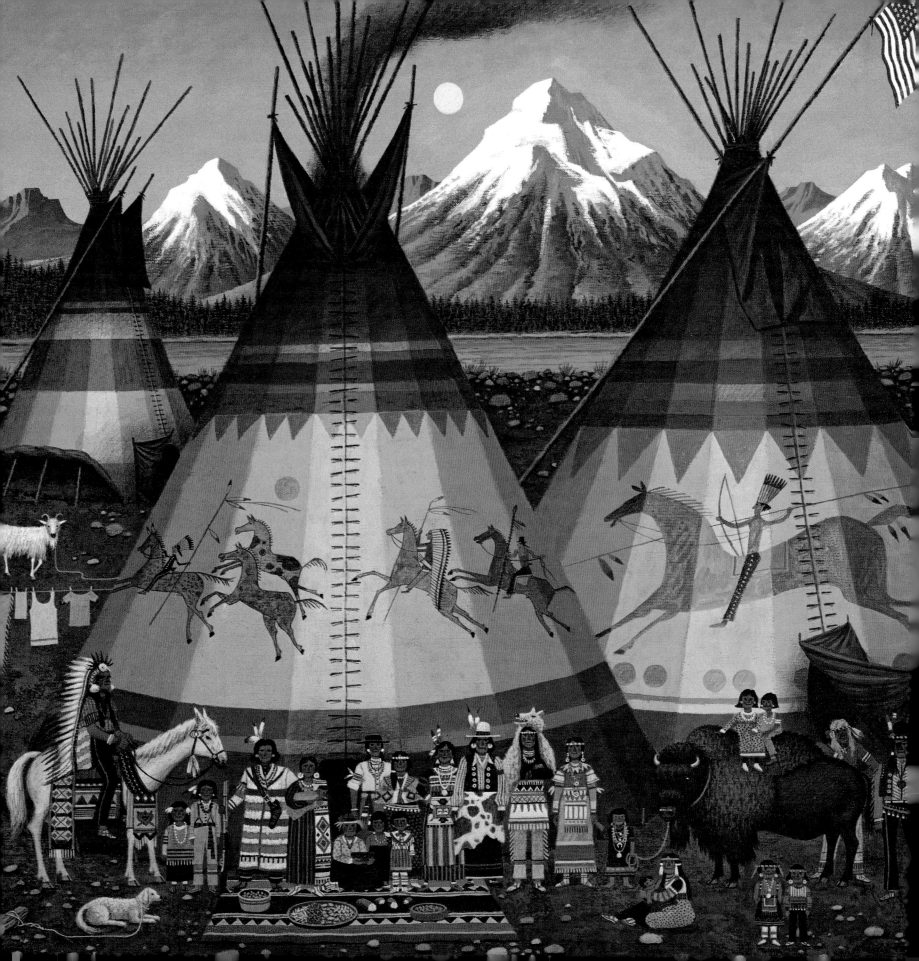

LET YOUR BOAT OF LIFE BE LIGHT, PACKED WITH ONLY WHAT YOU NEED, A HOMELY HOME AND SIMPLE PLEASURES, ONE OR TWO FRIENDS WORTH THE NAME, SOMEONE TO LOVE AND SOMEONE TO LOVE YOU, A CAT, A DOG, AND A PIPE OR TWO, ENOUGH TO WEAR AND A LITTLE MORE THAN ENOUGH TO DRINK FOR THIRST IS A DANGEROUS THING.

Another kind of family—the original hunters and gatherers of this land. No doubt American Indians don't see themselves quite as this painting depicts them, but they would surely appreciate its humor and recognize that the self-sufficiency of their way of life is abundantly represented here.

The richness of their spiritual beliefs and the complexity of Indian myth and legend can only be hinted at in the decorations that appear on the skins of America's first "mobile homes." Although theirs was an oral history that stretched back year by year, the stories of their great heroes, gods and myths still live.

Left: THE AMERICANS *Above:* THE BOAT OF LIFE [31]

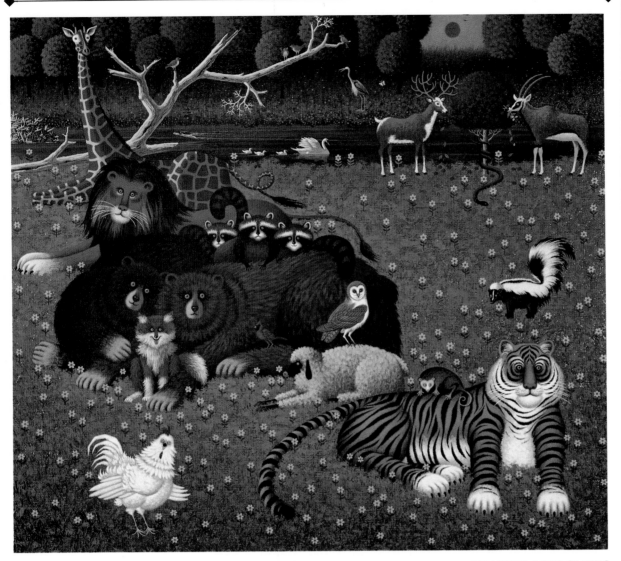

BEASTLY ASSOCIATES

You can't get much more friendly than the folks did on
Noah's Ark, to say nothing of what it did for the family...

NOAH AND FRIENDS

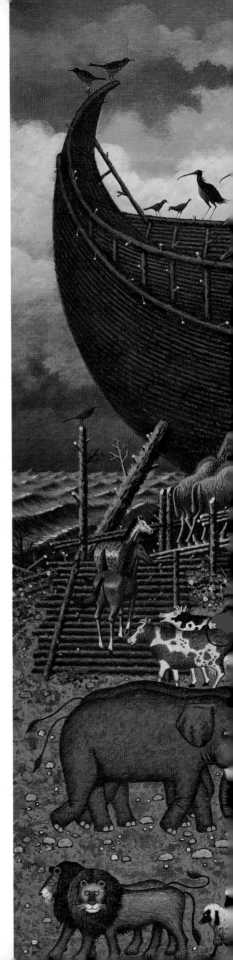

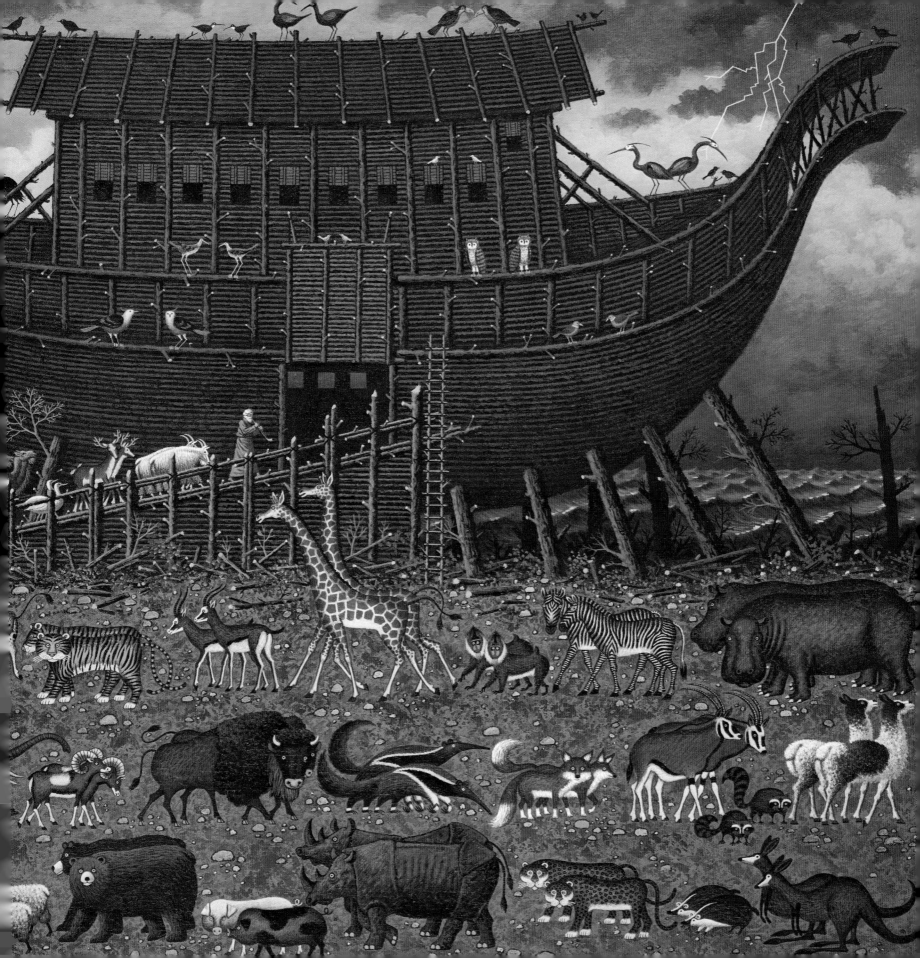

QUIET HAVENS

The turbulent years of breaking bonds with the home countries seemed to create a great need for security, at least in one's immediate surroundings. Communities of people, originally holding together for safety, grew closer, and the cement of friendship created havens to which adventuring Americans felt they could always return—the sturdy base that provided a good jumping-off place simply because it was always there.

To a nation of wanderers, hometown was a dear and important place, even if it was only three houses and a cow. If not everyone was born to a quiet, safe home,

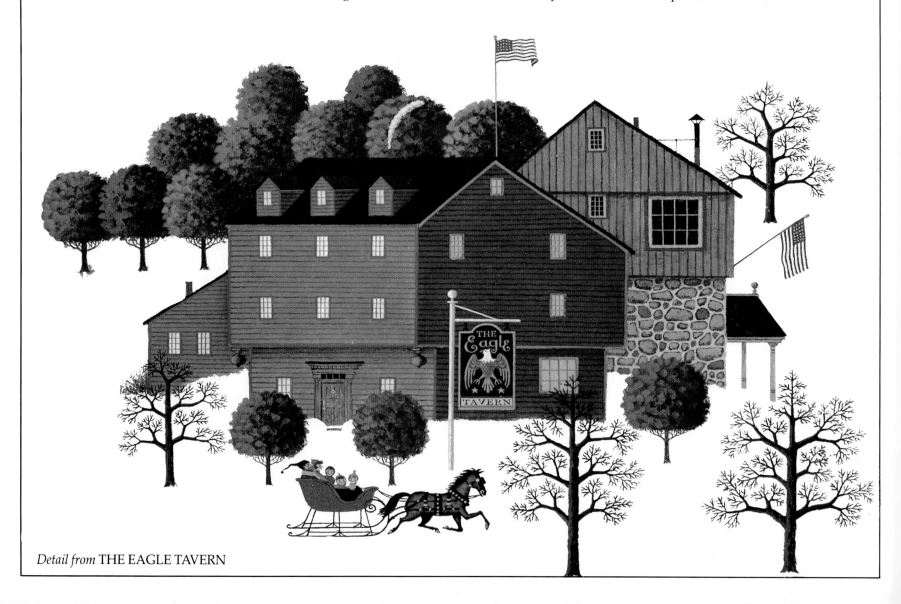

Detail from THE EAGLE TAVERN

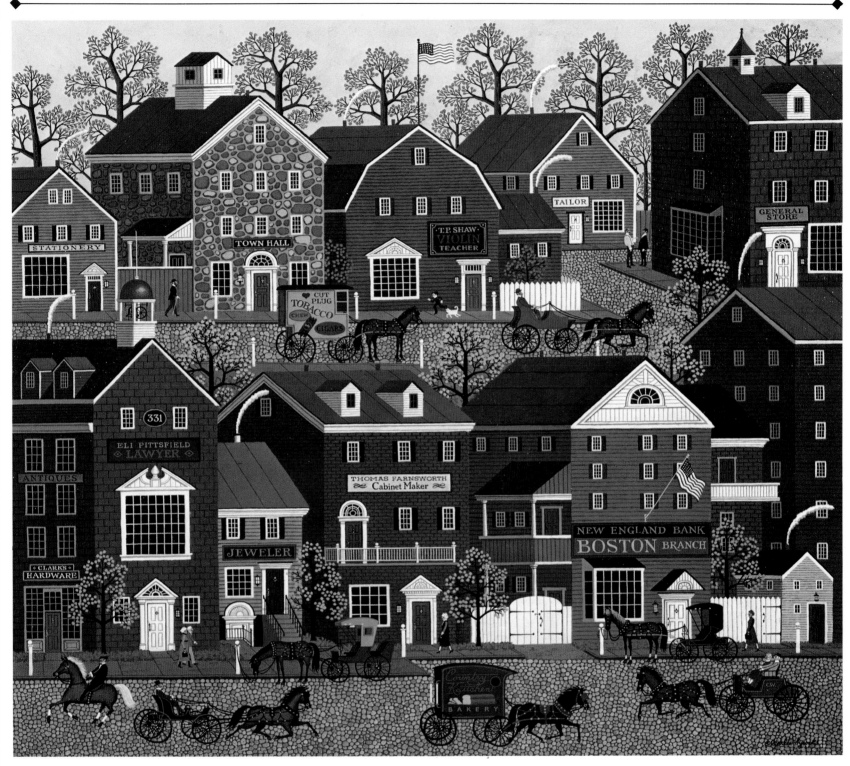

LILAC POINT GLEN
Overleaf: FAIRHAVEN BY THE SEA

then everyone could at least hope to provide such a haven for the children—and America, more than any other country in history, offered that opportunity. Cosy, close-knit communities of families and shopkeepers in the North, busy and bustling are typical of small-town America where everyone knew everyone else.

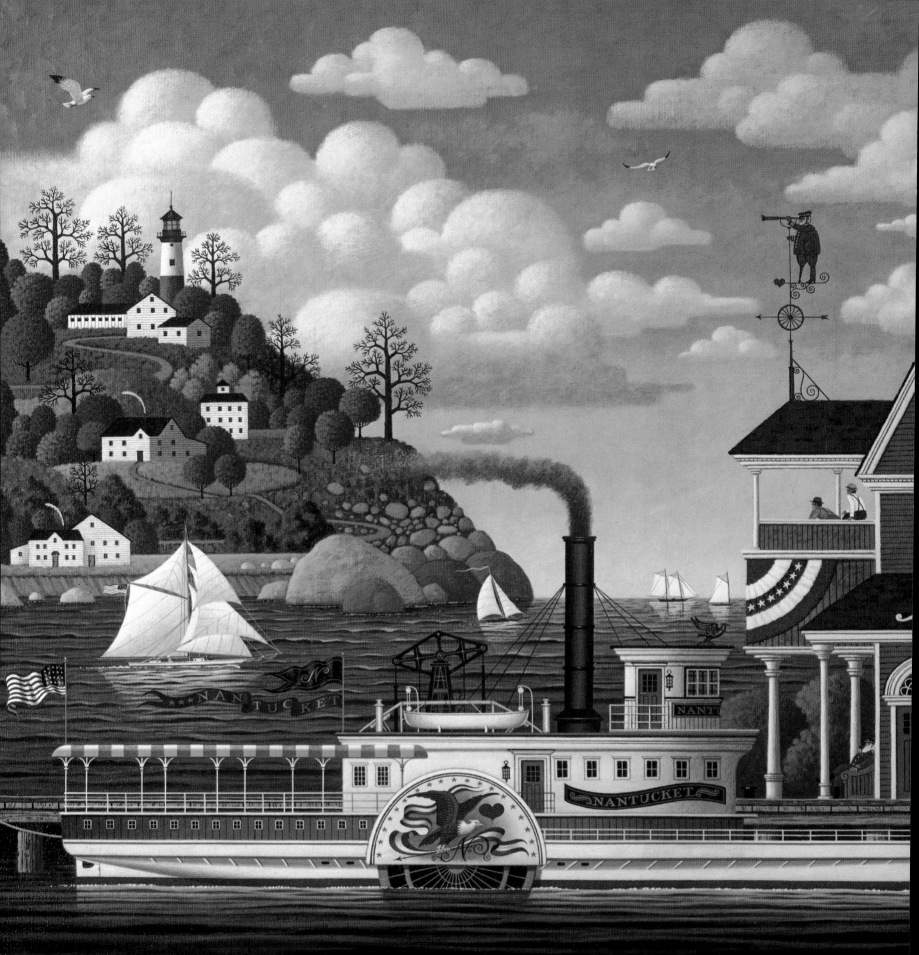

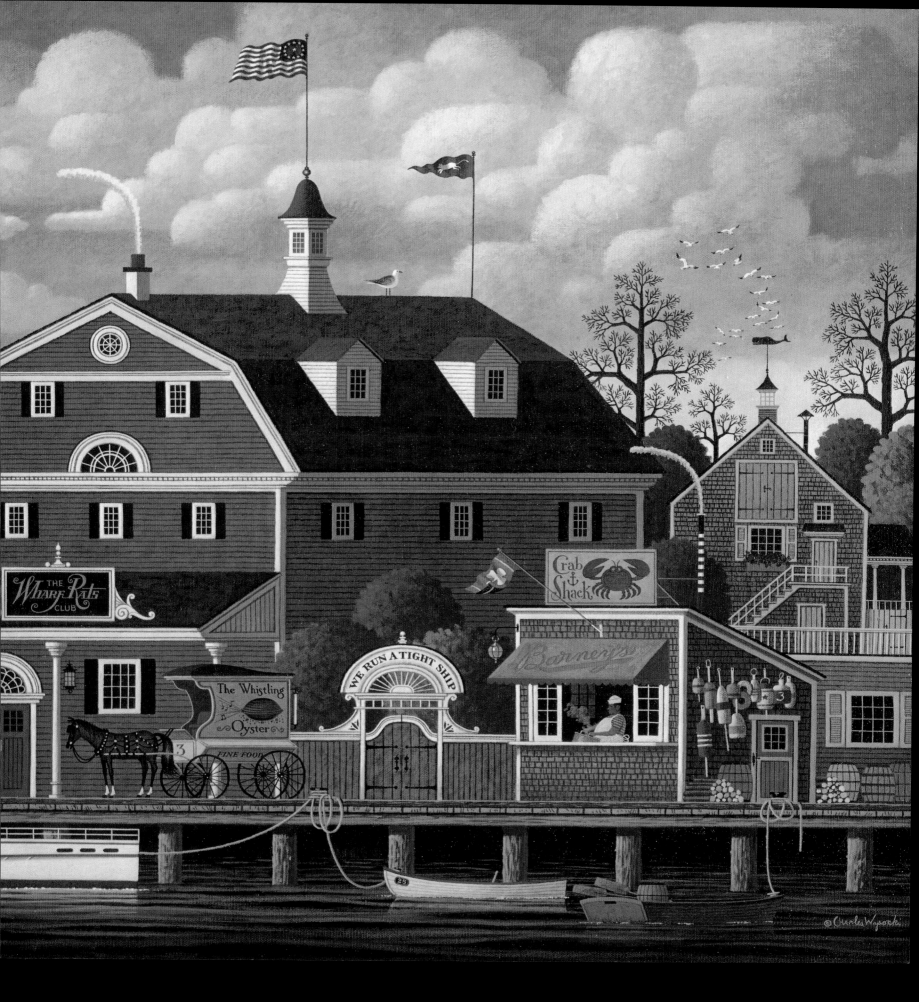

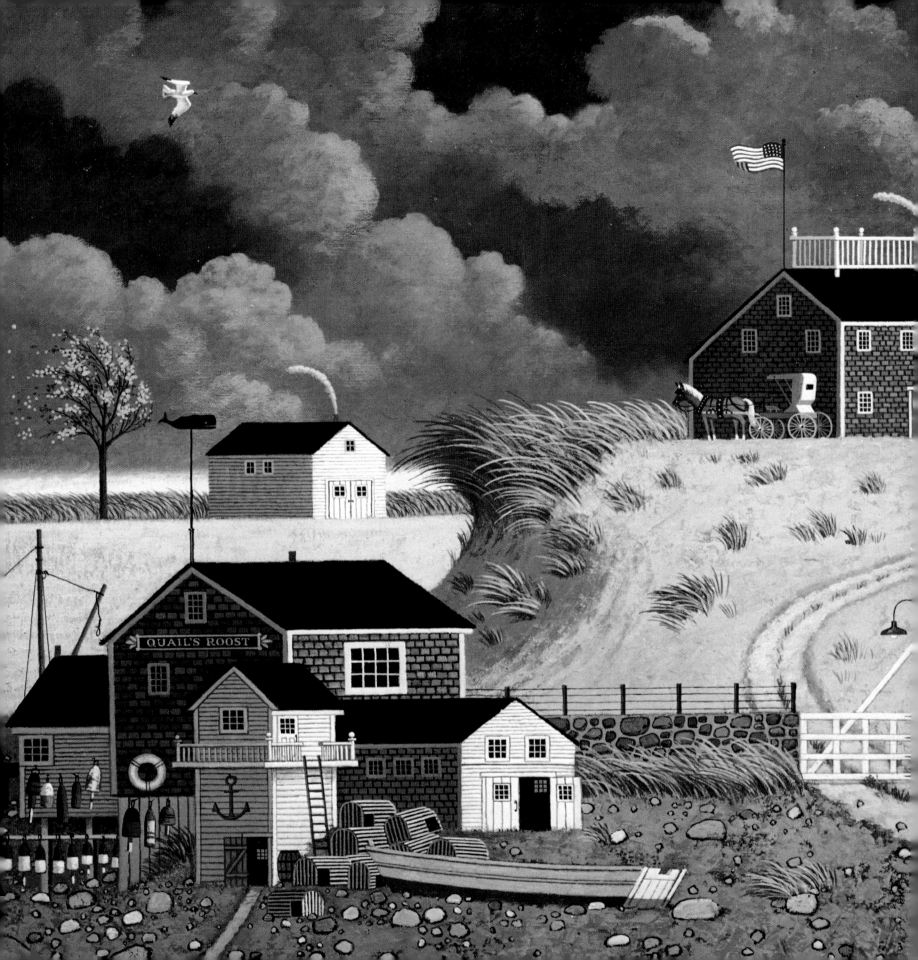

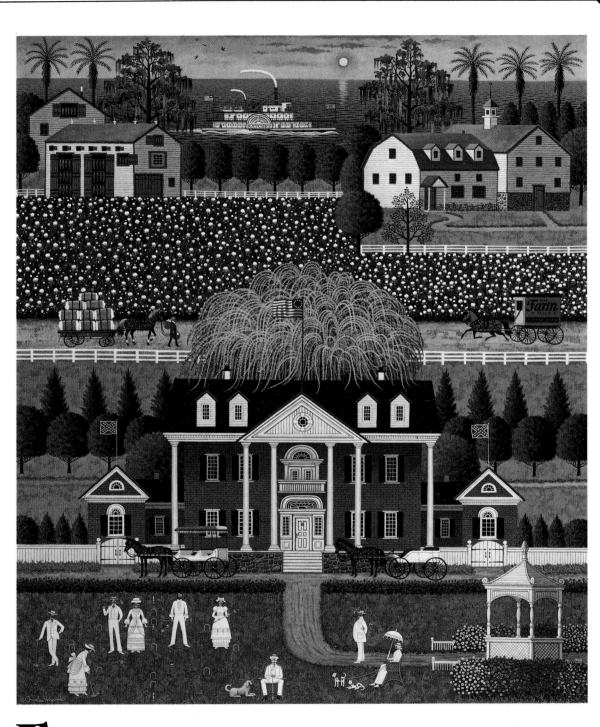

Family life in the old pre-Civil War South was leisured, gracious, with genuinely warm folks, always ready with an iced mint julep and honest hospitality. Symbolic of the life of this soft, fertile land are the riverboat, palm trees, Spanish moss, fields of cotton, tobacco sheds, the graceful mansion with formal white-clad figures playing at croquet, and at least five flags.

Left: QUAIL'S ROOST
Above: COTTON COUNTRY

[39]

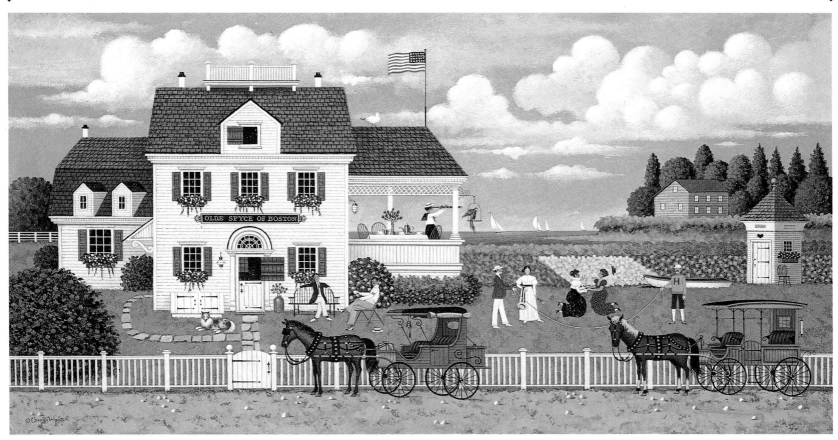

TEA BY THE SEA

There are days on the coast when everything is in decorous harmony—the unusually still air, a sleepy dog, a caged bird twittering on the porch with its carefully set tea table. The gentle horses have settled gratefully into the well-bred serenity, while visiting friends indulge the youngsters in a quiet game of skip-rope.

Presently, and without undue haste, adults and children will all sit down together for a comfortable talk and a cup of tea. After tea, there might be a walk on the beach, especially since it is so calm.

Social occasions such as tea were not rare, but when they were conducted out-doors—certainly a popular pastime—they were usually picnic parties, rather windy and gritty affairs. Nevertheless, the healthy life called to all, and despite sand, wind and insects, food never tasted as good inside as it did outdoors. The porch, like everything else in this painting, is a happy compromise.

This is in Martha's Vineyard, with its charming colonial homes and the particular delight of flower-filled gardens that bravely defy the salt winds of the sea.

[40]

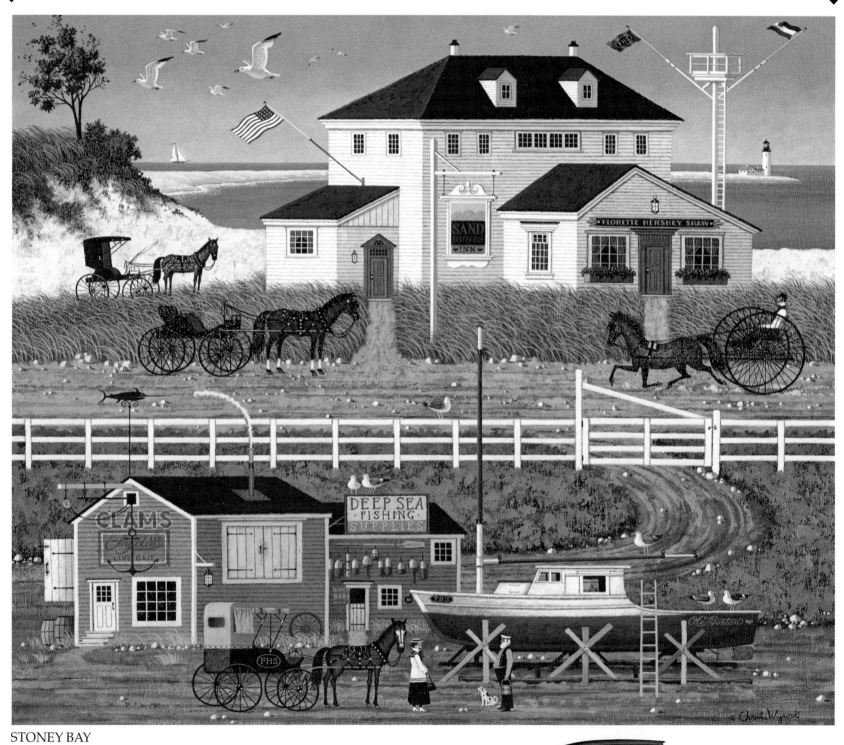

STONEY BAY

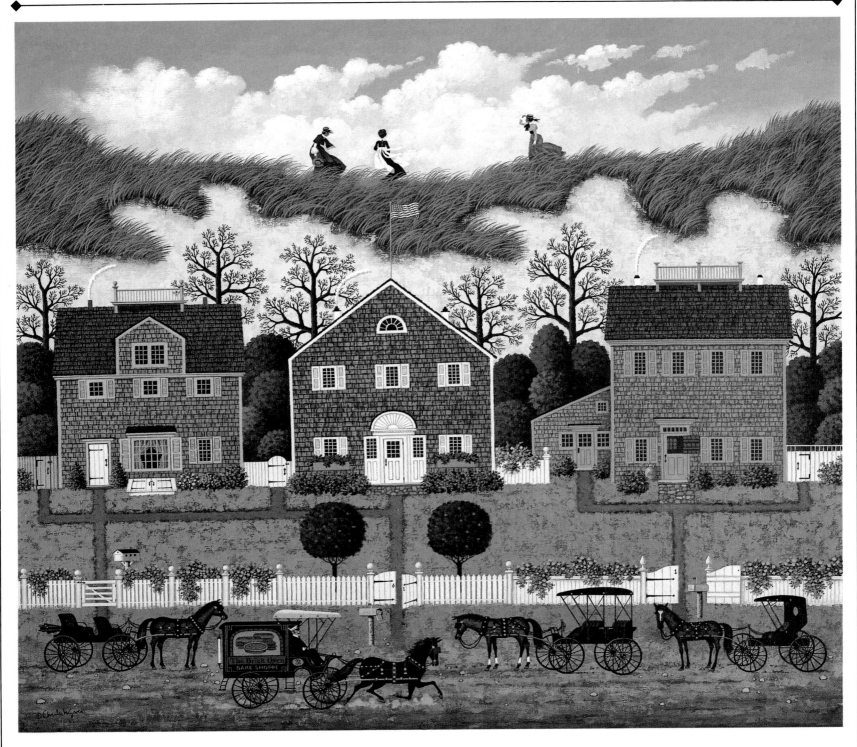

NANTUCKET WINDS

Nantucket was a whaling port, and though there's not a whale nor a ship in sight, there is no doubt about this being a windy, seagirt town. Moreover, the Victorian ladies being blown about so vigorously have deserted their widow's walks for a better view of the sea and harbor. It's unlikely that they would go to so much trouble without good reason, so perhaps a long-awaited ship has been sighted, always a time of high excitement in any seaport town, but especially among the hardy whalers.

GOOD MORNING

Quiet days by the sea are rare, especially in the fall. More commonly, you will find a screaming family of gulls riding on the wind, the spiny sea grasses bending before little scurries of sand, while around the houses laundry snaps back and forth, men wear snug caps or hang on to their hats, and the ladies tie their bonnets securely.

But once in a great while you get a day, or even a lull between gusts, when the ears are startled by the sudden absence of turbulent air. Then you can hear the clatter and clop of passing buggies, and if there is a waterfall in the neighborhood, the sound of its splashing is clear. The stillness of a golden Indian summer day, so usual inland, is all the more precious where wind is almost constant, harrying and bustling and pushing.

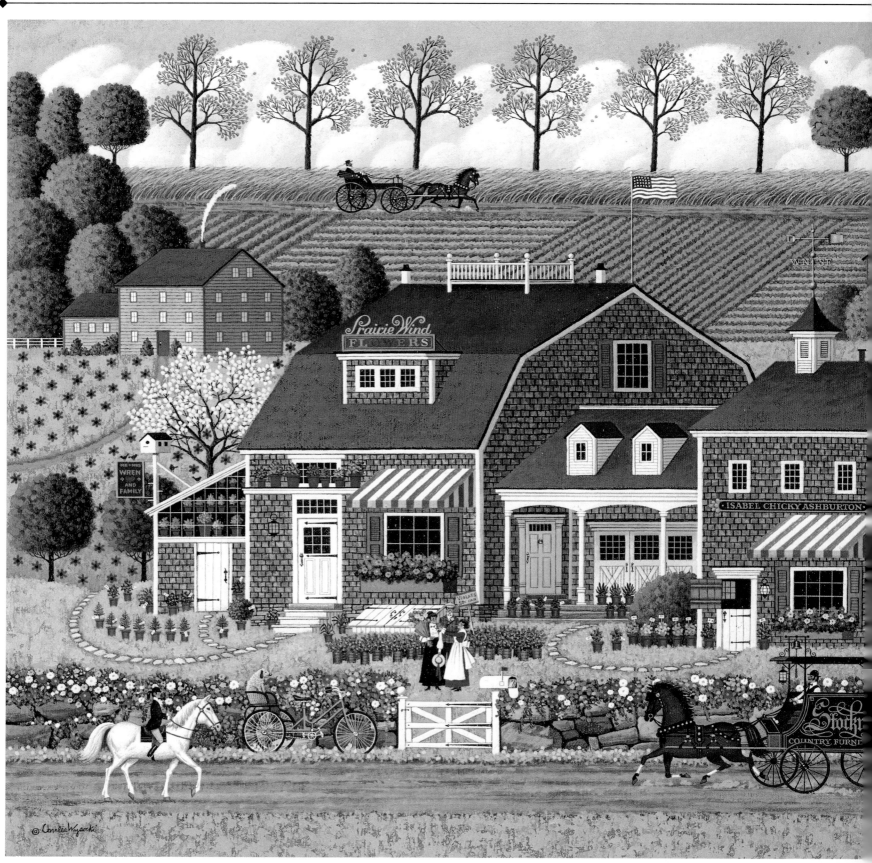

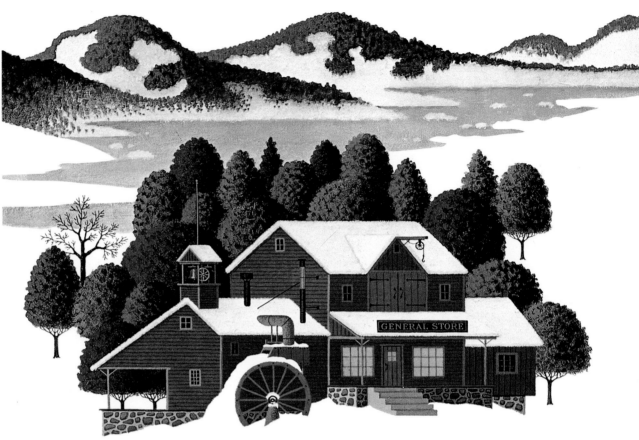

Nothing in this delightfully formal painting suggests the wildness of the prairie—except the name of the inn. The manicured fields attest to long and careful husbandry of the bountiful earth, while the immaculate setting with its neatly arranged flower beds, precise flagstone paths, the mailbox, bicycles and even the name "Stockwell" on the wagon indicate a settled, relaxed community. And so, no doubt, it is.

For this landscape has been lived in for a long time, by New World standards. Maybe for as long as a hundred and fifty years. But somewhere along the line, someone in the settlement must have felt the pull of the West and set out to make his fortune. Perhaps he made enough to come back to the East and, remembering hardships along the way, started this inn to take care of weary travelers. So the "prairie wind" remained in their blood and, perhaps, not all that far removed from the background of this setting.

Above: Detail from CONNECTICUT TOWN SHOPPERS
Left: PRAIRIE WIND FLOWERS

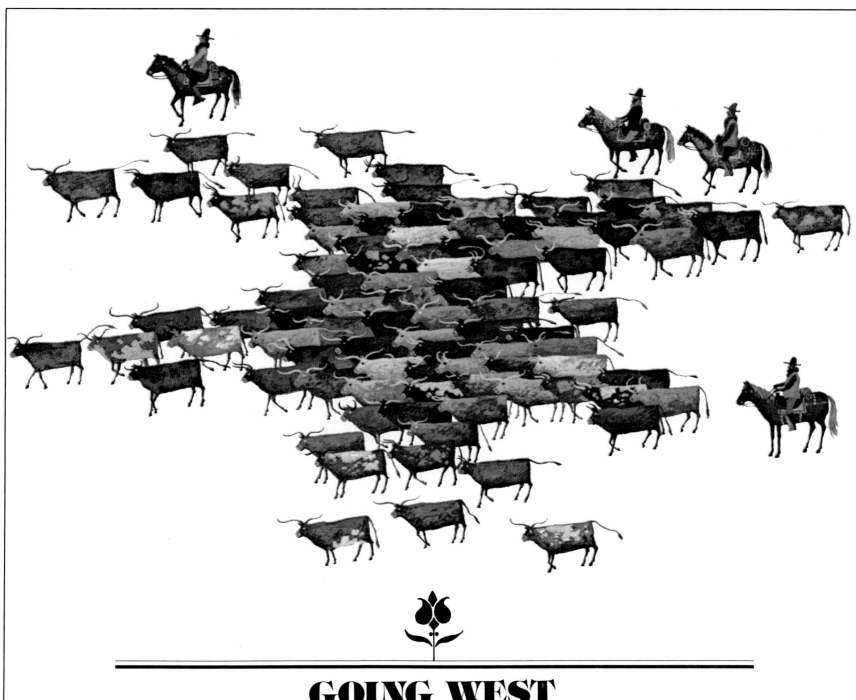

GOING WEST

Perhaps no tale has so captured the imagination of the world as the saga of settling the American West. It was a speck in time as we measure it, but those few years gave the world enough American folk heroes to supply thousands of books and hundreds of films with stories of mountain men, pioneer settlers and their families, of their endurance, courage, humor and the plain dogged cussedness that would not give up. Favorite of all are tales of the cowboy.

The days of the open range lasted only a very short time, but even after fences appeared, the job of the cowboy continued, and it was hard and demanding.

Detail from CATTLE DRIVE

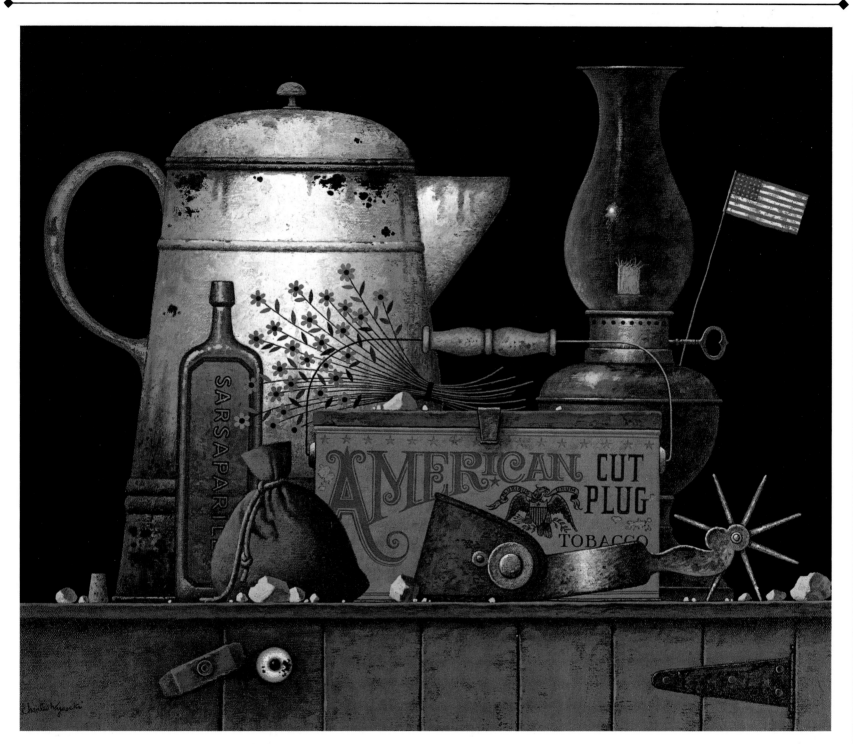

Coffee and a chaw were precious solace during the long, lonely days and nights. Coffee warmed the belly and kept a man awake, and chewing tobacco kept his mouth moist while riding the dusty-dry trails.

The form of the "western" has become stylized, but the quality of greatness clings because it has its roots in the reality of what those men and women did. The taming and settling of a great land was a tremendous challenge, tremendously met, in a brief surge of history that has made a legend for all time.

The movement westward involved all kinds of people. Nor was it a move that could be made empty-

COWBOY TRAPPINGS

[47]

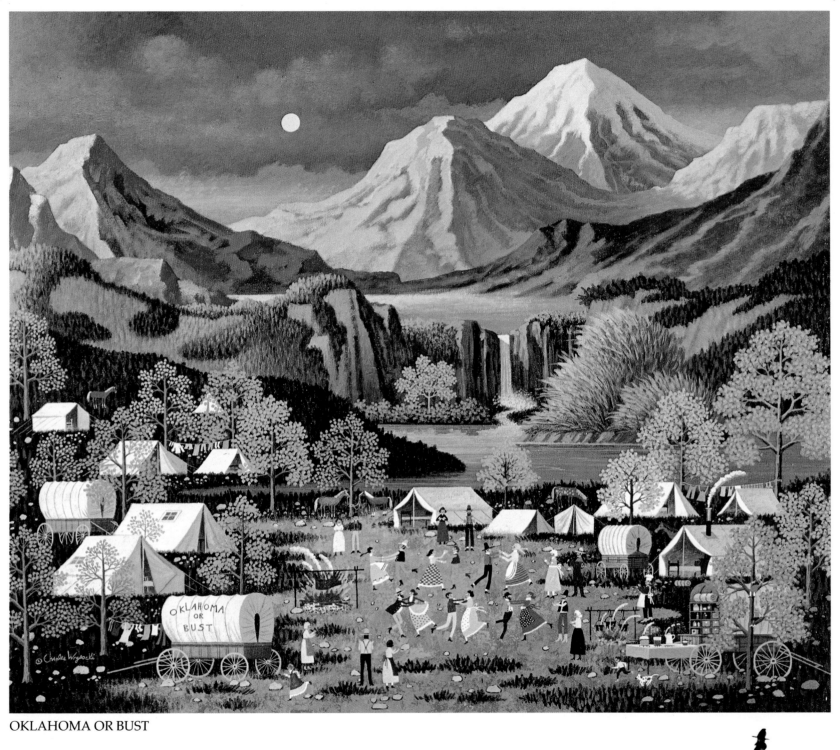

OKLAHOMA OR BUST

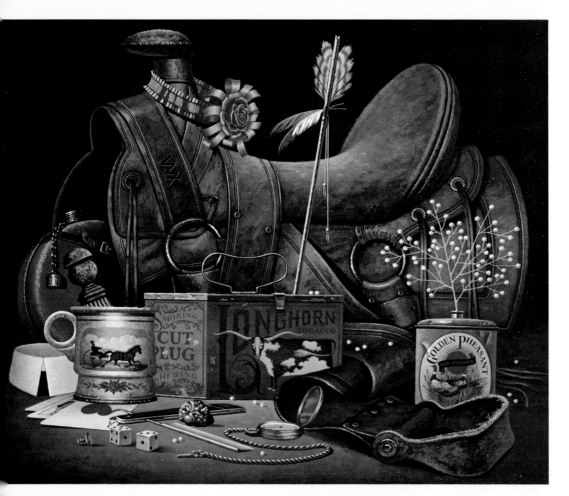

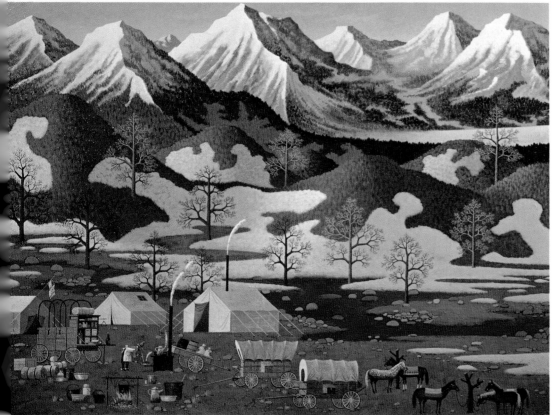

handed. Indeed, one needed to have substantial resources—at least one wagon, oxen and horses, household goods, supplies for six months, tools to work with, clothing, a gun and ammunition, bed linen, blankets—the lot.

Moving a whole family and everything it owns from one place to another is not the easiest of tasks at any time. It's a prospect most people regard as a nightmare. When the circumstances include pulling up all stakes and taking off through the unknown, and to an uncertain destination, many would be overwhelmed.

But for thousands, the promise of living on one's own land represented a challenge rather than a threat. And the wagon trains kept moving. Though some did not make it, the many who did found a comradeship built of shared risk, courage, humor and patience, especially when, as the old song says, "The hills don't get any higher, but the hollers get deeper and deeper . . ."

On the trail, keeping the stock strong, well fed and watered was almost more important than feeding the folks. Each wagon was responsible for its own, and sometimes the evening meal could be a chancy affair, depending on how well supplies were holding up, the weather, how good the hunting (if any) had been that day , and the availability of fuel (ladies, in the beginning, were outraged at the idea of using dried buffalo chips).

Later, though, when ranches had been established and cowboys were rounding up or trailing herds of cattle, the chuck wagon became the heart of the cow camp, and the cook a very important fellow indeed.

Above: COWBOY TREASURES
Below: THE COOK

[49]

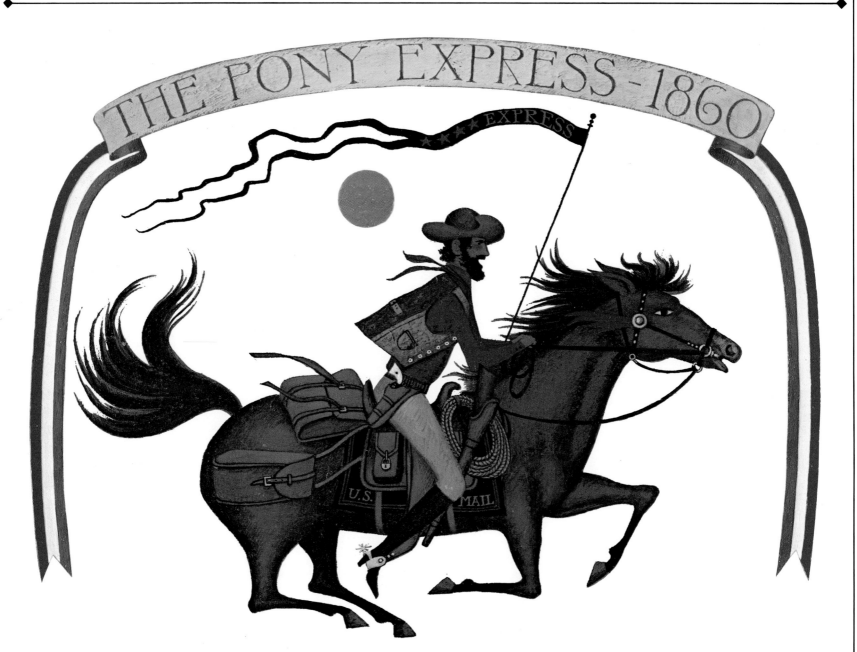

THE PONY EXPRESS - 1860

Begun in April 1860, the Pony Express carried mail from St. Joseph, Missouri, to Sacramento, California. Speed was of the essence. With the horses going flat out, it was necessary to provide a change of animal every fifteen miles. Riders were changed far less often, and some were incredibly young. This created a plus in terms of weight and stamina. Bronco

Charlie Miller, for instance, was only about twelve years old when he first rode the mails. A horse coming in riderless, Charlie's father put the boy on a fresh beast along with the mails and sent him on his way.

In winter, teams of mules were driven back and forth over the trail to pack the deep snow. So $5.00 for the delivery of a letter would buy the services of at

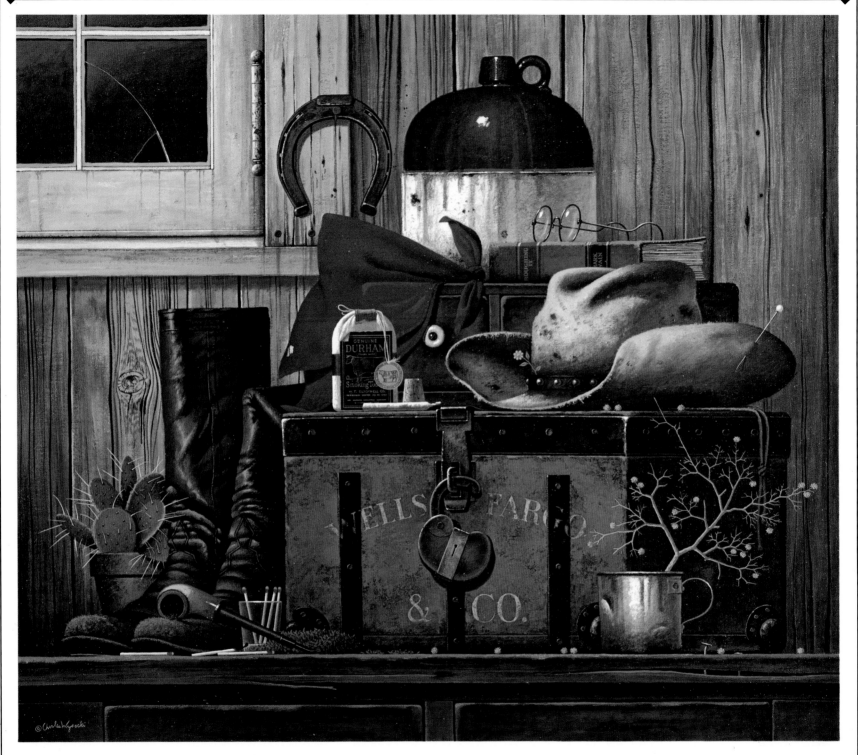

least 140 horses, probably 25 to 30 riders, upwards of 175 station owners, and several dozen mules.

The Pony Express was an extraordinary undertaking that lasted not much more than two years, before it was overtaken by the telegraph in late 1861. But during its brief history of speed and daring (only eight days to traverse two thousand miles through storms, hostile territory and punishing terrain), it established probably the most romantically gallant episode in the history of mail delivery.

WELLS FARGO
MEMORIES

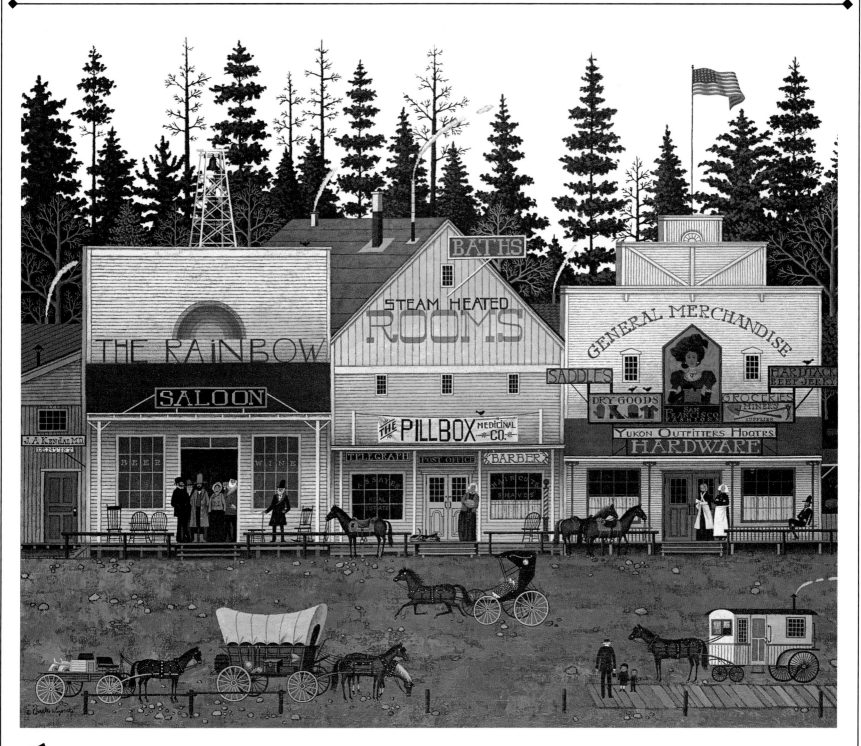

After the West got settled enough to establish cattle ranches, small cowtowns offered a reward at the end of a long, hard trail drive. The first place the cowboys would head for was the saloon, where "Cigareets and Whiskey and Wild, Wild Wimmen" might be available, not necessarily in that order.

Occasionally, a bunch of men long on the trail would hoo-raw a town, firing off guns to announce their presence. Westerners were generally tolerant of such excesses, providing no real harm was done. Milder pleasures would include a bath, a decent meal, a card game or two, more whiskey, and more women.

WESTERN TOWNSFOLK

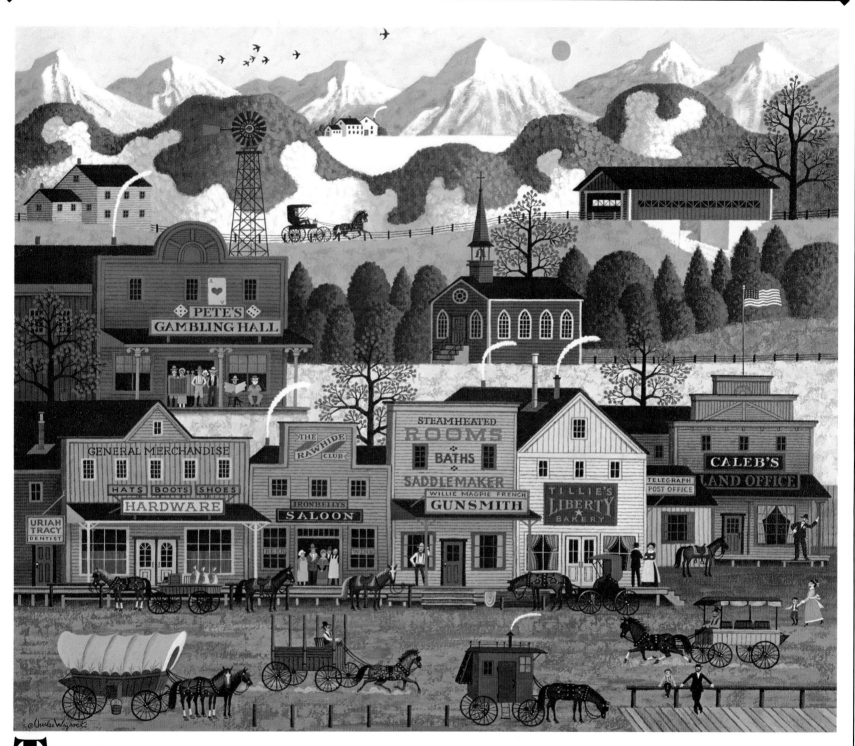

The small western town was often just about all the civilization a cowboy knew. Few had the resources to travel, much less pay the outrageous prices demanded by hotels ($5.00 a *day*!) in sophisticated cities like San Francisco. Yet end-of-the-trail was great—a time to refurbish worn-out clothing, repair hard-used saddle and gear, and, with luck, have the wherewithal for a new pair of tight boots (always the cowman's greatest vanity). It was a tough and lonely life. Maybe that's why the cowboys hit a trailtown with a bang and a whoop, roaring and ready to spend every last hard-earned dollar.

PETE'S GAMBLING HALL

[53]

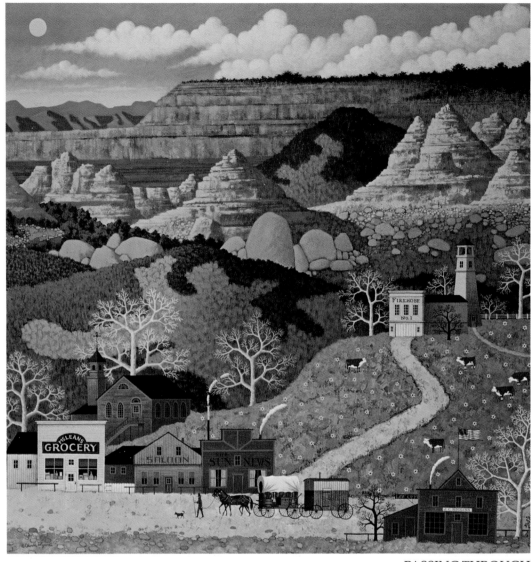

PASSING THROUGH

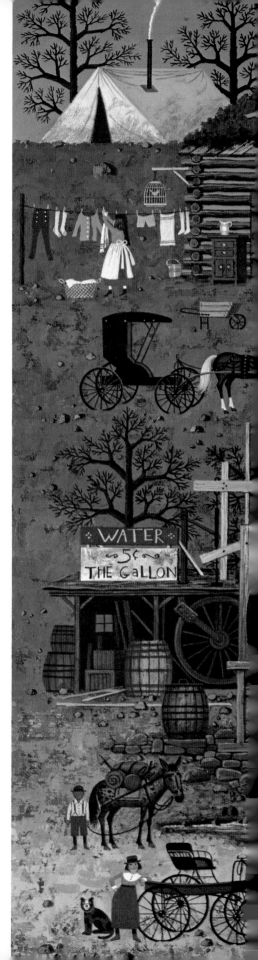

I n all its aspects, rugged individualism was most at home in the West. And of all the western scenes, the transient mining town was probably the most rugged. Along with the hunt for land to settle went the hunt for gold.

But every so often, a particularly enterprising type would set himself up as a town founder. He had probably started by making a strike and could finance a grocery-cum-hardware store, from which he could make sales at fantastic prices to all who followed the lure of his strike. The importation of further amenities, such as whiskey, would rapidly follow. A key factor in renting space or setting up shop was control of the water supply. Clearly, R.J. Kirby has a stranglehold on "his" town.

On the other hand, he has created a well-organized community of neat tents and some frame buildings—even provided the luxury of a cow. Furthermore, there is a fam-

KIRBYVILLE

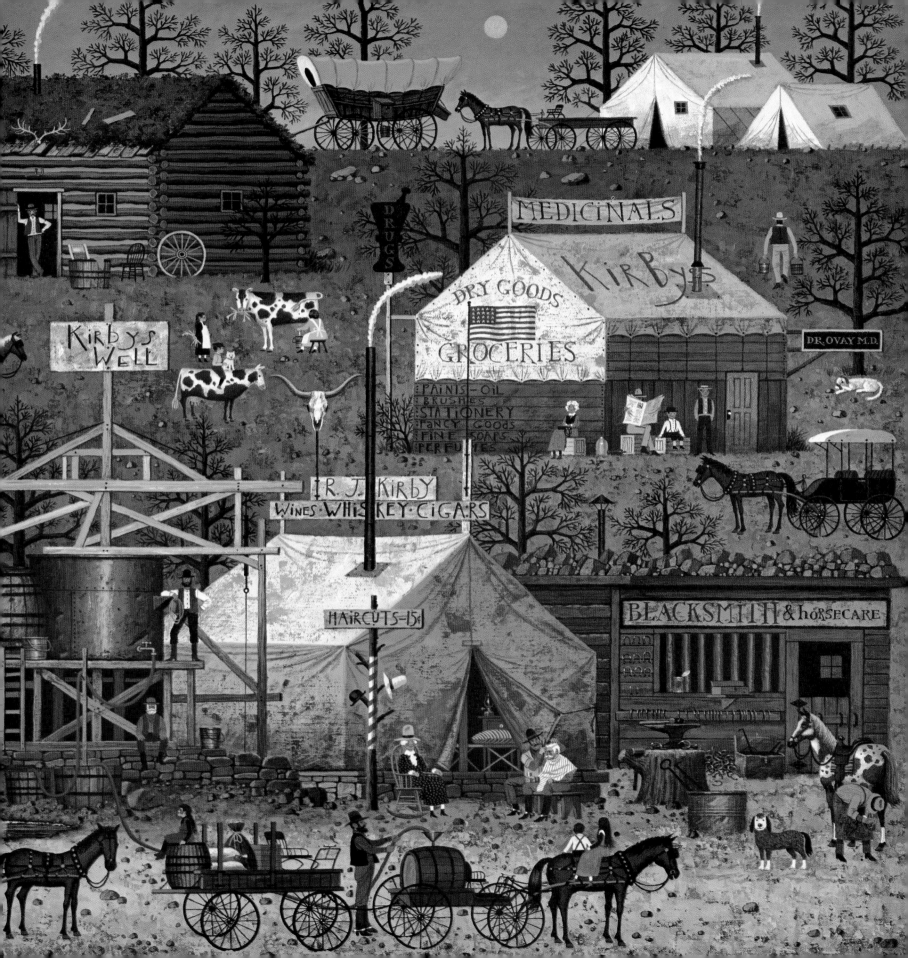

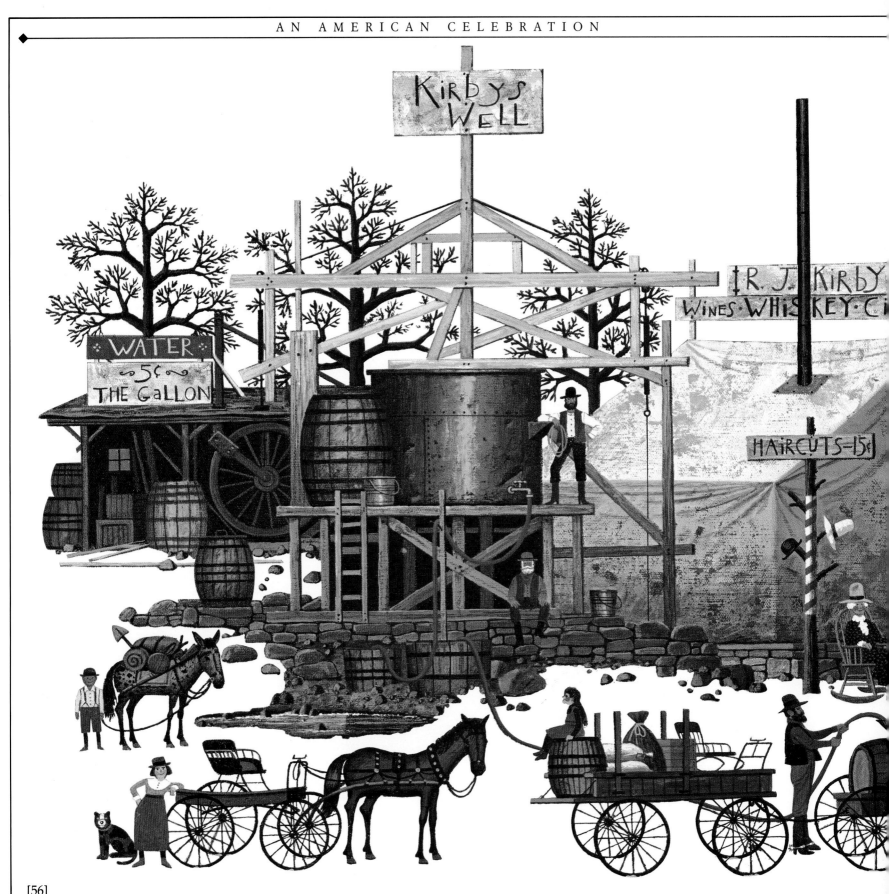

ily far enough along toward civilization to be actually doing a laundry. It may be a rough-and-ready town, as towns go, but the comforts of home have been given more than a passing nod.

Mr. Kirby, though he might be considered a shade sharp, was also shrewd enough to see a surer fortune in meeting the needs of miners than in the unreliable earth. R.J. didn't know it, but he was making history, for in the end his breed would not only build the towns but also set up a network of transport systems to supply them.

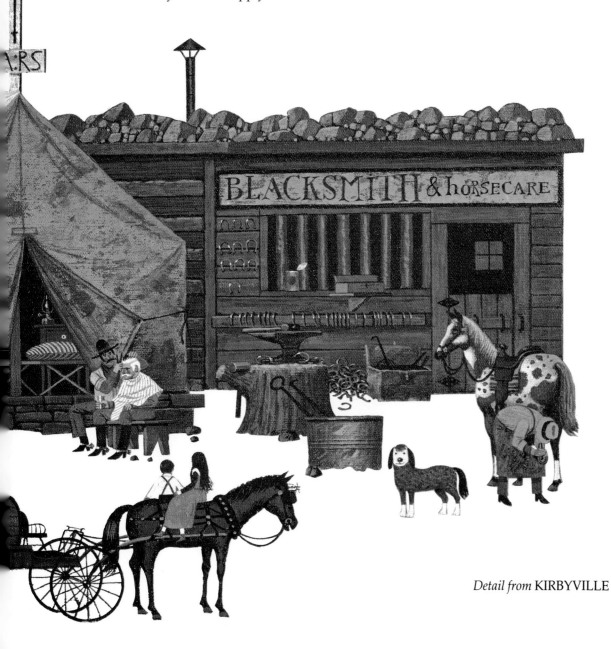

Detail from KIRBYVILLE

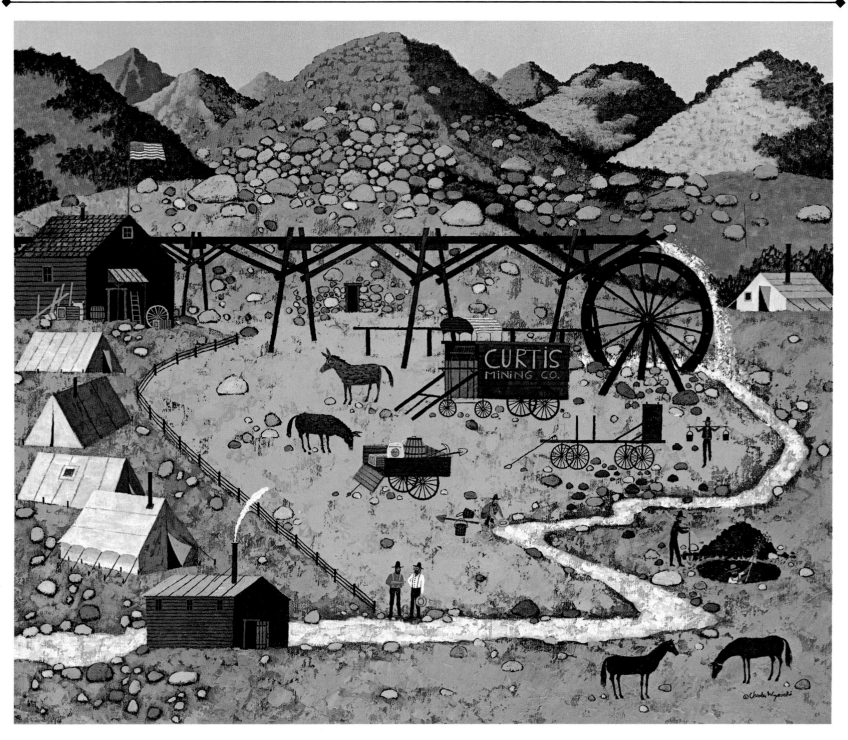

Several generations later, the same combination of greed and dream and determination that had sent men out to pan icy streams for gold in winter and to sweat with pick and shovel over unwelcoming rock in summer, now sent them out to dig for black gold.

Striking oil could mean the wealth would gush out of the earth and drench the lucky winner. But, as with the old-time goldminers, it took the soul of a gambler and the guts of a wolverine to stay with it when your luck was out.

CURTIS MINING CO.
Right: SUNSET HILLS, TEXAS, WILDCATTERS

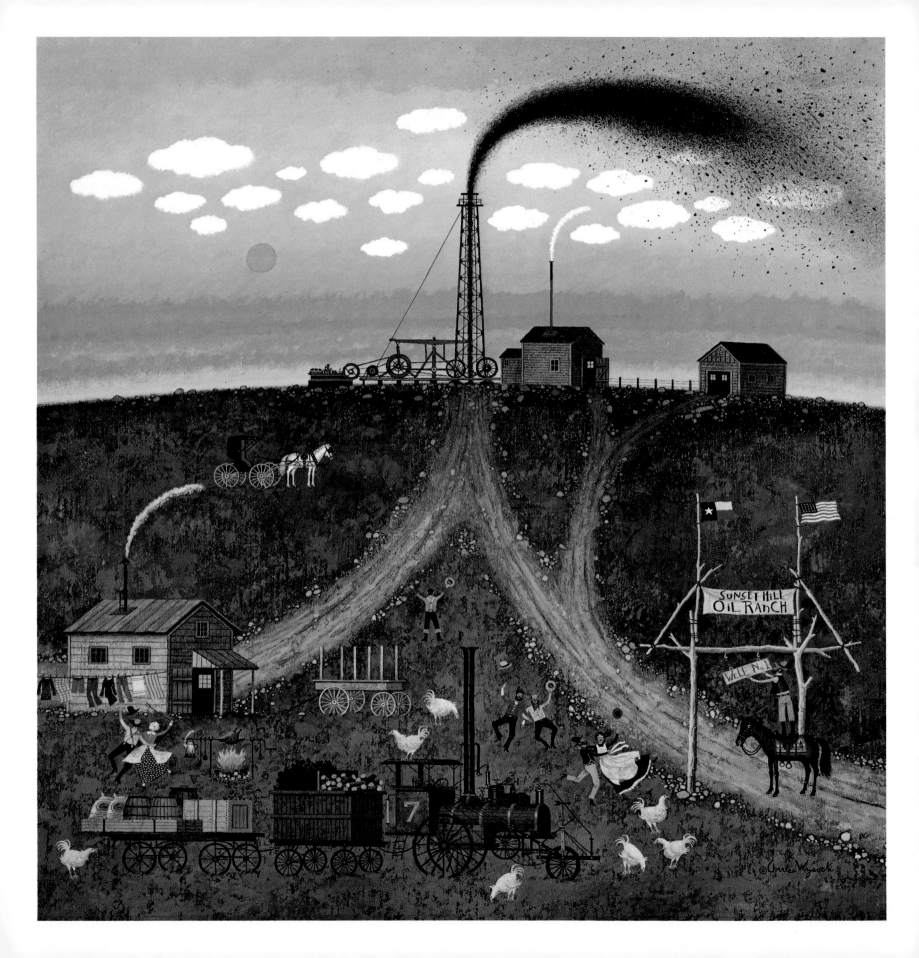

LAND OF PLENTY

Long before oil, and even before gold, the real wealth of America began to create a way of life that would support the whole country for generations to come. The small, self-sustaining family farms of the East got settled first, and rapidly began to produce an astonishing bounty. But it didn't happen by itself.

Clearing the trees and then the rocky acres of the Catskills and the Adirondacks involved the use of heavy wooden sledges hauled by great shaggy-footed farm horses. The backbreaking work,

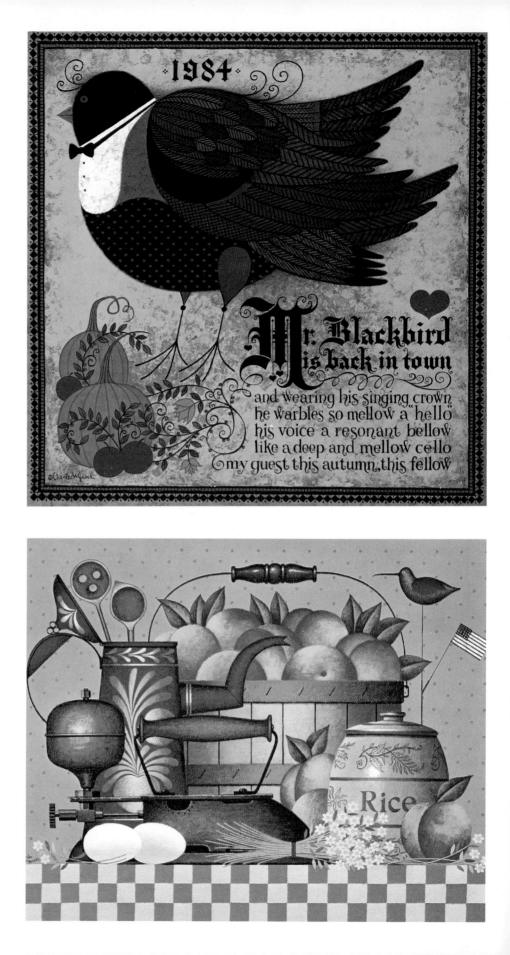

Above: MR. BLACKBIRD

PEACHES

first of digging the rocks and piling them on the sleds, then of disposing of these enormous loads, resulted in the miles of dry-laid rock walls that still wander over hill and valley, marking out the old pasturage for dairy farms and the sloping acres where orchards of Wine-saps, Baldwins and other apples produced hundreds of bushels each year. In the fall, especially after a high wind, farmers learned to keep an eye on the cattle—if they got into an orchard and ate the windfall, there'd be a lot of drunken cows to bring home. Meanwhile, in

FARM FOLKS

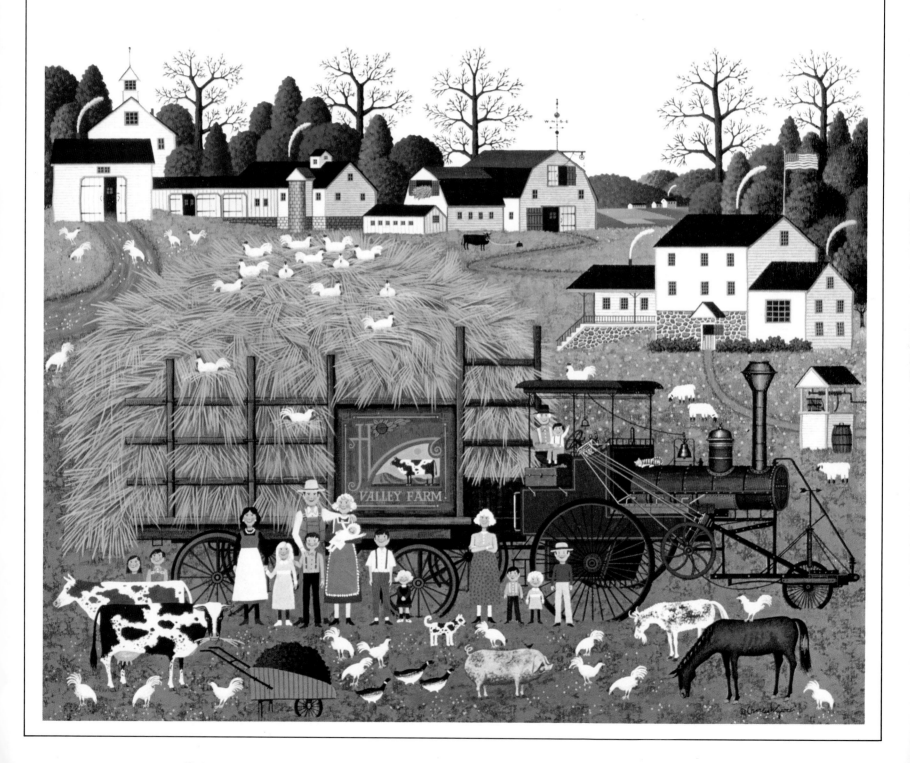

the meandering valleys, ground crops and vegetables were being grown.

Early on, sheep were introduced and took happily to the hills, no doubt reminded of their own rocky crags in Scotland. In fact, the seeds of wild thyme they brought over on their woolly backs also found a comfortable new home and eventually became the source of that rare delicacy, wild thyme honey. And there were always hogs, of course. Poultry and eggs usually provided pin money for the farmwife, but the hill farms weren't much on really big cash crops. However, there were plenty of sugar maples, wild black walnut, hickory and butternut; and very importantly, hardwoods for the mills; while the great, sad, magnificent old pines yielded up their bark for the tanneries.

A bit farther west and north, all up and down New England and into Maine and Pennsylvania, the land was richer, producing a harvest of grains, corn, root crops, summer and winter vegetables, and an abundance of wonderful fruits—berries of all kinds, peaches, apricots, apples, pears, plums and the tart quince.

America ate well.

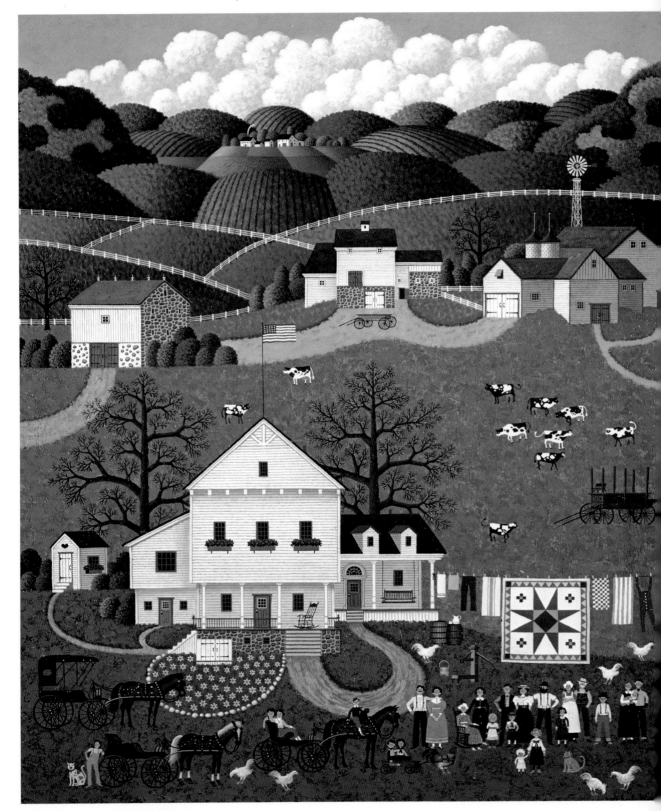

COLORADO FARM FAMILY

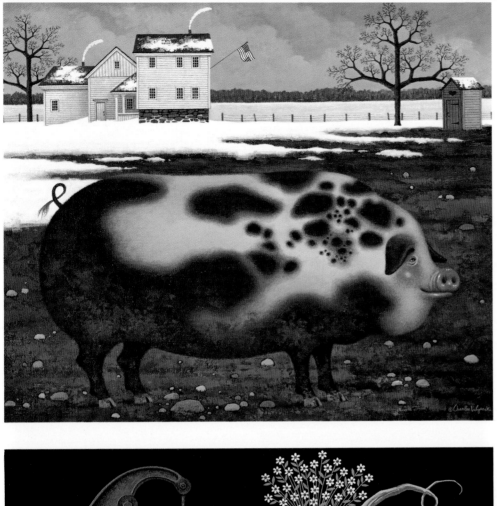

Left: THE PIG
Below: Detail from BEASTLY ASSOCIATES

PUMP, PUMPKIN AND A PRAYER

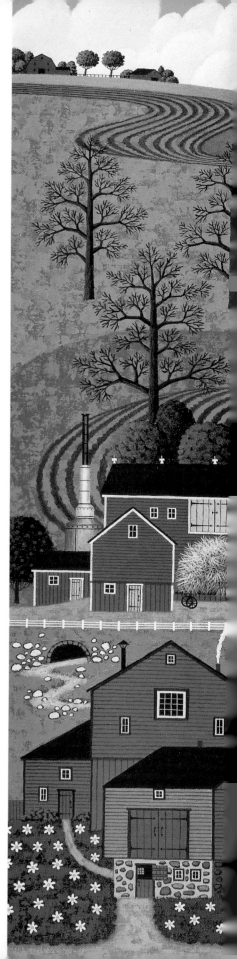

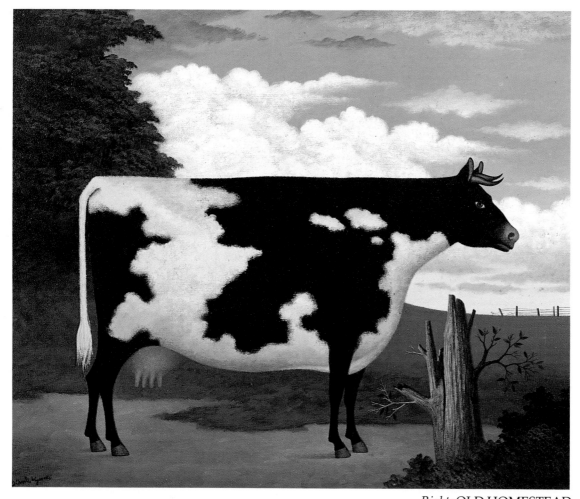

Right: OLD HOMESTEAD
Above: COW
Below: THE PLOW

THE HEAVY PLOW BRINGS WET THY BROW

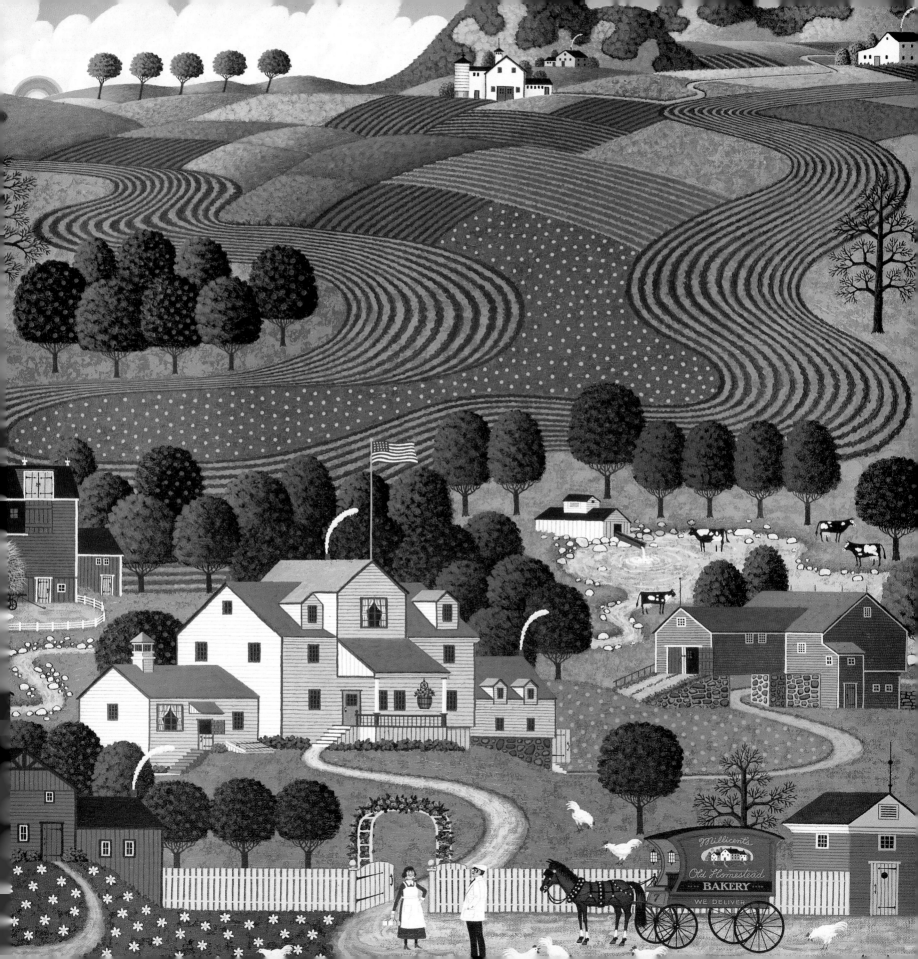

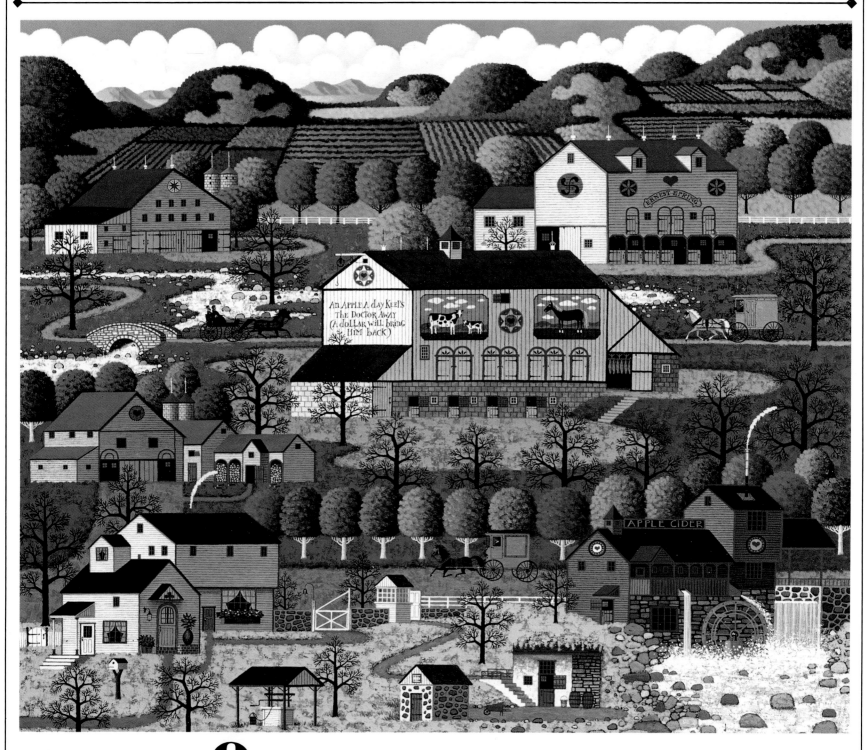

AMISH AUTUMN

Quilting was a winter activity that bore fruit in the summer. But many families made these exquisitely stitched covers for their own use, taking great pride in their intricacy and design, often following the tradition of the farmwife who undertook to make a quilt for each of her granddaughters. A family history could be sewn into the design with tiny scraps of material left over from old dresses, curtains or bits and pieces of wornout clothing. And there were "friendship" quilts: a young wife would give each of her female relatives and friends a small square of cloth on which they could either draw or embroider a design

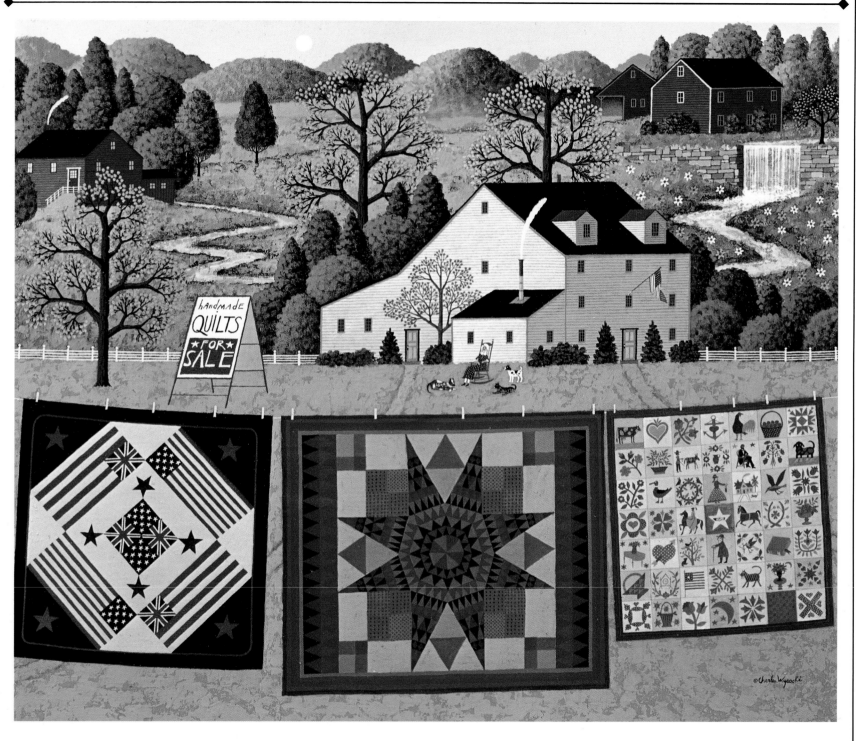

or perhaps their initials. The young wife would then complete the embroidery, and the whole would be put together as a quilt to remind her of good people and gay times in her youth.

Fortunately, there was a lot of sharing in the meticulous work all these creations called for, and a great deal of fun to be had at the quilting bees. But one wonders how there were ever any extras left to sell!

THE QUILTMAKER LADY

[67]

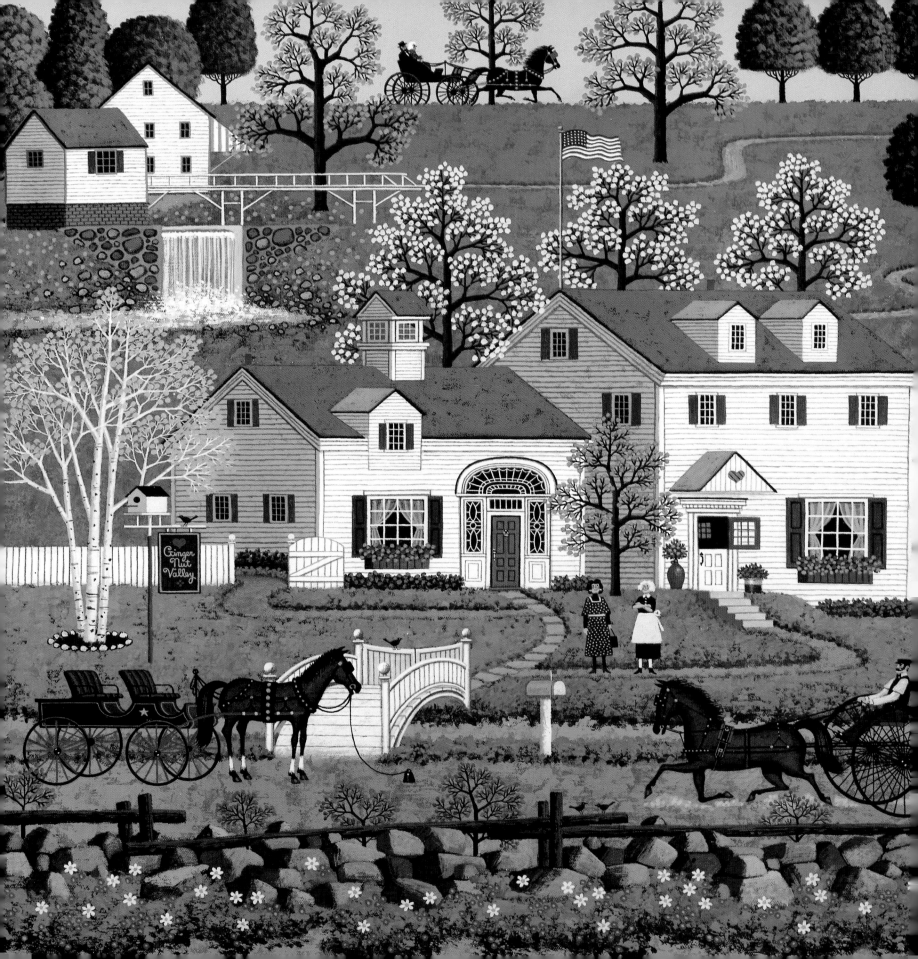

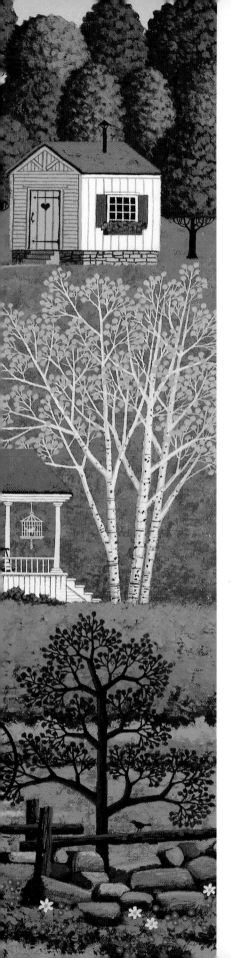

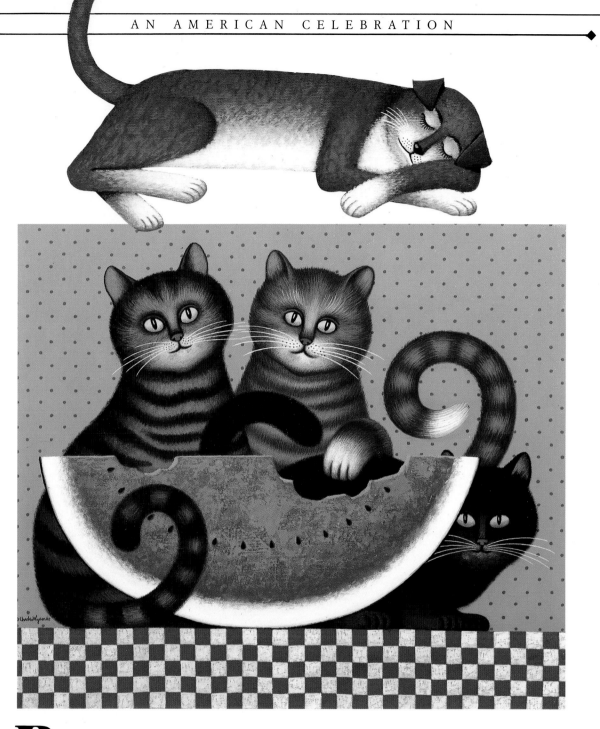

Prosperous farms gradually began to generate gathering places—centers of activity that developed into small towns. Neighbors got to be within shouting distance of one another. Evening socials could be easily enjoyed. Horses were still working stock, but cats and dogs and birds had graduated to the status of pets—sharing all the comforts of home, including the family foods.

Top: Detail from TWINS AND TANDEM
Above: KITTY'S TREAT
Left: GINGERNUT VALLEY

[69]

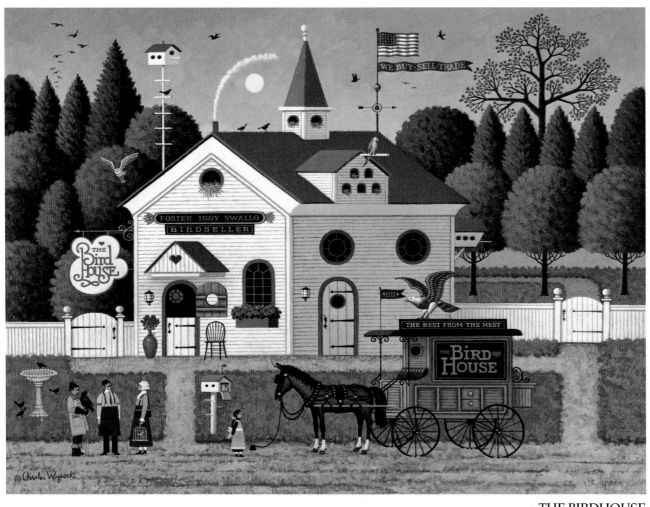

THE BIRDHOUSE

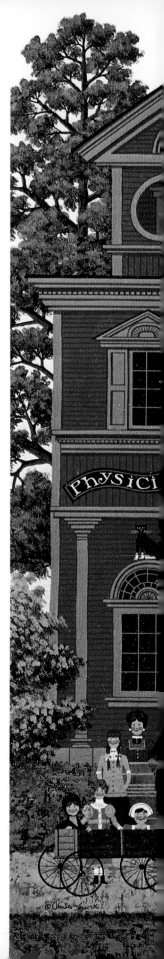

Civilization was clearly taking a firm hold when bird fanciers could indulge their foibles by purchasing feathered friends at such a distinguished emporium, assured of getting only "The Best from the Nest."

Incredibly, with the new skies full of avian exotica such as cardinals, hummingbirds, grosbeaks, warblers, nuthatches, cheeky jays, finches and loudly scolding wrens, Mrs. Small-town America still preferred to elevate the tone of her parlor with an ornate birdcage and a happily trilling canary. In fairness, it should be added that her yard almost invariably contained an equally ornate feeding station, a proper birdbath and other amenities for the wild population.

Detail from MERRYMAKERS' SERENADE *Right:* DOCTOR BONKLEY'S FAMILY

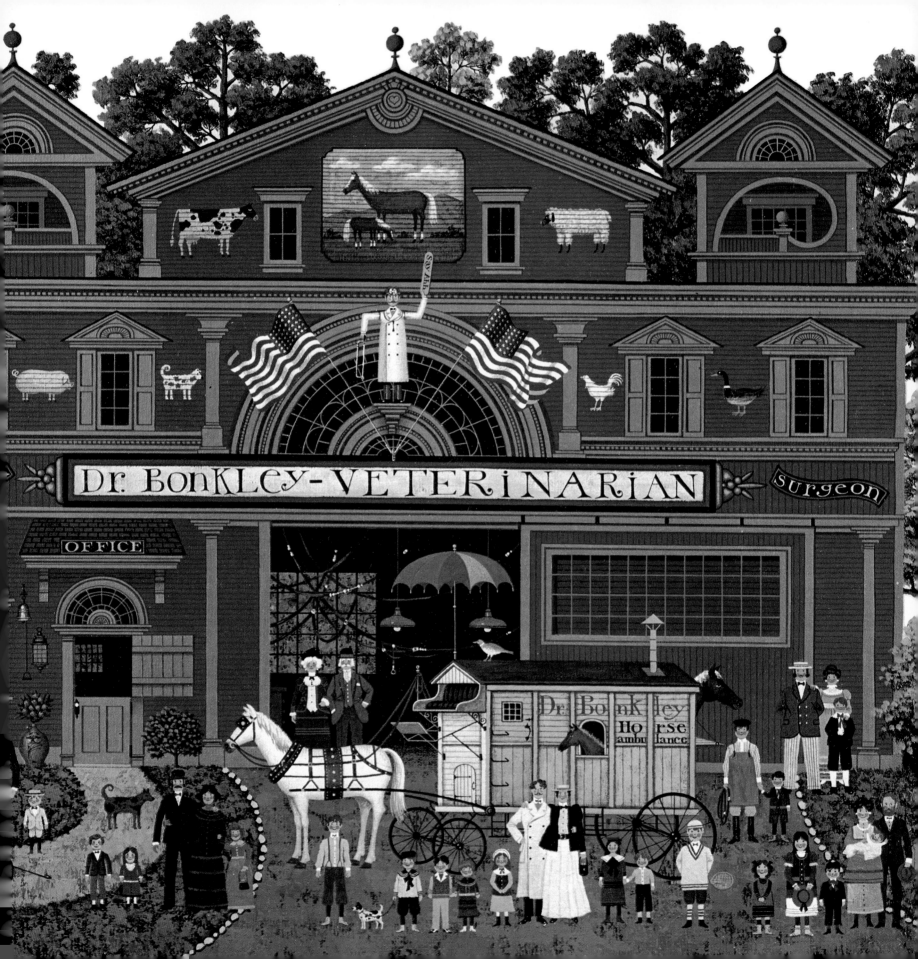

LITTLE STORE ON THE CORNER

Out in the country, most folks relied on home produce to keep the table supplied—fresh vegetables (bottled for the winter), meat from home-fed sheep, hogs, and chickens; and dairy products from your own cow, maybe shared with a neighbor. Shopping was a real expedition, something that would certainly take all day. There would likely be a country store you would visit in the wagon every cou-

WESTERN TOWN

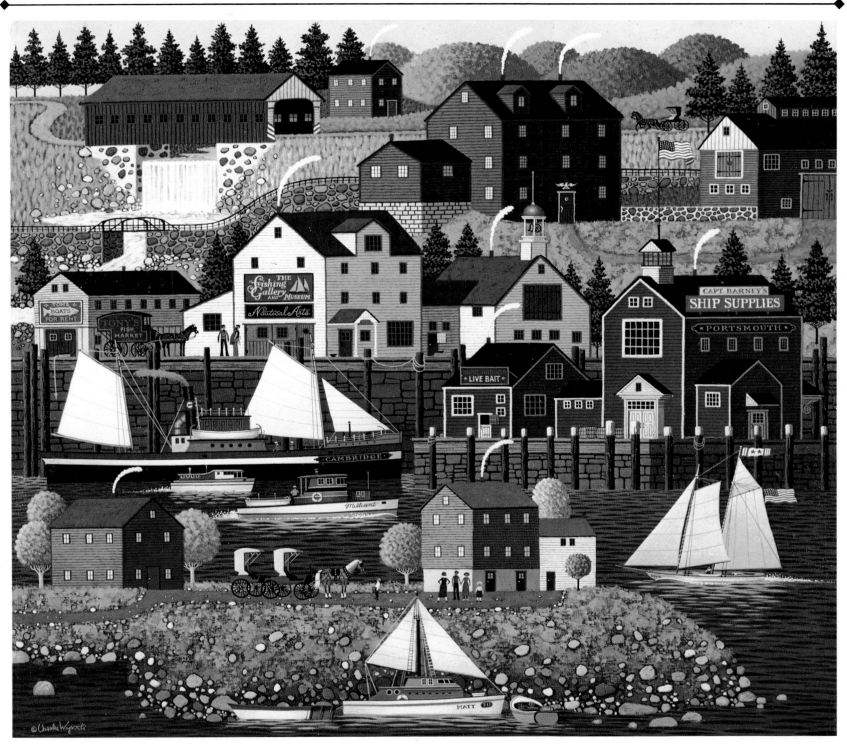

ple of months, a glorious emporium that carried virtually every necessity for daily living, from tools and wagonwheels to crackers and pickles. Naturally you didn't look to find the refinements of life squirreled away somewhere in that cavernous barn, but there was always the magnificent Montgomery Ward catalog (a major source of dream-reading in every home) which literally did carry absolutely everything from "Langtry" hairpieces to astonishingly elaborate and curlicued wood stoves. Expensive, though. One of those stoves would cost you $19.80. But "Ladies' Shirt Waists" were $.48 each, $5.60 the dozen. Country folks had to watch their pennies.

Small-town America, on the other hand, was more

THE CAMBRIDGE
Overleaf: PLEASANT VALLEY SQUARE

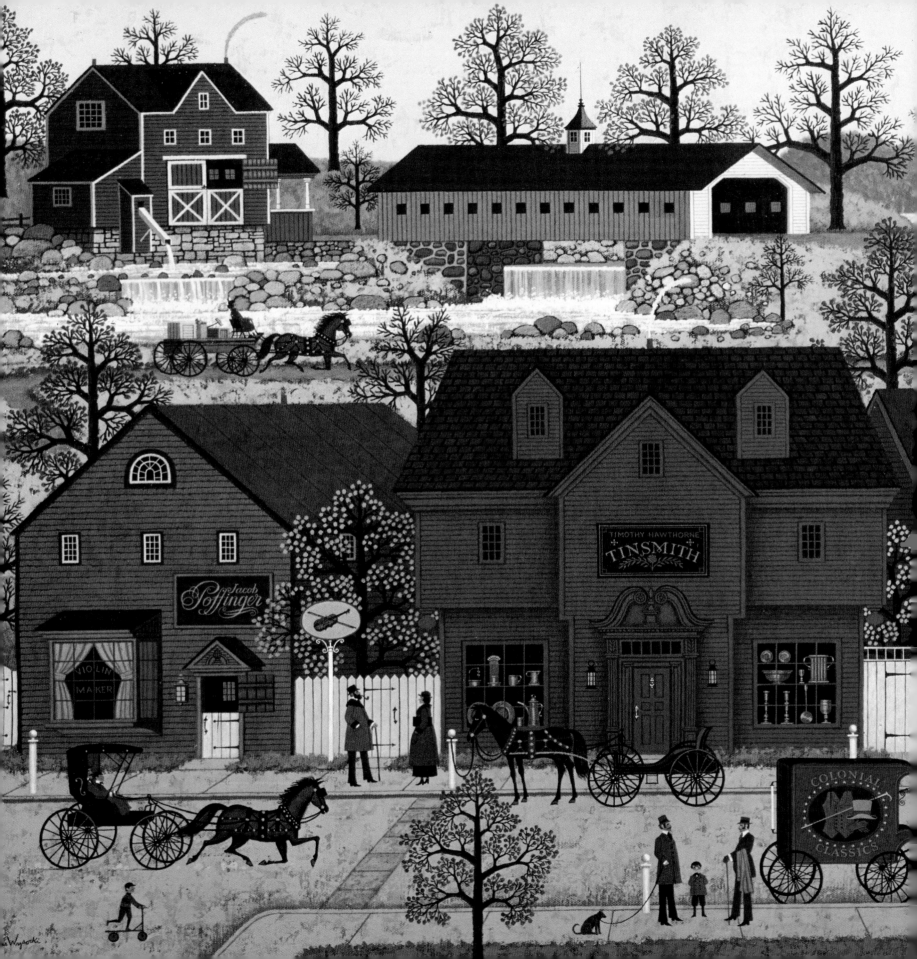

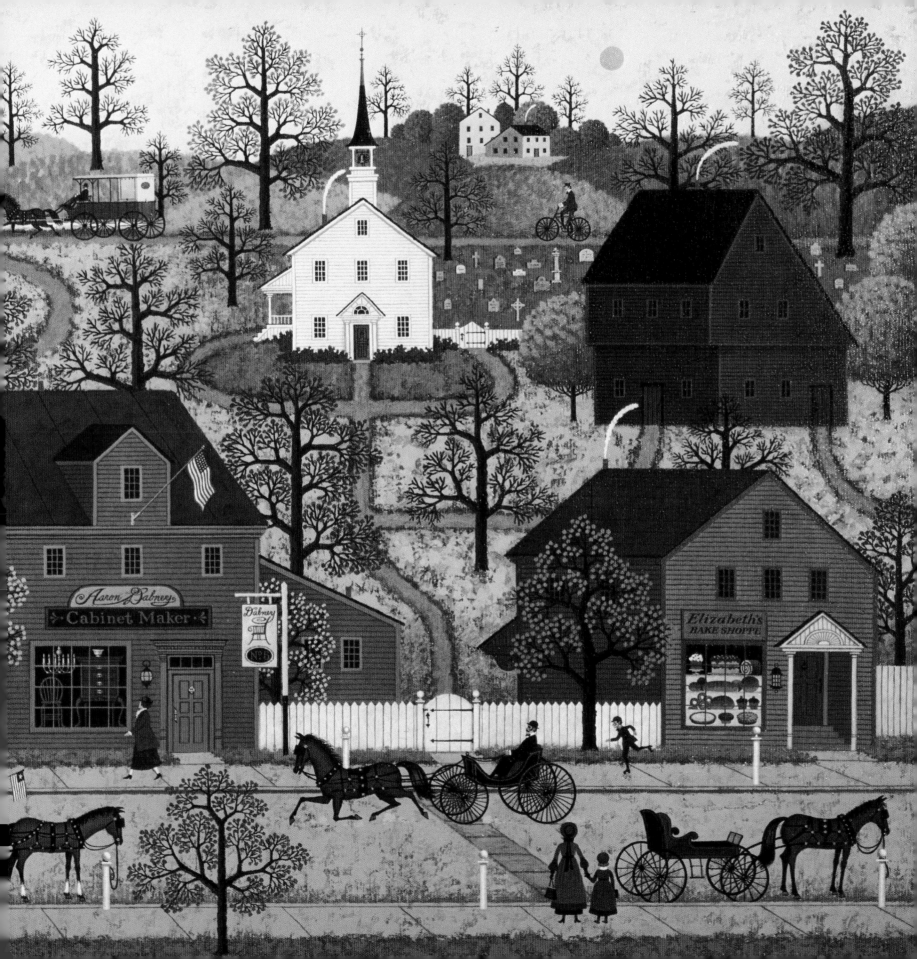

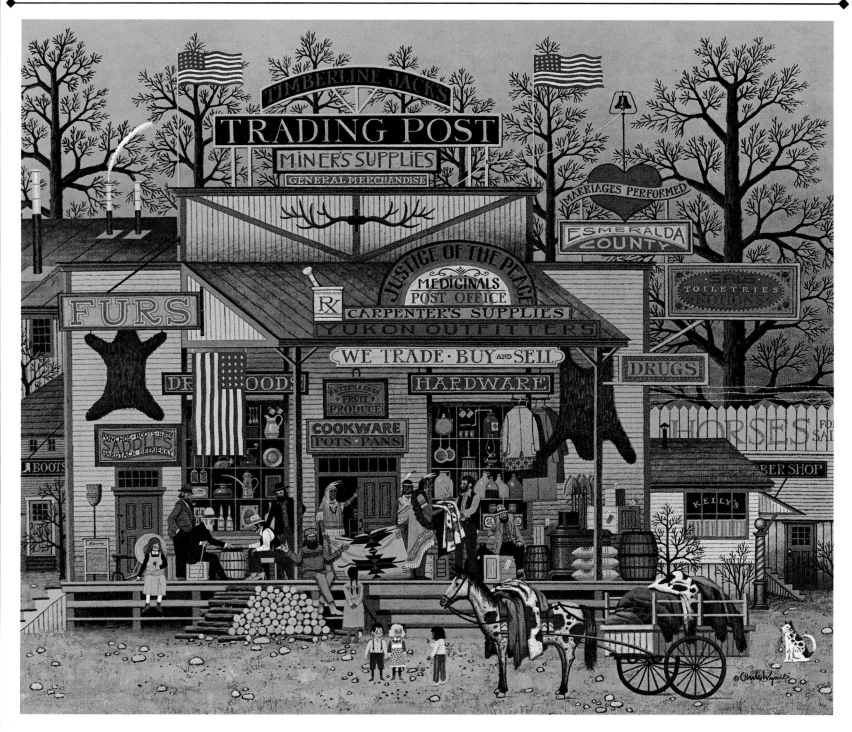

TIMBERLINE JACK'S

freehanded, doing its shopping just about every day in individually owned stores. Very much a part of the busy, productive life were "the butcher, the baker, the candlestick maker"—to say nothing of the grocer, wine merchant, fishmonger, cabinetmaker, and many others. Generally milk was delivered daily, the wagon drawn by a patient horse who knew exactly where to stop. And there were the barbershops; the stores for dry goods, linens, hardware, ready-made furniture, yard goods, china and glass, millinery, clothing and books; a livery; a carriage store; and, of course, the indispensable drugstore and ice-cream parlor.

Even here, in the towns, a lot of baking and handwork were done at home, but the raw materials came from the small family stores where the proprietors not only knew their customers, they often bought for the

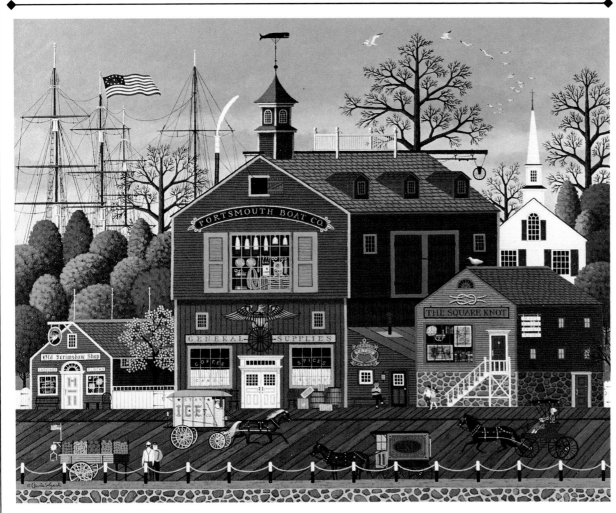

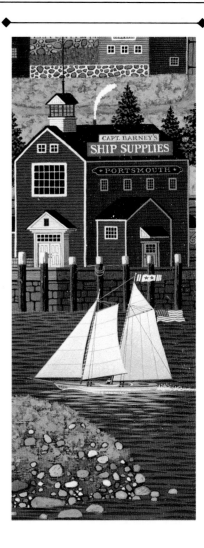

special needs of a particular individual. Shopping was a personal matter, and in such a delightful variety of familiar places it became a social occasion, less formal than the church center, and a great way to encounter neighbors and exchange recipes, complaints, patterns and scandal.

Shopping was fun, a major activity that made a big piece of the world go round—a happy function of the period when individuals owned stores, person-to-person was an all-important reality, and the circle of friendship extended to an entire community.

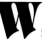aterways always attracted business. In fact, before the advent of railroads, water was the main factor in much of the transport for the East. The building of the Erie Canal—connecting Lake Erie through 350 miles of farmland with the Hudson, and thus with New York City and the Atlantic—was a saga in itself.

The hard-won existence of the Erie Canal opened up the whole Northeast, as well as offering a new route to the Great Lakes area and the Northwest. It created river and canal towns, with their accompanying specialized stores and skills, and a lifestyle for those who serviced the boats and lived on its banks. And it gave rise to a generation of raucous, not to say bawdy, folk songs to help while away the time as the rivermen moved up and down the length of the waterway.

THE ERIE CANAL

We were forty miles from Albany,
Forget it I never shall;
What a terrible storm we had one
 night
On the E-ri-ee Canal!
 Oh! The E-ri-ee was a-risin',
 gin was gittin' low,
 And I scarcely think we'll get a
 drink
 'Til we get to Buffalo-oh-oh,
 'Til we get to Buffalo!

Detail from
THE CAMBRIDGE

RIVERFRONT STORES

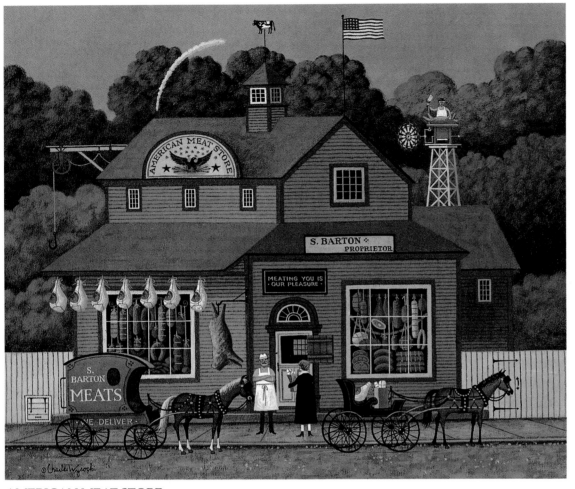

AMERICAN MEAT STORE

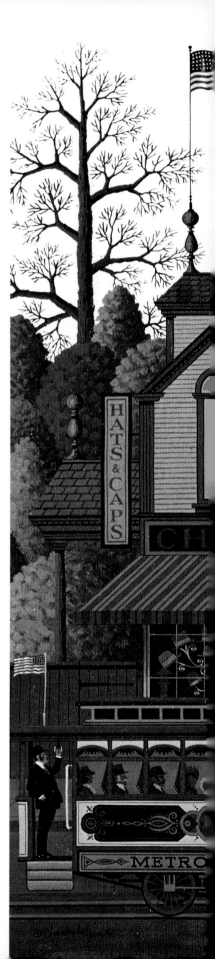

Above: FISH SELLER
Right: THE HABERDASHERY

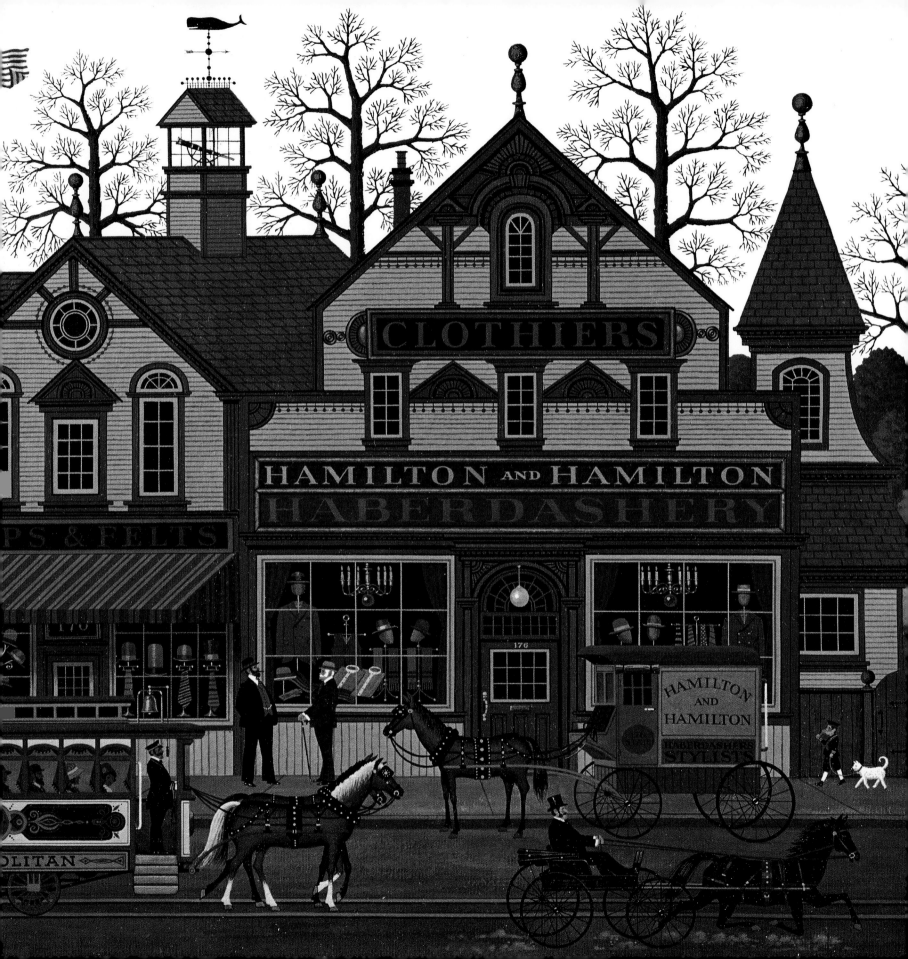

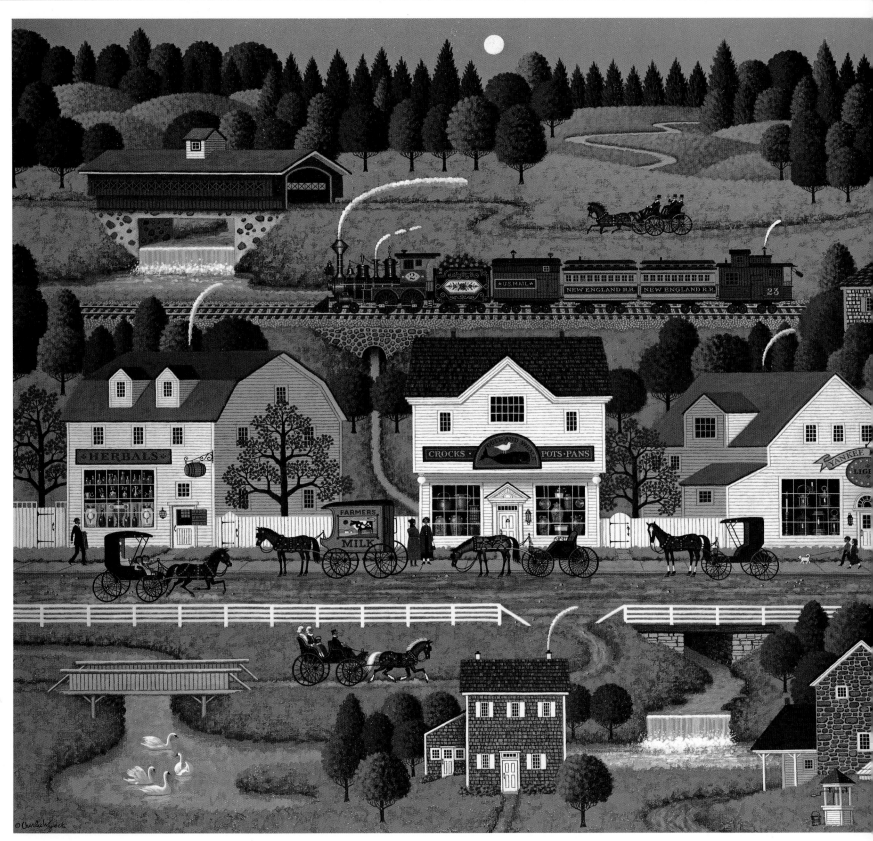

YANKEE WINK HOLLOW

THE COUNTRY SCHOOL

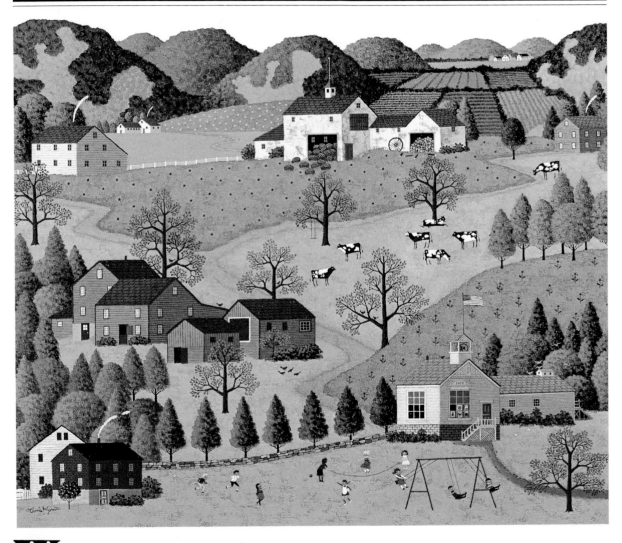

When School Districts were first laid out, at least one very simple standard was used: "Schools should be as far apart as a five-year-old can reasonably be expected to walk . . ."

This was not only humane, but eminently practical. Country kids worked, and chores couldn't be dealt with if half the help was off spending hours walking to and from school. Getting food on the table came before education. In fact, a lot of the time (in deep snow, at planting time, at harvest) many kids had to skip school anyway and simply make up their three R's at home.

But the one-room country schoolhouse was far from a hit-or-miss affair. The teacher was expected to cope, and usually did, with every age from five to (sometimes) sixteen and, of course, with both

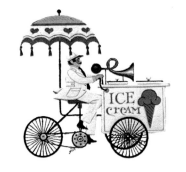

sexes. Neighbors provided winter wood and any major construction that was needed, but running the school was the responsibility of the dragon who headed it, including keeping the stove burning in winter, cleaning up the yard in summer (jobs she could assign to the kids), controlling the manners and deportment of her pupils and seeing to their learning.

Schooling was precious. Books, valued because they were relatively scarce, were treated with respect and read many times. The pupils, because they were indeed so varied in age and pace, got individual attention. And what they learned stayed with them.

The one-room country schoolhouse was around as a major source of education until well into the 1920s—but perhaps its happiest gift was in providing a place in which to do a lot of growing up, maybe raise a little hell once in a while and, above all, in creating communities of people who all knew one another and shared their common problems and joys. The old horse-drawn ice-cream cart, announced by its tinkling bells, was as familiar as one's own front yard. In spring, it might sometimes be waiting outside school for the kids to come boiling out. In the long, hot summers, it would patiently make the rounds of the quiet, shaded streets in New England and just about everywhere else in America.

This vendor is evidently waiting for customers to get back from school, meanwhile enjoying his own product and an idle game of hopscotch.

Above: ICE CREAM AND HOPSCOTCH
Right: VICTORIAN STREET

VICTORIAN BLOOM

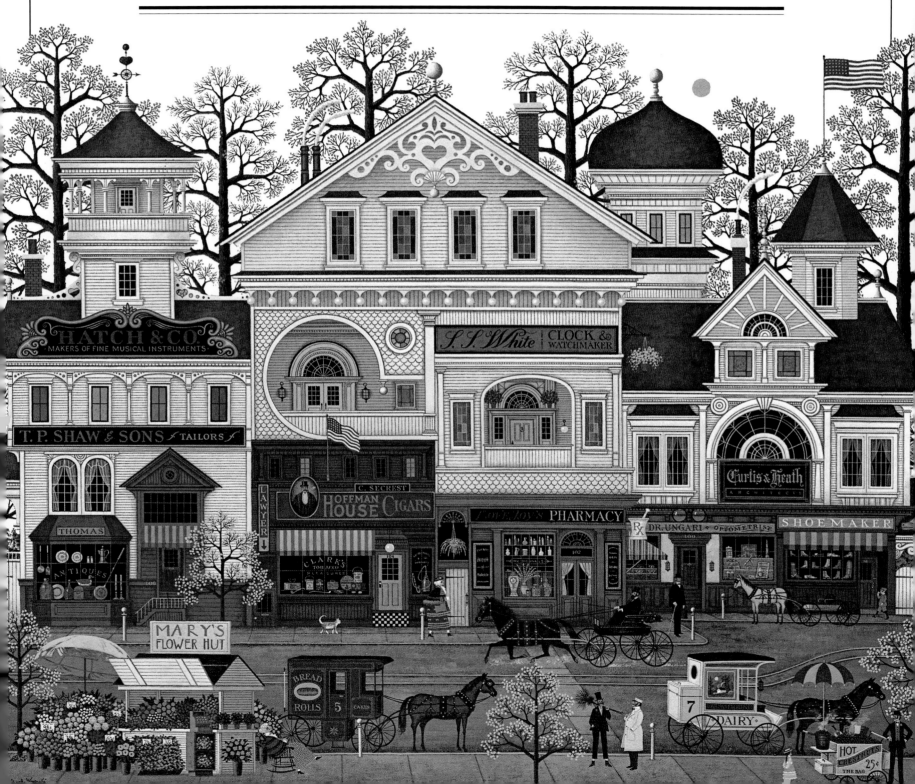

By the 1890s, America's prosperity needed an outlet. Much of the building saw a burgeoning of lavish over-decoration, but there is a grace to spaciousness that embellishment can only enhance—and the homes were getting larger and larger.

There was, however, a distinct divergence of architectural styles by the turn of the century. Nothing changed the austerity, the clean lines, of the traditional New England home—shuttered, rectangular, practical and sturdy—a bastion against winter's storms, beauty inherent in its very function. New England also birthed the saltbox house and, in coastal towns, the widow's walks from which anxious wives would watch for the return of their sailor husbands. In the South, too, habit and climate dictated a suitable style—high-ceilinged, shaded rooms and verandas supported by elegant pillars.

In the Middle West, though, the homes of reasonably well-to-do people began to sprout wings, porches and round rooms topped with cupolas; even upper-story columns supporting oriels, and other building exotica. Eventually, gingerbreaded peaks, scalloped shingles, pillared porticoes, turrets, balconies and bays blossomed, adding height, complexity and (some felt) charm to the average house.

Finally, Victorian architecture came into its own, flowering with all its flamboyant embellishments in cities with relatively mild climates, such as San Francisco. But the style was copied in the East as well, which developed flights of fancy in the form of hexagonal and even octagonal homes—requiring forests of ornamented chimneys to take care of the heating problem.

Derby Square is a masterly depiction of Victorian architecture in all its full-blown glory.

Below: VICTORIAN HOUSES
Right: DERBY SQUARE

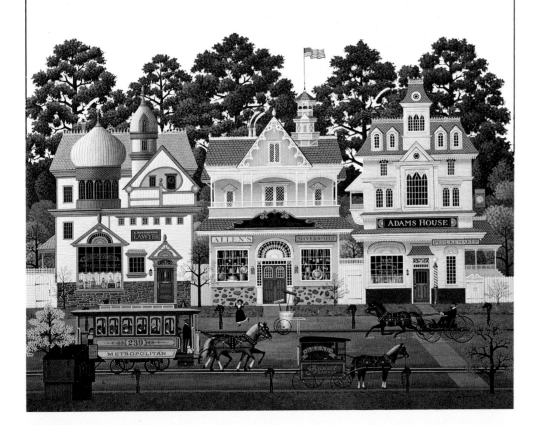

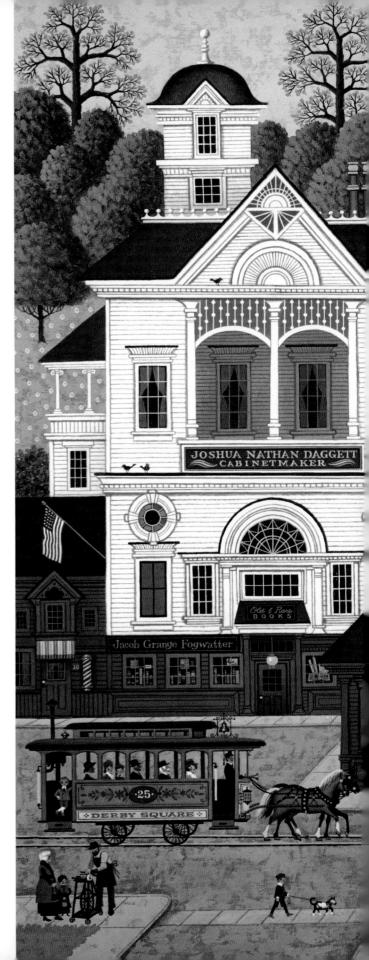

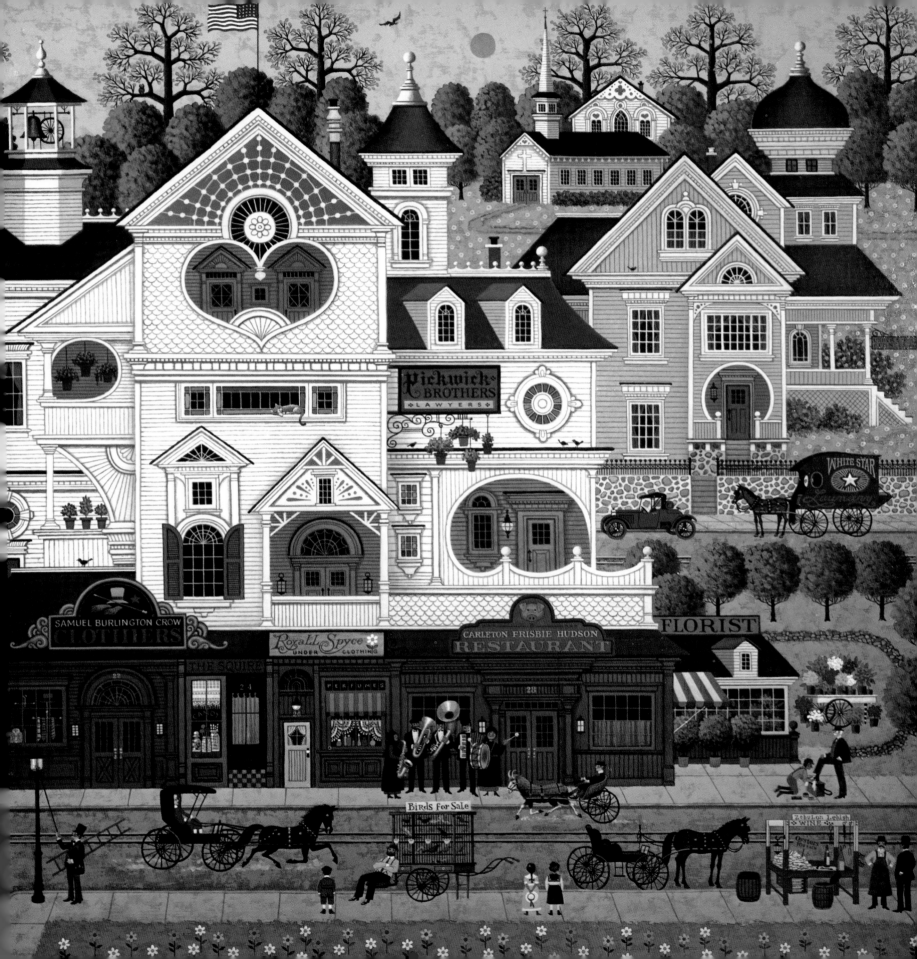

A QUIET FAITH

In sharp contrast to the Victorian boom, life for some remained what it had always been. Of the many religions and creeds that America shelters, the Amish, a branch of the old Mennonite sect, probably held most closely to the tenets of a faith conceived in a different time and a different place.

In Pennsylvania, where most the Amish are to be found, their homes remain austere and simple, and they still abjure the use of modern technology, running their farms and their lives in the old-fashioned way and maintaining their rich heritage of hand skills in weaving, pottery, metalwork, building, animal husbandry and the other living crafts that they brought with them from

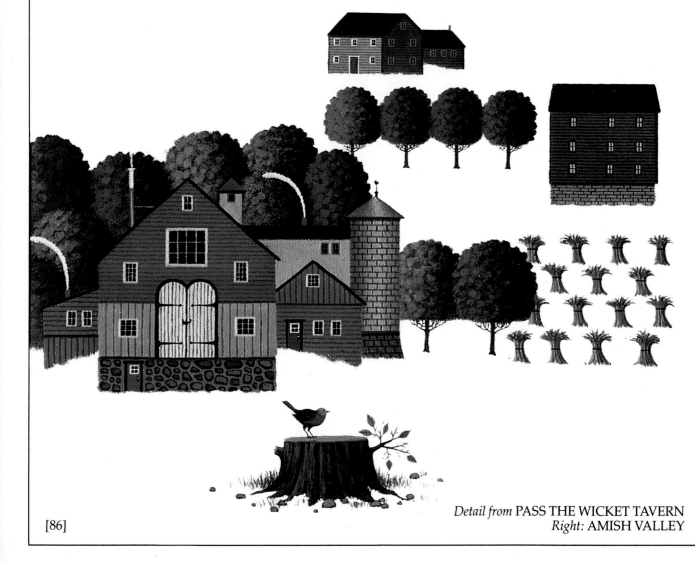

Detail from PASS THE WICKET TAVERN
Right: AMISH VALLEY

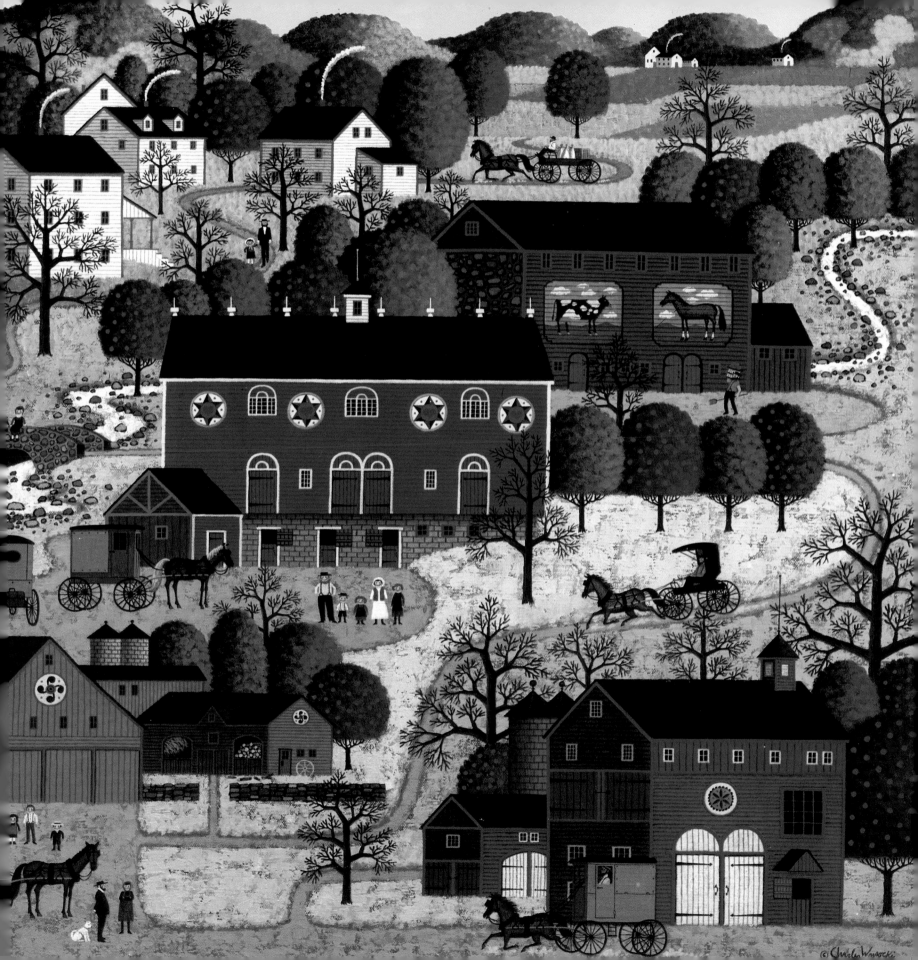

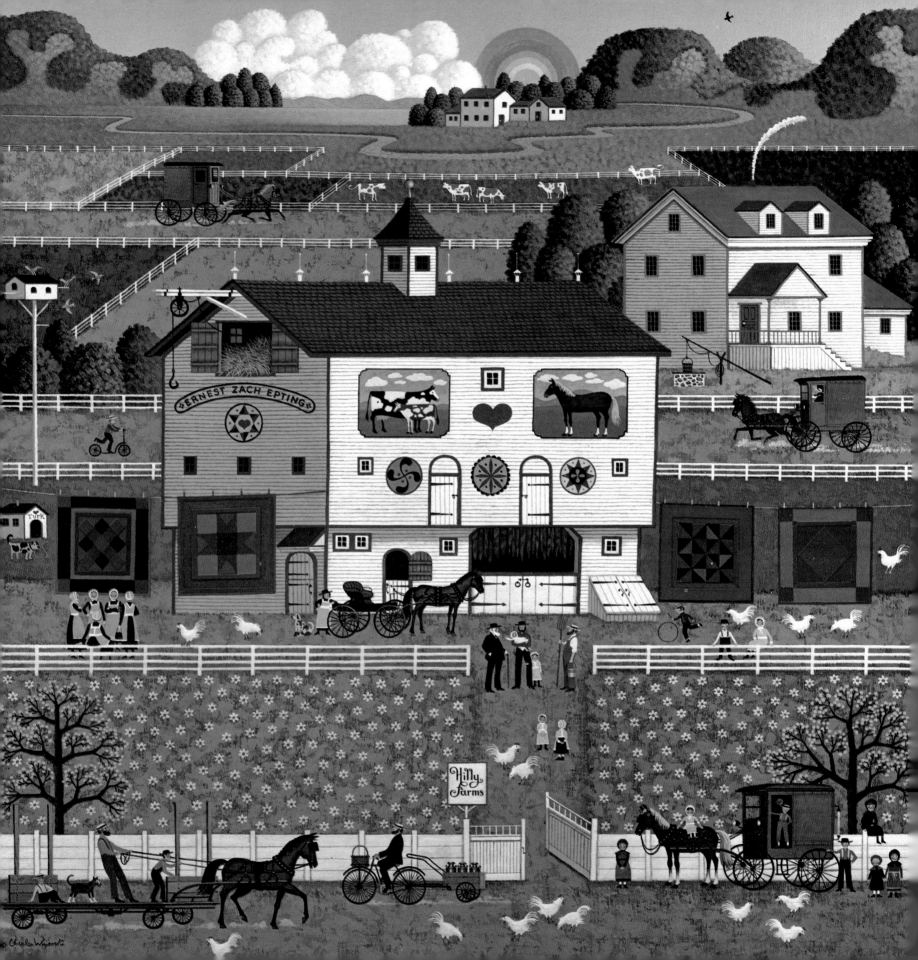

Germany, Switzerland and Russia three hundred years ago.

Amish farmlands are richly productive, their stables and outbuildings as clean and meticulously kept as their homes. And, contrary to popular belief, the hex signs are painted on their barns not "to keep evil spirits away" but rather "just for fancy."

Left: AMISH NEIGHBORS

Above: Detail from OLD GLORY FARMS
Below: WATERMELON FARMS

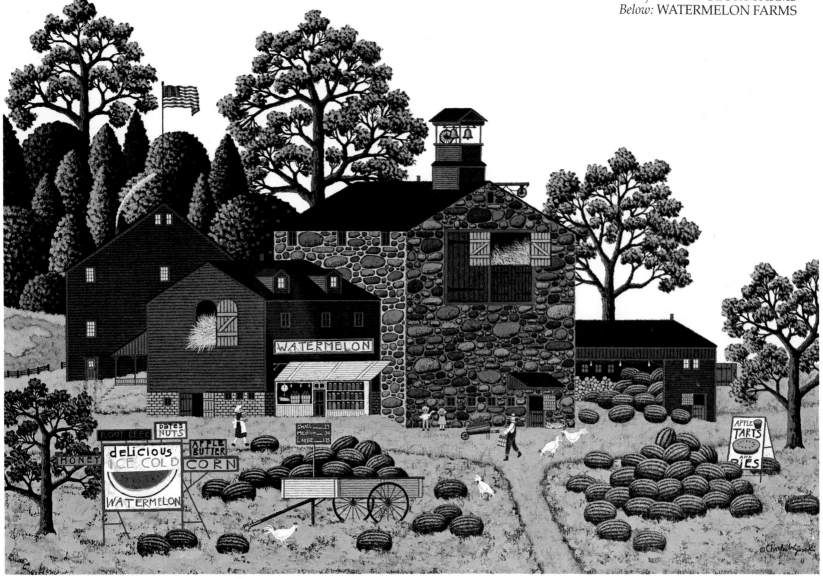

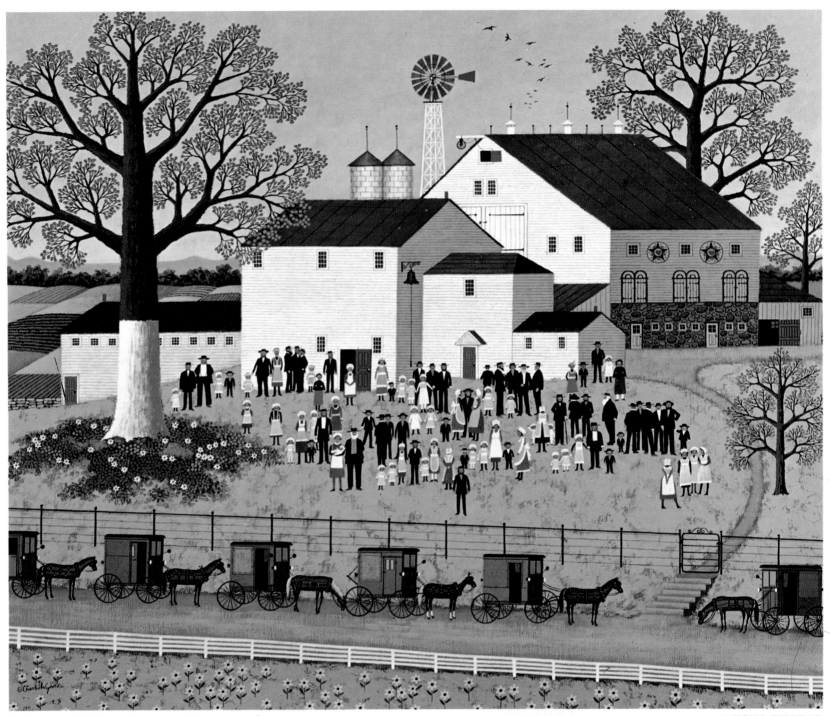

AMISH MEETING

Unlike their neighbors the Mennonites, the Amish have no churches. Instead, they worship in their own homes.

Good neighbors are always important. Out west, in pioneering times, your livestock and sometimes your life could depend on how many and how near your neighbors were. So a barn raising was always a celebration, settling in a new family to share in the fun and help solve community problems.

It is a tradition the Amish have never abandoned. Barn raisings are still communal affairs, occasions for friendly exchange, for thanksgiving and laughter, for shared work and loving mutual support.

THE BARN RAISERS

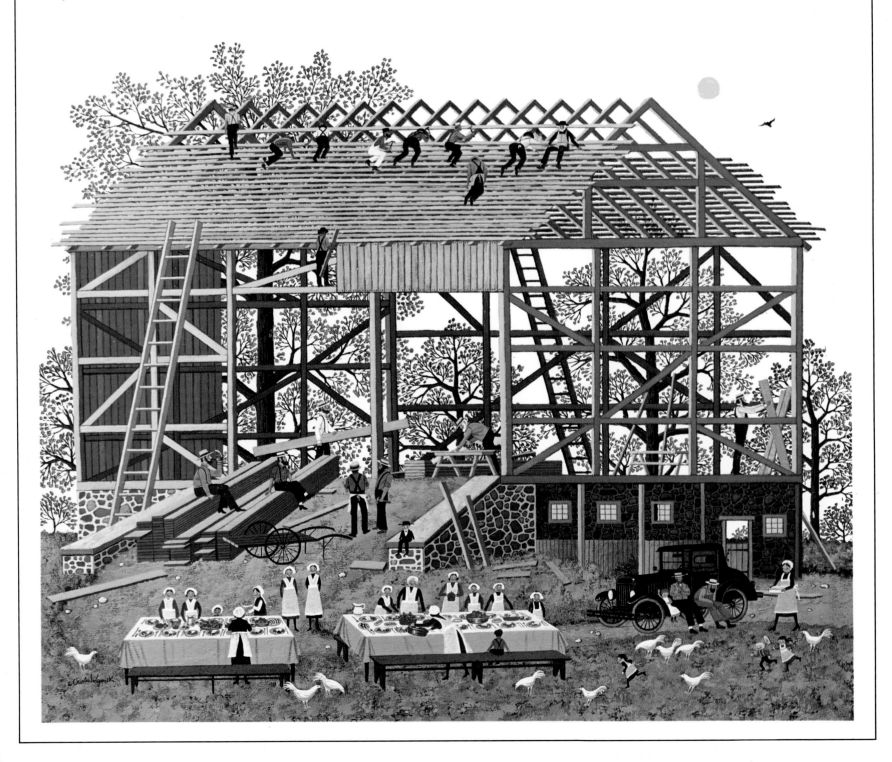

SUNDAY BEST

As with so much in America, religion took many forms. Early on, people had to rely on traveling preachers who happened to come their way. When small communities began to develop, neighbors would get together and put up a building, perhaps to serve as both church and town meeting-place. The next structure might be a school. Or if there were enough kids to require it, the first common building might be for the pursuit of the three R's, and next would come a place of worship. Certainly, in most American communities, the twin centers of influence were the local one-room school, and the church.

Saloons played a rather more convivial role (though none the less decisive) but were, unfortunately, primarily the domain of the male. And of course were privately owned. However, the running of school and church and related affairs was generally in the hands of the females. The local schoolmarm needed to be a pretty feisty character, and when it came to getting things done, the ladies were a power the community relied upon, including the local minister.

With freedom of religion at the heart and core of

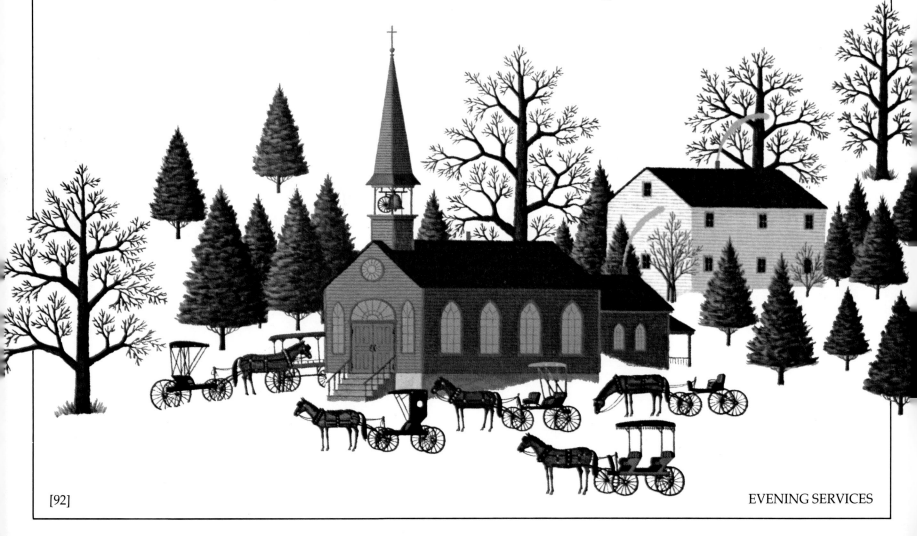

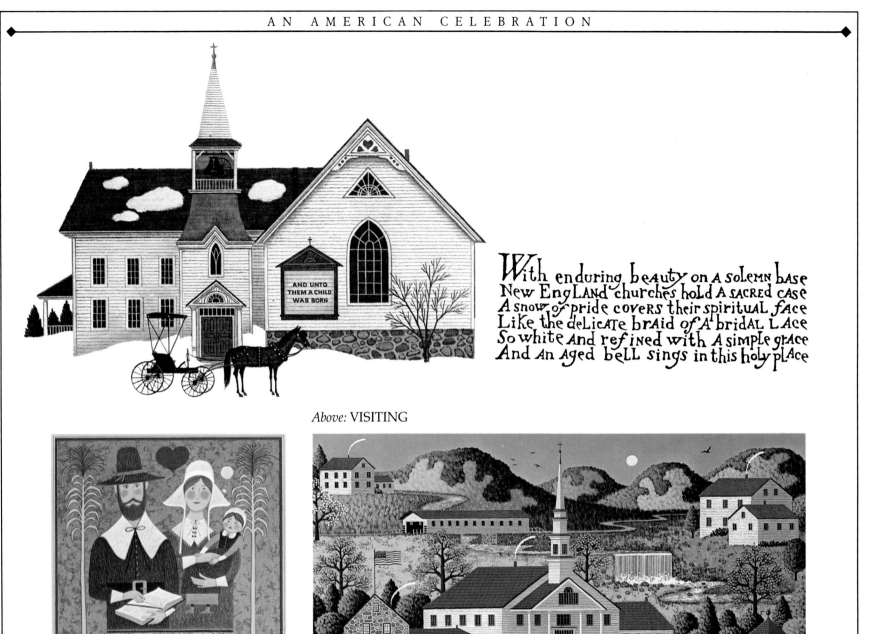

AND UNTO THEM A CHILD WAS BORN

With enduring beauty on a solemn base
New England churches hold a sacred case
A snow of pride covers their spiritual face
Like the delicate braid of a bridal lace
So white and refined with a simple grace
And an aged bell sings in this holy place

Above: VISITING

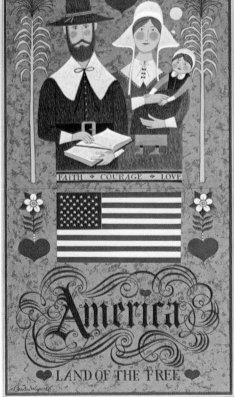

AMERICA, LAND OF THE FREE

FAITH • COURAGE • LOVE

America LAND OF THE FREE

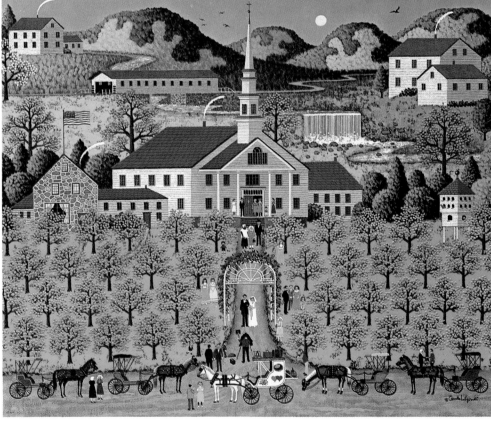

NEW ENGLAND WEDDING

America's founding, it was natural, as communities grew into small towns, that many forms of worship should become the norm. It might be hellfire and brimstone, ecstatic Holy Rolling, formal church, or a quiet time and place for devotion in one's own way. But often the local church continued to serve also as a social center, a place for people to meet and deliberate on common problems or to hold money-raising fairs and celebrations. In any case, whatever the form, Sunday was always a special day.

Eventually, with proper full-time churches of various denominations built and supported by regular parishioners, Sunday, for many people, became simply a day of rest, a chance to show respect by dressing up, a day when the ladies wore their most dignified finery (and when the men couldn't wait to get out of their "Sunday best"), a time for kids to play, for grown-ups to visit neighbors, for enormous midday meals (known as dinner) and for comfortable after-dinner snoozes.

And, in the evenings, maybe a bit of quiet smooching on the porch for the young people

A day of rest, respect and richness that added another dimension to the traditions of a rapidly evolving new way of life.

Boston, Massachusetts, one of America's oldest city ports, has long been a positive hive of tradition. Here Americans held the famous Tea Party, throwing the tax yoke overboard along with the tea, a perfectly proper procedure for any righteous but civilized rebel. They thus declared themselves independent of the old country, although not necessarily of all its values.

Indeed, Boston has contrived to remain intensely conservative, a town where the rhythms of life move to a leisurely beat which has not fogotten the gentle pace of the horse-drawn era nor the comfortable traditions of a proper Sunday.

Bostonians might be astonished to find this charming and unlikely swan boat in their midst, but would undoubtedly approve its grace and the formal family outing and probably even the cat, which is clearly enjoying its water-borne ride.

Right: PLEASANT SUNDAY
Below: FREEWHEELERS

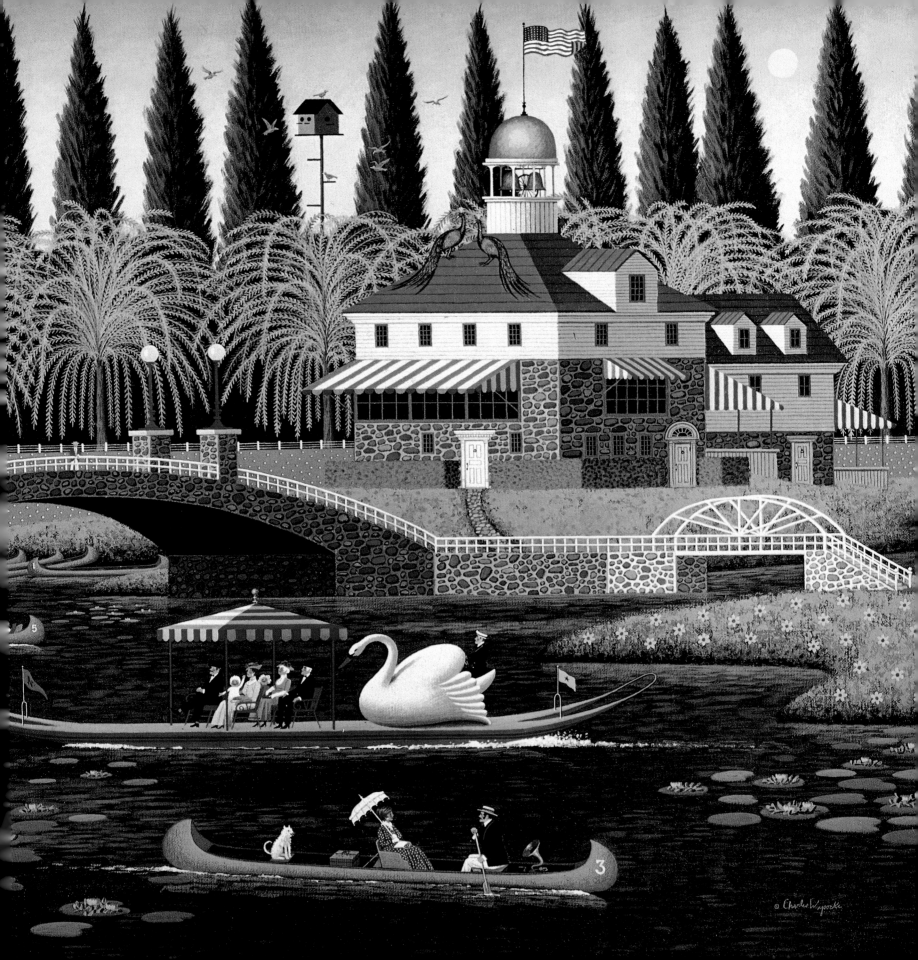

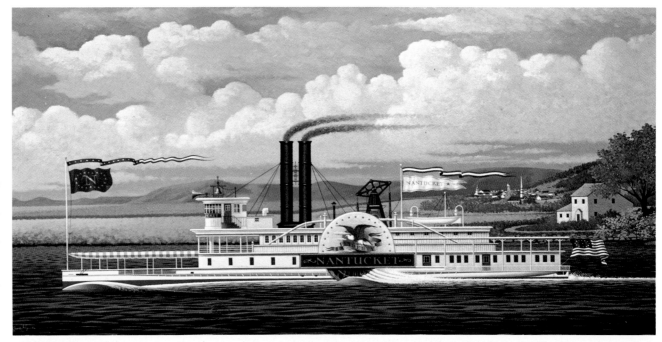

While Bostonians indulged in their decorous water sports, other, more daring folk set forth on longer voyages.

Merrily rolling along with the clouds on a summer day, by steamer or sail they journeyed to other shores and possibly picnics, dancing, and certainly good company.

Above: THE NANTUCKET
Below: THE LEXINGTON

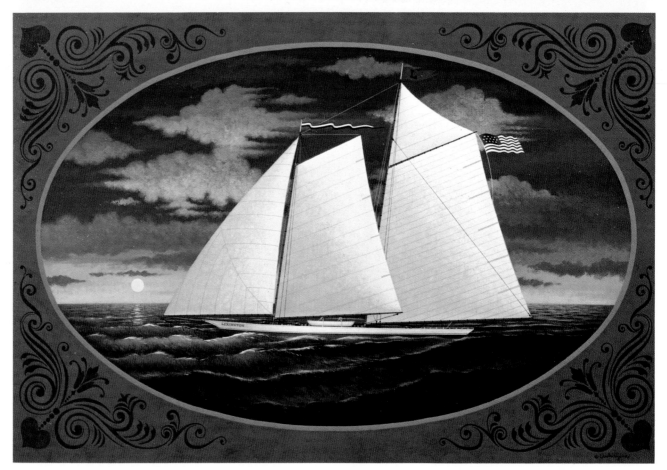

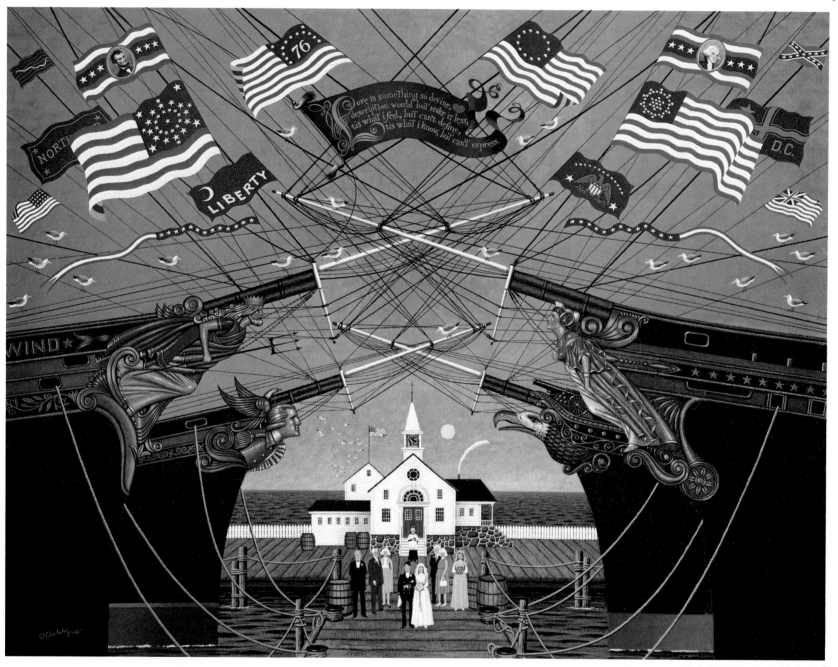

Love is something so devine,
description would but make it less;
tis what i feel, but can't define,
tis what i know, but can't express.

DOCKSIDE MARRIAGE

Summer weddings were popular although usually conducted in more formal, or at least more conventional, circumstances. Surely not many could boast such a splendid setting!

FIREWORKS & PARADES

Holidays in early colonial times were few and far between. The country was built on a work ethic based on rural time—dawn-to-dusk labor at all seasons. So when the occasional holiday did come along, it was greeted with joy and a sense of all-out celebration that set a standard for the years to follow.

By the turn of the century, the still young land, now much richer and more civilized, had accumulated many causes for national rejoicing, and folk took the time to do so in the freehanded tradition passed down from the "old" days. Being the father of any country is a rather formidable concept, but no doubt solemn George would have been pleased by the nation's honoring his awe-inspiring role on Washington's Birth-

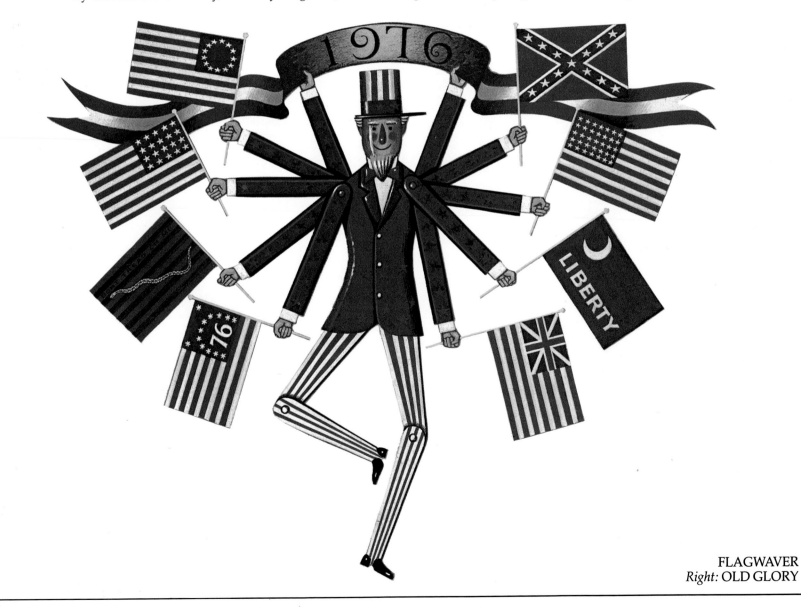

FLAGWAVER
Right: OLD GLORY

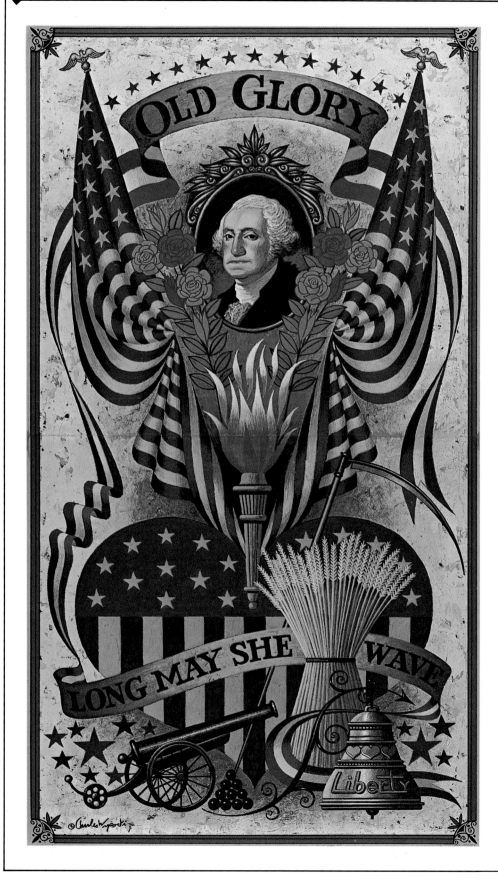

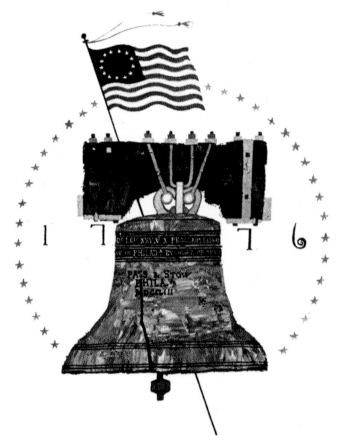

LIBERTY BELL

day; as the name of Lincoln, synonymous with the freedom on which America is based, is also honored; and that of Columbus, by a rather circuitous route, for his discovery of the American landmass.

More traditional were Christmas and New Year's, part of a built-in pattern from times much older than America's, and from "old countries" of every variety and description. But Thanksgiving, although it, too, coincides with more ancient harvest celebrations, had taken on a special significance and become dear to American hearts, remaining a day for feasting and family get-togethers, for tables laden with the bounty of the new country—turkey, cranberries, corn, clams, pumpkin and mince pies, and glorious assortments of pickled wonders—first fruits of preparation for winter.

However, it is the Glorious Fourth of July that is wholly American, an occasion for magnificent fireworks and patriotic demonstrations, for proud parades in even the smallest hamlets, for community picnics and backyard cookouts—a day for rejoicing, for remembrance and reaffirmation of the Declaration of Independence that set a new pattern and a new style in a New World.

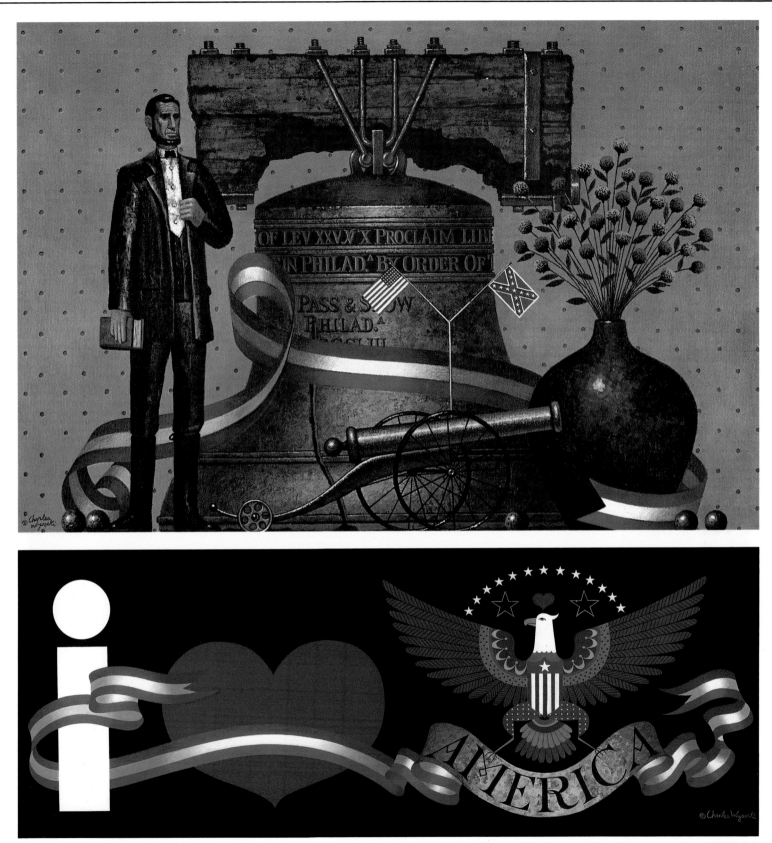

Above: HONEST ABE *Below:* I LOVE AMERICA

ROLL CALL WITH A BANG

America loves this holiday, and Thanksgiving, and all the others, commemorating each with parades, feasts, games, gifts, races, contests, dances and any other appropriate diversion, almost always liberally oiled with strong alkali and good humor. Celebration is part of this big-hearted and openhanded nation's natural gift for hospitality, inspired by sheer exuberance, wonder for the richness of the land, and reverence for its brief but astonishing history.

[101]

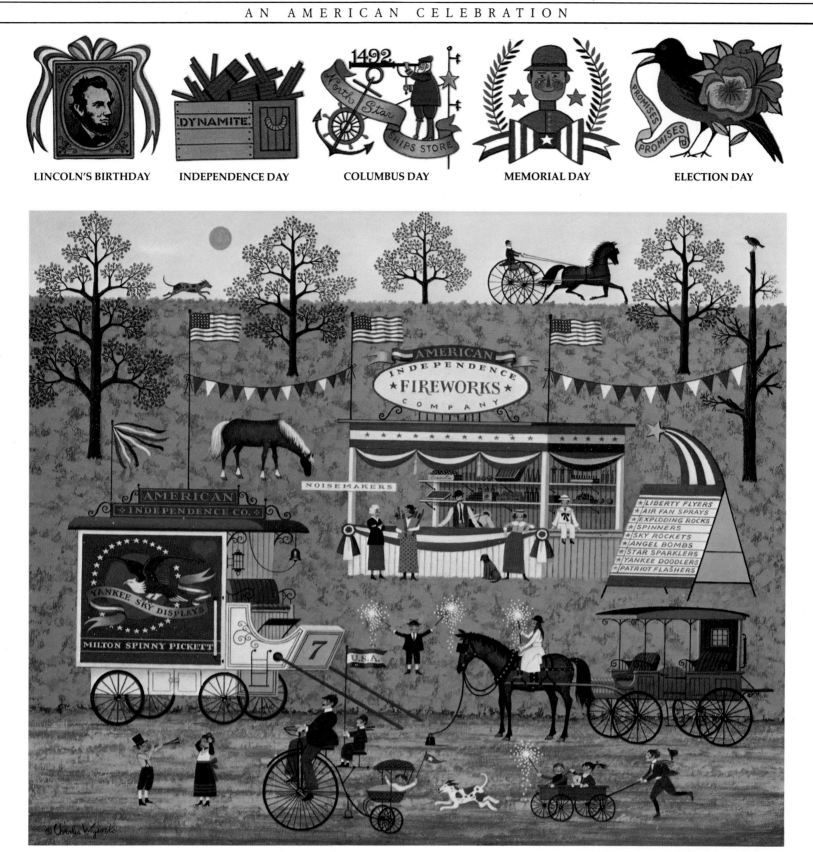

LINCOLN'S BIRTHDAY **INDEPENDENCE DAY** **COLUMBUS DAY** **MEMORIAL DAY** **ELECTION DAY**

BANG, BOOM, BAM AND POW

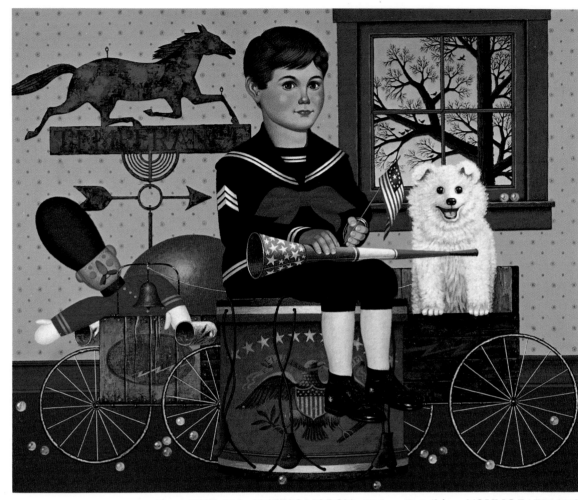

Above: THE ALL-AMERICAN BOY *Below: Detail from* YOUNG PATRIOTS

All over the country, in every town and village and hamlet and city, this most American of holidays, the Fourth of July, evokes the patriotism that was sparked by the Declaration of Independence.

Proud marchers from all organizations, accompanied by the citizenry, assorted dogs and excited small fry, stoutly, if overheatedly, complete the parade route, supported by a splendid band from the local school for whom it is the high point of the year. The great day will culminate in cookouts, a community picnic and a magnificent display of fireworks.

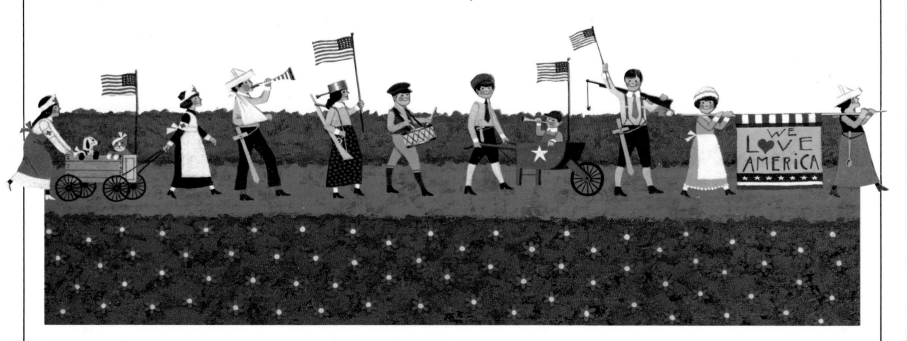

This painting depicts the Independence Day celebration at the White House in the first year of the Ronald Reagan presidency. More than four thousand people from all over the country attended, and the theme was "Turn of the Century." The original art is part of the permanent White House collection.

FOURTH OF JULY, 1981

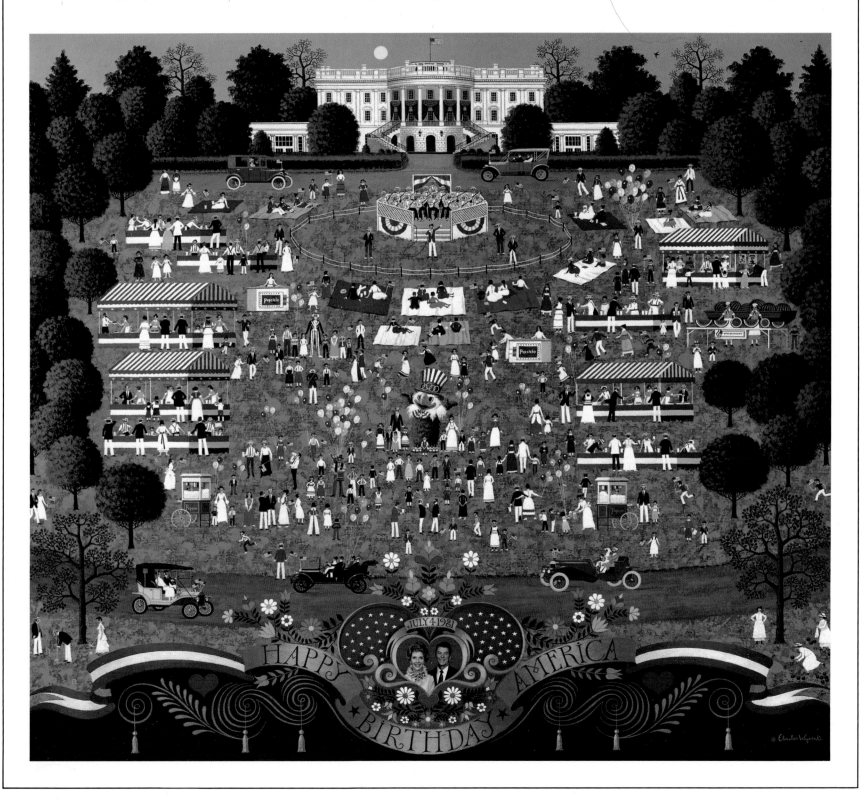

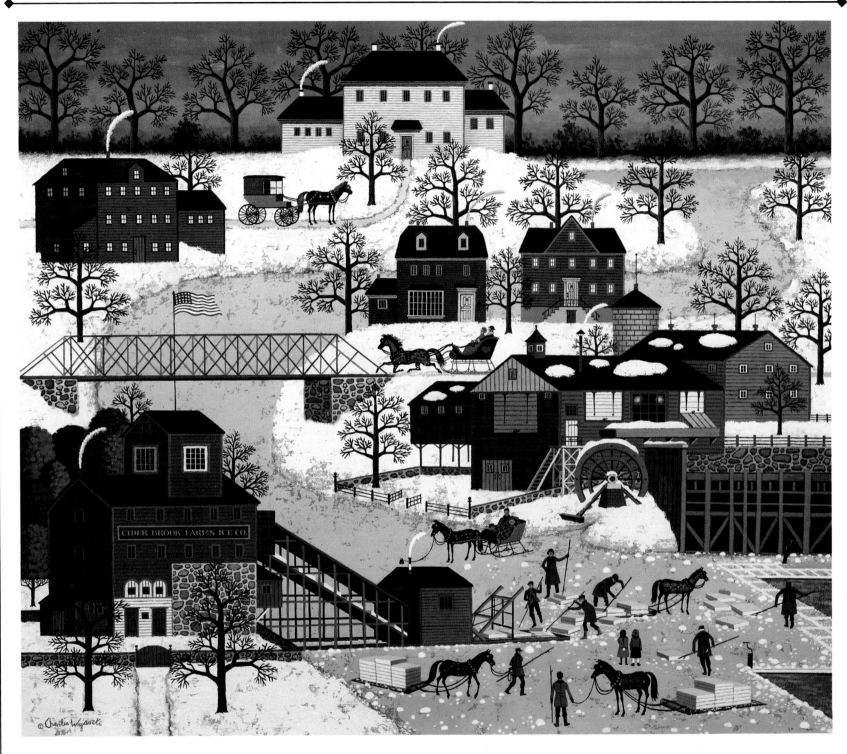

At the height of summer, during the long, breathlessly hot days, how pleasant it is to have cool drinks and ice cream—deliciously reminding one to be grateful to those hardworking folks who went out in the frigid depths of winter to cut ice for use in keeping the blazing hot months to follow bearable.

And how delightful, while sitting on the porch sipping crackle-cold lemonade, to contemplate the exciting possibilities of the annual summer vacation, now rapidly approaching.

CIDER BROOK FARMS
ICE COMPANY

[105]

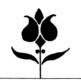

SUMMERTIME

Decisions, decisions! How to know what to pack and what *not* to? For in summertime, all America becomes vacationland.

In years gone by, sturdy tourists embarked on trips to the West, to spend time on a ranch or see the Grand Canyon, the Dakotas, the Tetons, Yellowstone. Most jumping-off spots could be reached via the truly magnificent railroad system, which ran just about everywhere. But further travel would be covered in some form of horse-drawn vehicle: or even by riding the animal itself.

From coast to coast, Americans reveled in their

Opposite: CAPE COD STAR
Above: CHILDHOOD
MEMORIES

[107]

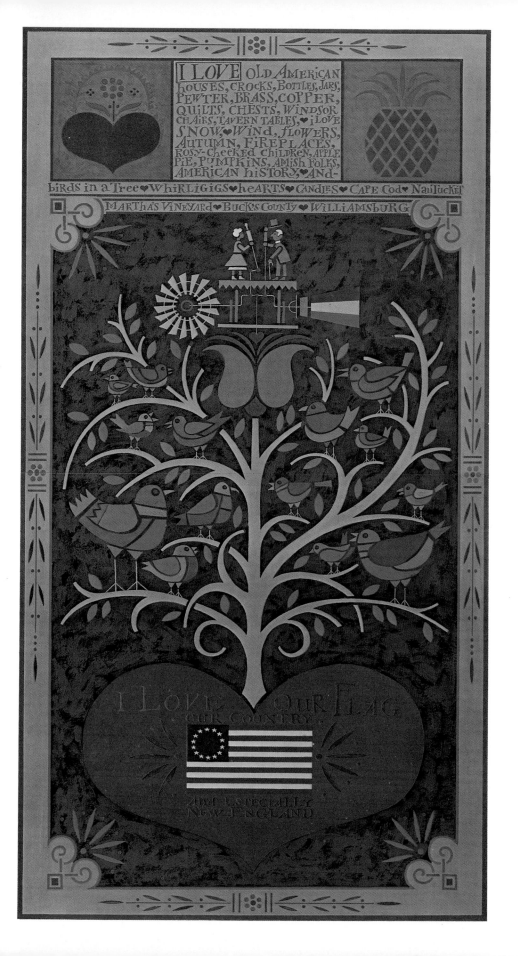

Left: I LOVE

country's scenic wonders, although in the East these could be appreciated more decorously (and certainly in greater comfort) from open-air trolley cars running on the many spurs the busy railroads built. Where railroads didn't go, windsails might take the more venturesome. But in comparison with the daring western forays, these trips were mere excursions, made from a secure base to which a civilized person could return in the evening. For what was really done in the summer was to go away, and stay, in some suitably salubrious place—rather than go bucketing about.

The rich, of course, could disport themselves at opulent hotels (when they were not sequestered on private yachts or in vacation mansions), but the vast majority of Americans enjoyed more modest establishments by the sea or in the mountains. The East Coast, in particular, was dotted with "cabins" (spacious Victorian structures that generally ran to at least several rooms), located on beaches, rivers and lakeshores or high in the cool of the hills from the Poconos clear up to the Canadian border.

Those unable to afford their own cottages could always stay comfortably at the legions of boarding and rooming houses whose year-round residents would expect to make a few dollars from their regular summer guests. These were private homes converted to commerce for a few short months, and thus pro-

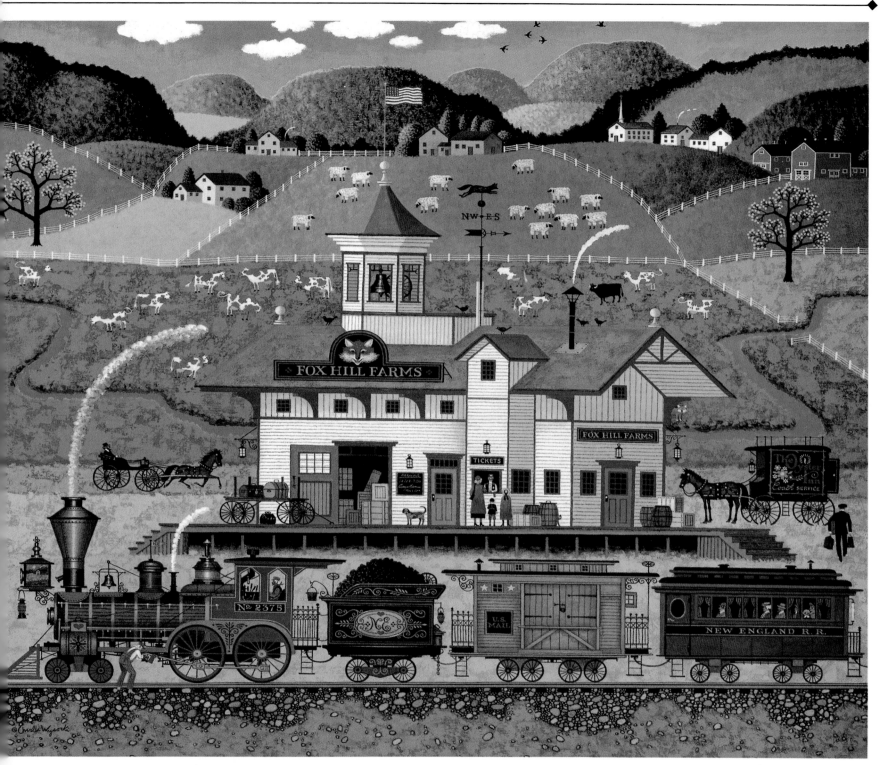

vided all the comforts without the worry of running an establishment.

From these vacation homes and boardinghouses, generations of Americans sallied forth, summer after summer, to dig in the sand, dabble in shallow waters (the ladies suitably clad in voluminous swimsuits featuring total cover-up), stroll on the promenades, play at softball or skiprope or even tennis, bicycle or hike,

FOX HILL FARMS

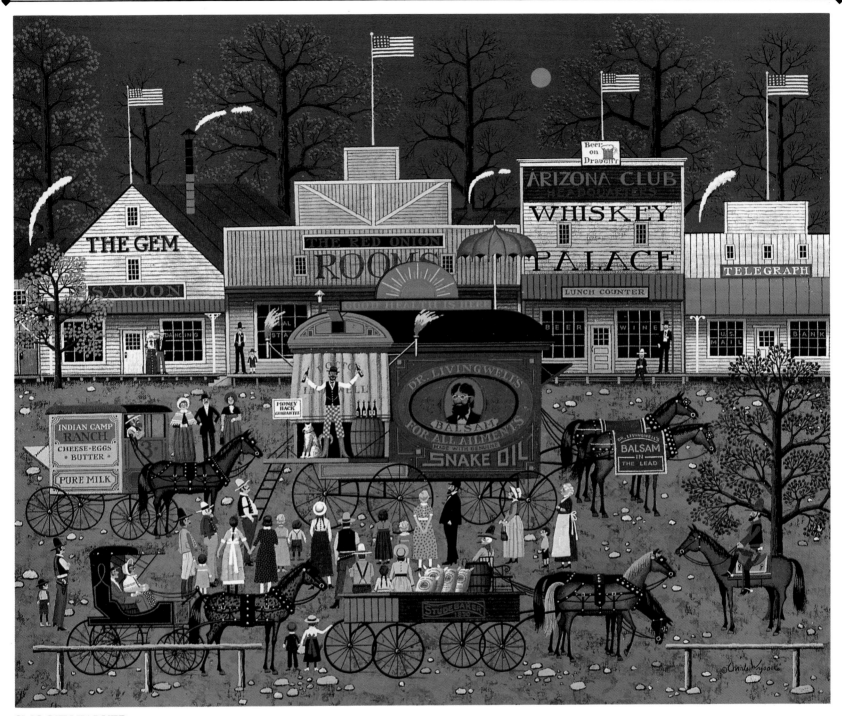

SMOOTH TALKER

take the trolley or a carriage to scenic spots and amusement parks, to paint, fish, sail, swim, picnic, and in general, sedately revel in the gifts of sun, woods, water, and some of the world's most spectacularly beautiful scenery.

And in the long, leisurely evenings there might be a few songs around the piano, or perhaps someone would have a mandolin or ukelele. Or you could catch up on writing your diary, or read a book. In that "soft summer air," time seemed to stretch forever. Vacationing in New England offered a rich variety of possibilities—endless

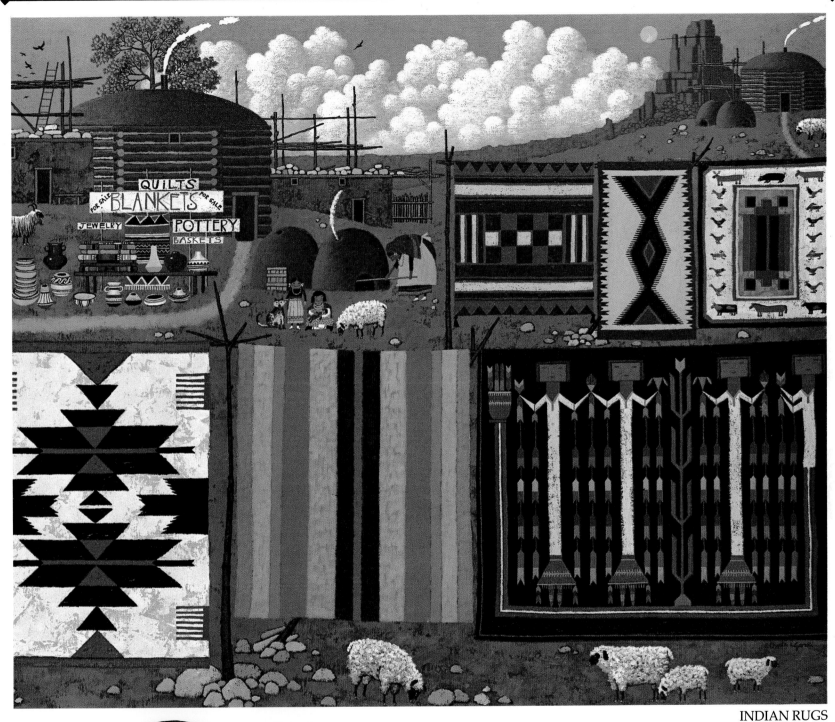

INDIAN RUGS

beaches and lakes, the joys of mountain streams and woods, fancy hotels or fishing villages, and the quiet pleasures of "going rustic" and living with the family on a farm like Fox Hill. Here, one could participate in activities such as hayrides and picnics, leaving the joys of more strenuous fun to the kids who could be kept happily busy tending cows and chickens or even haying—while happy grown-ups took the opportunity to loll about in the orchard or on the cool porch.

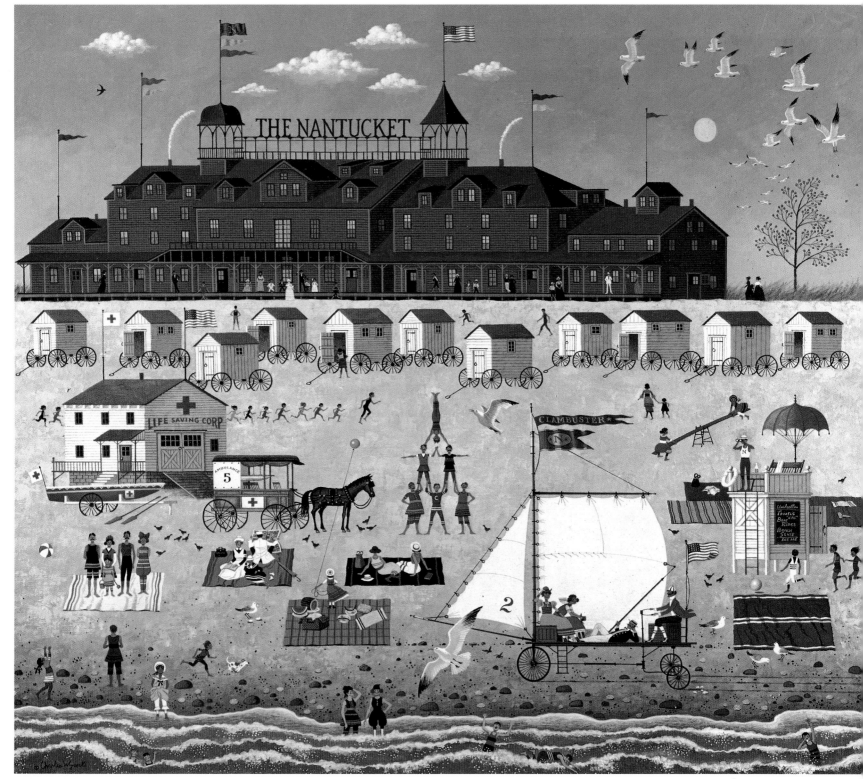

THE NANTUCKET HOTEL

The mid-1880s saw the burgeoning of vast, opulent, baroque structures called resort hotels—all-inclusive playgrounds offering luxury, privacy and every vacation facility for the very rich and fashionable. Surroundings could run to two thousand landscaped acres of polo grounds and cricket fields (popular among the gentlemen), tennis courts, golf courses, lakes and scenic spots; and trails for hikers, horseback riders and bicyclists, with extensive gardens for strollers. Many of the great buildings had heated freshwater and saltwater indoor swimming pools. If there was a common ground, a middle name, a single attribute that characterized all these exuberant structures, it was "BIG." One hotel boasted seventeen *miles* of corridors (guests were conveyed to the many social functions and meals in wickerwork rickshaws).

In such gargantuan company, The Nantucket was relatively modest, an endearing building that had grown by fits and starts, sprawling comfortably in a homey atmosphere, its main attraction the boundless, busy beach. But it, too, was big.

All in all, The Nantucket and its more pretentious competitors, then and now, are a remarkable testament to the admiration Americans feel for sheer size, and to the bounding vitality that demands and copes with it.

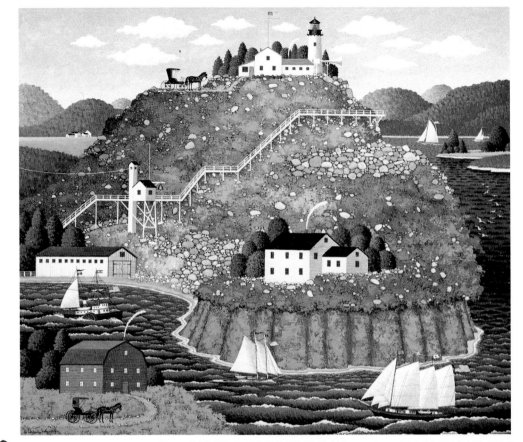

Above: WARP IN THE WIND BAY *Below:* SUNDAY SAILORS

Summer and the sea seem to go together. Nothing can touch the utter peace and isolation of a sailboat gently rocking along in a quiet bay, nor the breathless excitement when that big fish hits after one has been sitting somnolent for hours over a slack line. And there are small coastal islands to be explored, with rocky pools, private mini-beaches and shaded picnic places—an infinity of joys that only getting out on the blue water can provide.

Summer and the sea may go together, but baseball has to be the middle name of the hot, sunny season.

A far cry from the time (1903) when the second horseless carriage ever to cross the continent took sixty-three days to get from one coast to another. But the gallant vehicle (an open-air Packard) was not at fault. It was the fact that there weren't any roads. (Long-distance travel was more usually accomplished via the marvelously ubiquitous railroad.)

In such circumstances, a horse could still do a lot better than four wheels.

So it is comforting to know that by the good old mid-1920s not only was the paving better, but careful thought had obviously been given to methods of diverting the minds of the thousands now ceaselessly driving back and forth. All across the country, the kindly Burma Shave folk set up teasing little signs with incomplete messages, sometimes in verse, to encourage drivers to hurry along to the next bend in order to discover and chortle over the next piece of the puzzle.

Above: TEDDY, ABIGAIL AND BAA BAA *Right:* BURMA ROAD

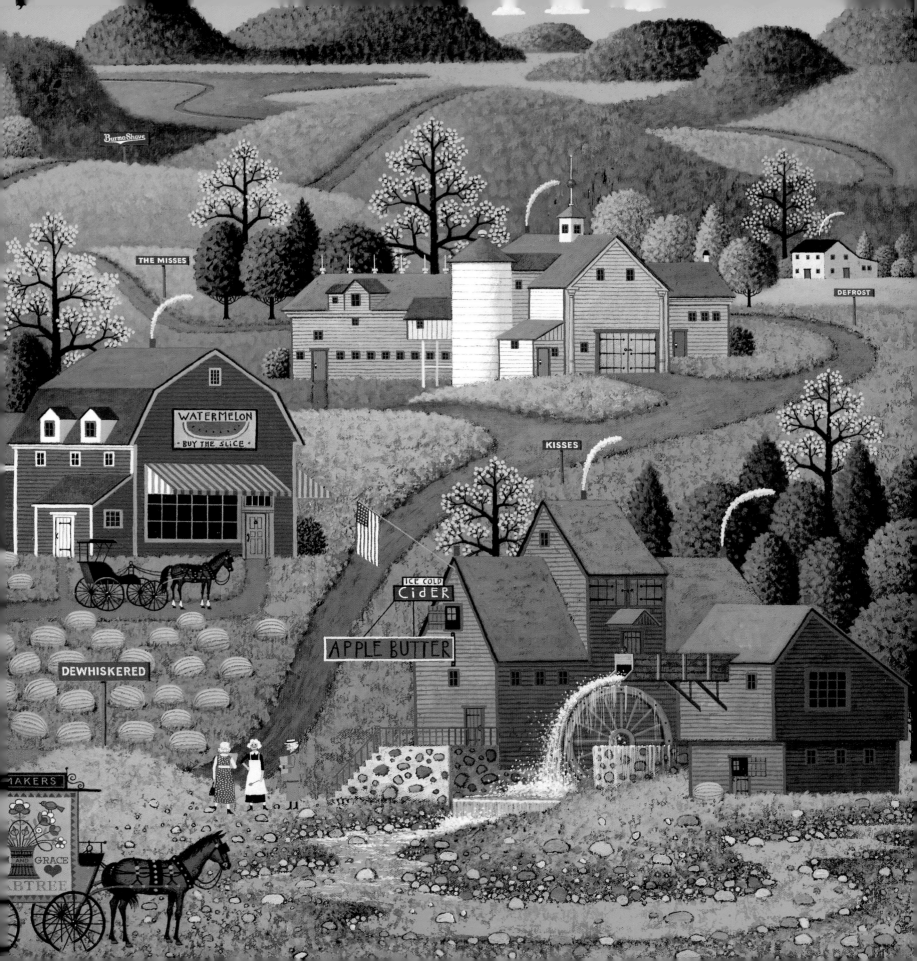

MANSFIELD AIR
SPECTACULAR

WINDBLOSSOM

in fact, you didn't even need a license. You were a pilot or you weren't. All you had to do was get up there, fly that thing—and find a place to land.

The pilots flew their flying machines from field to field, performed fantastic exhibitions of skill and daring, and sold rides to the hardier spectators.

Eventually, promoters took to conducting air shows that astounded yokels and townsfolk

T he early 1920s saw the first generation of airmen, fliers who had learned their skills in the Great War. But this was still the horse-and-buggy era, at least out in the sticks. Since horses couldn't fly, men had made their own wings, and they were bound and determined to use them. So the fliers took to barnstorming as a way of life.

There were no airports, of course—

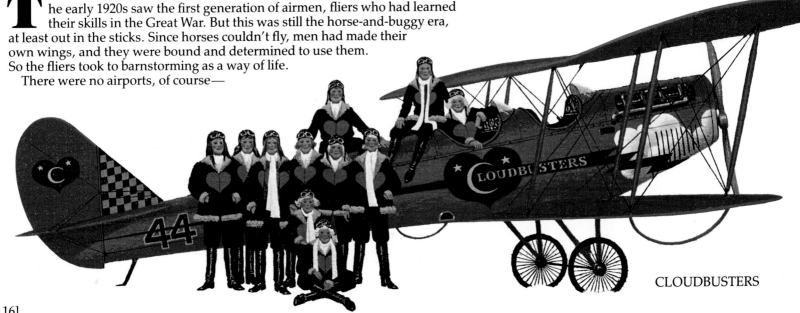

CLOUDBUSTERS

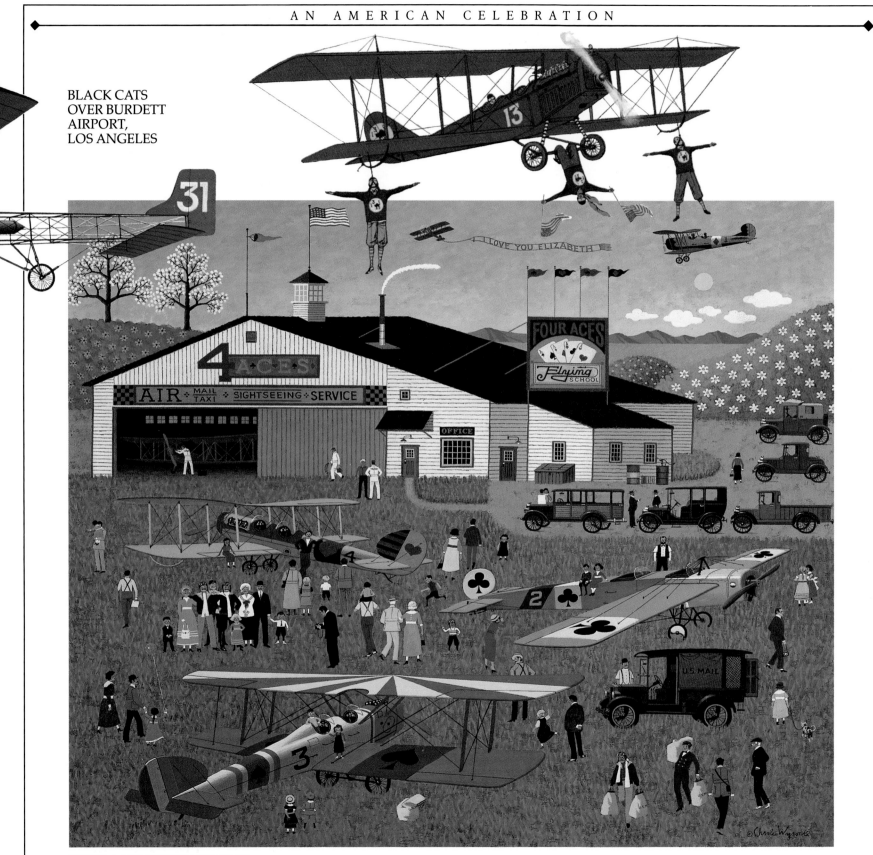

BLACK CATS
OVER BURDETT
AIRPORT,
LOS ANGELES

FOUR ACES FLYING SCHOOL

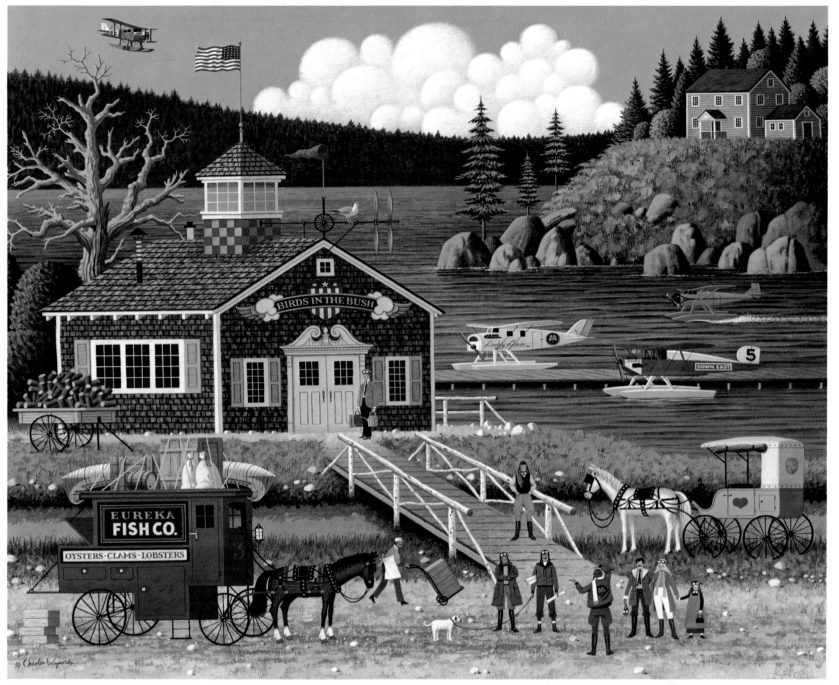

BIRDS OF A FEATHER

alike, making a gala spectacular out of any likely occasion such as a state fair or just about any holiday.

Water landings were marginally safer than having to look for a friendly field. And Maine was dotted with calm lakes that invited gatherings of dauntless performers of aerobatics who could properly appreciate each other's fabulous exploits . . .

Right: HOME FOR
THE HOLIDAY

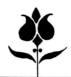

ALL ABOARD!

It is surely odd that the mighty railroad had its origin in the humble, donkey-drawn mining cart which ran on rails.

In America, the first public vehicle to run on tracks was the horse-drawn Baltimore and Ohio Railroad carriage in 1828. A couple of years later, though, the *Tom Thumb* made a successful powered run, and minigauge tracks proliferated all over the East Coast and even inland, carrying dinky railroad cars chuffing busily about the landscape.

The year 1862 saw the beginning of the daring effort to complete a set of tracks clear across the country. From then on the railroads gradually penetrated every nook and cranny of America, over incredible structures of flying trestles that took awed passengers across mighty rivers and canyons, chugged up moun-

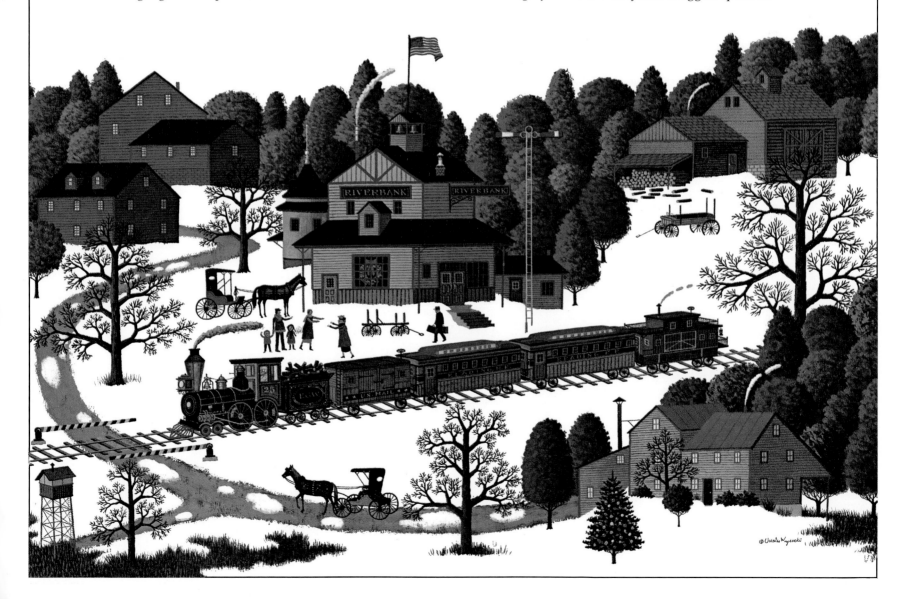

WHERE THE
BUFFALO ROAM

tains and branched out on a network of spurs. The long distances traveled sparked the invention of the sleeping car, but private carriages did not emerge until the railroad barons took control in the late 1880s. By then the transport of most freight and passengers was dependent on a handful of men.

The carriages built for the wealthy were opulent—tussocked, tasseled, carved, gilded, and generally

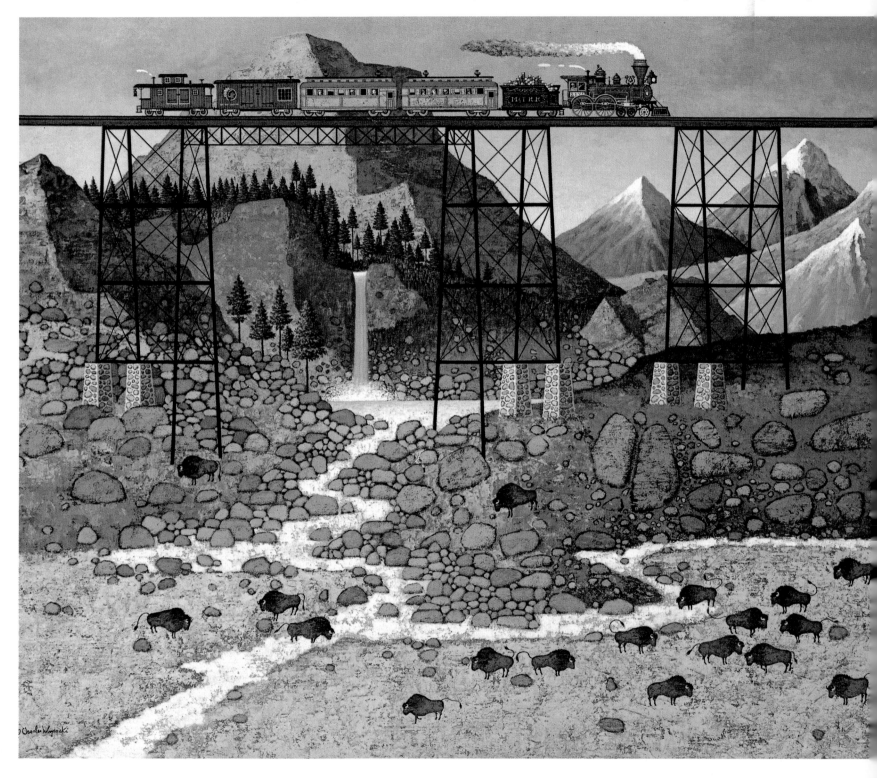

Right: Detail from SUNSET HILLS,
TEXAS, WILDCATTERS
Below: Detail from FOX HILL FARMS

RAILROADIANA

decorated in the rich style of the best Victorian homes. Moreover, they were furnished with plush-covered couches, easy chairs, dining tables, escritoires, full beds, dressing tables, mirrors and every other artifact devised for the comfort of man; and hung with curtains, drapes, chandeliers, and brackets for flowers; besides being equipped with luxuries such as steam heat (piped from the engines), which not even most homes could boast.

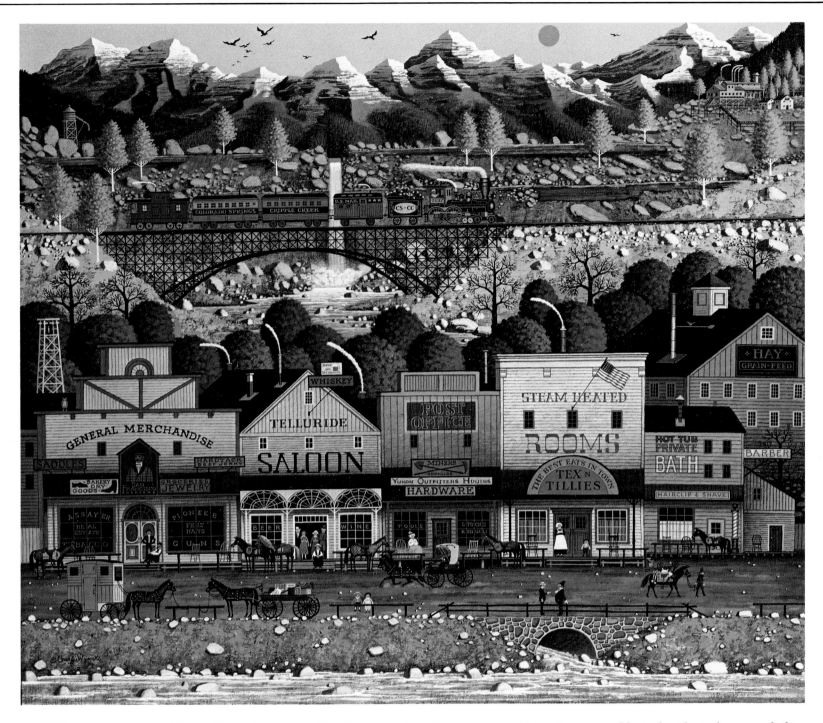

SLEEPY
TOWN WEST

Mr. and Mrs. America and family traveled less luxuriously, but still in reasonable comfort and with remarkable speed, to all parts of the continent.

And what a breathless thrill it was to journey by train! Days of packing and preparation preceded taking the buggy to the bustling station, where a final anxious check was made to ensure that all bags, trunks, bandboxes and toys were present. Then began the impatient wait for the train, the first curl of excitement at a distant rumble and, at last, the overwhelming arrival of that churning, ponderous metal monster, hissing steam and clanking its great pistoned wheels as it drew slowly to a halt at the platform. There it stood, huge, breathing smoke, snorting ashes, belching a challenge to the passenger—*all aboard!*

No wonder that wherever the railroad went, the world stopped whatever it was doing to gape and wave and cheer!

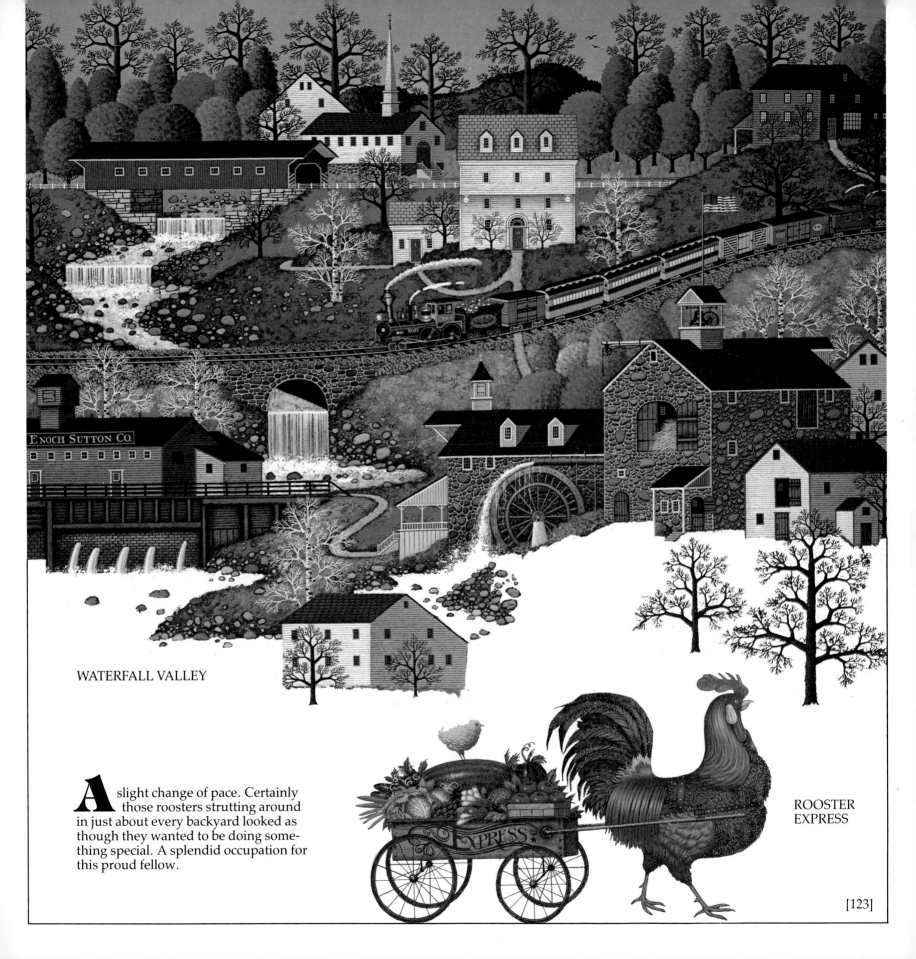

WATERFALL VALLEY

A slight change of pace. Certainly those roosters strutting around in just about every backyard looked as though they wanted to be doing something special. A splendid occupation for this proud fellow.

ROOSTER EXPRESS

ENOCH SUTTON CO.

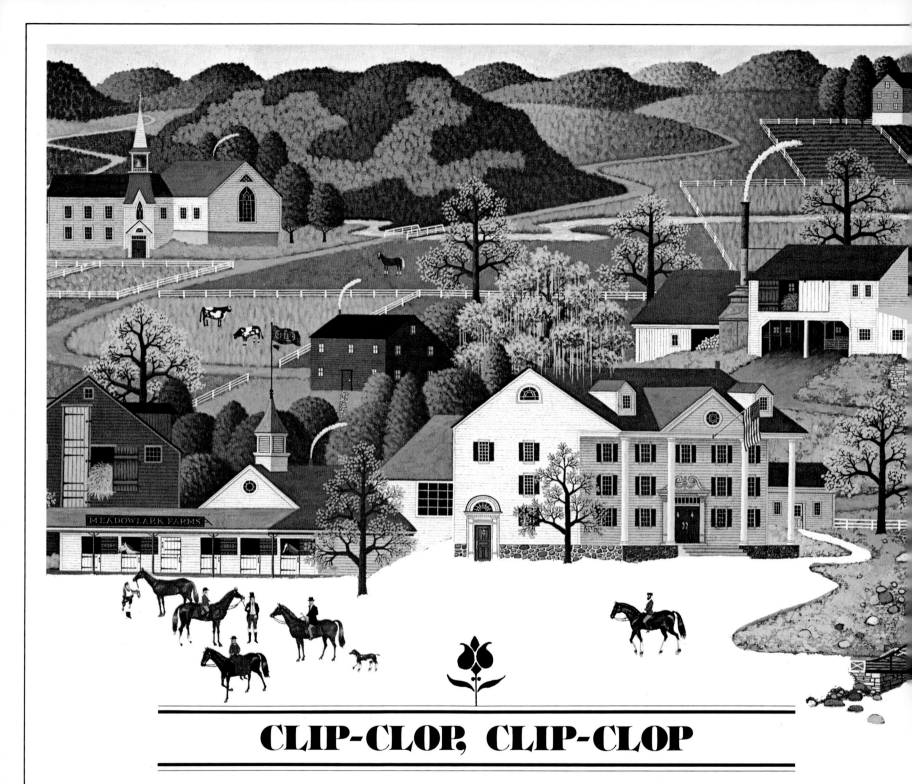

CLIP-CLOP, CLIP-CLOP

By airplane, railroad, horseless carriage, bicycle, on foot and in ships—Americans seem to have been born to travel. Maybe it was having to cross three thousand miles of ocean, followed by three thousand miles of raw land to get to where they wanted to be, but whatever the cause they are constantly on the move. In the early days they did most of this traveling on horses or in horse-drawn vehicles.

So there were horses everywhere—horses out on the plains for riding and for hauling, horses in the cav-

alry, workhorses on farms for pulling wagons and plows, horses in the towns and cities for every conceivable purpose (at the height of its horse population, New York City stabled 400,000 horses—a sanitation problem of mind-boggling proportions), horses to pull stages, carriages, trolleys, fire trucks, wagons, buggies—just about any place you looked there were numbers of that large, nervous, placid, stupid, smart, obedient, stubborn, *everything* animal. One thing all horses had in common was character. Which made the ordinarily tedious chore of getting from one place to another a lively and personal matter.

In the West, ranches bred good work animals, and a fine breed of superbly deft quarter horse, along with an occasional rough racer. In the Blue Grass country, horse heaven, the breeding and training of horses specifically for racing

was a gentlemanly occupation, although early American authorities frowned on gambling and hence—a logical astonishment—on racing. As well try to stop the tide. The whole country was founded on one of the biggest gambles of all time, and horsepower was what made it possible.

So, no matter how much church and even government might disapprove, America's love for her equine friends continued unabated, and certainly no one ever managed to come even close to stamping out "the sport of kings"—perhaps because, in fact, the excitement of a day at the races was not confined to the rich, nor ever had been. Willy-nilly, and despite the early blue laws (so-called because they were originally printed on blue paper), a large segment of the population attended races to make their bets and capture the priceless thrill of watch-

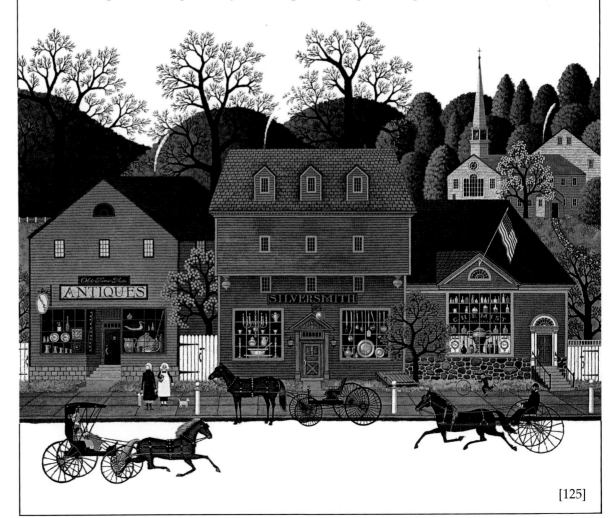

MEADOWLARK FARMS
Right: VALLEY FARM STREET

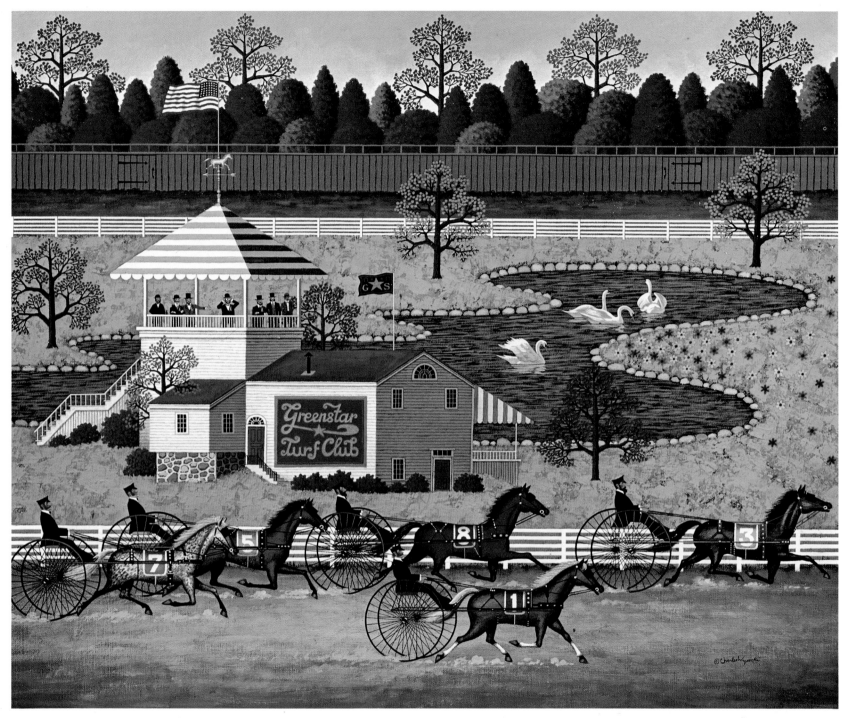

RACING AT THE GREENSTAR

ing their favorites thunder to victory. (Or conversely, of course, to drown their disappointments.)

Certainly a good horse race could be counted on to draw a crowd at any state fair, any time, and especially when the star attraction might be that famous animal "Joe Joker," who would run a course against time all by himself for the sheer joy of it, without driver, sulky, competition or guidance. Spectators, even if

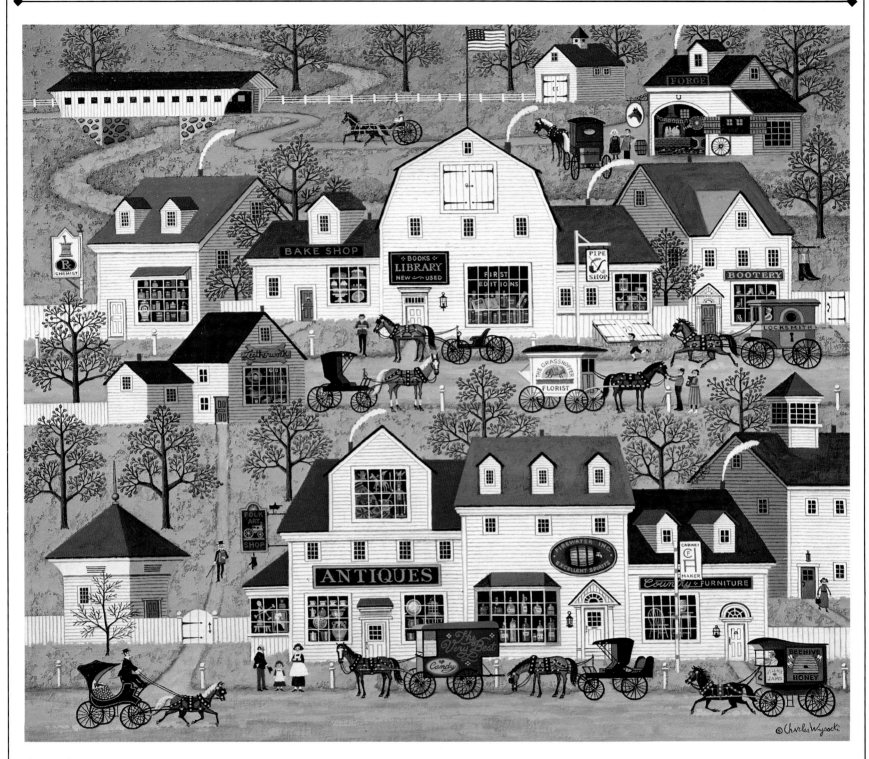

they didn't bet, certainly had at least as much fun as the horse.

Very much a part of everyday life, horses were always indispensable, frequently ornery, often beloved, and sometimes magnificent. And still are.

For decades after the horse ceased to be a common sight in cities, out in the country and the small towns he was still king. While the railroads opened up the land to rapid travel, life on the farms—the nation's breadbasket—remained much the same, and if living in the cities was all hustle and bustle, the country still moved at a leisurely pace, geared to the horse.

SHOPS AND BUGGIES

[127]

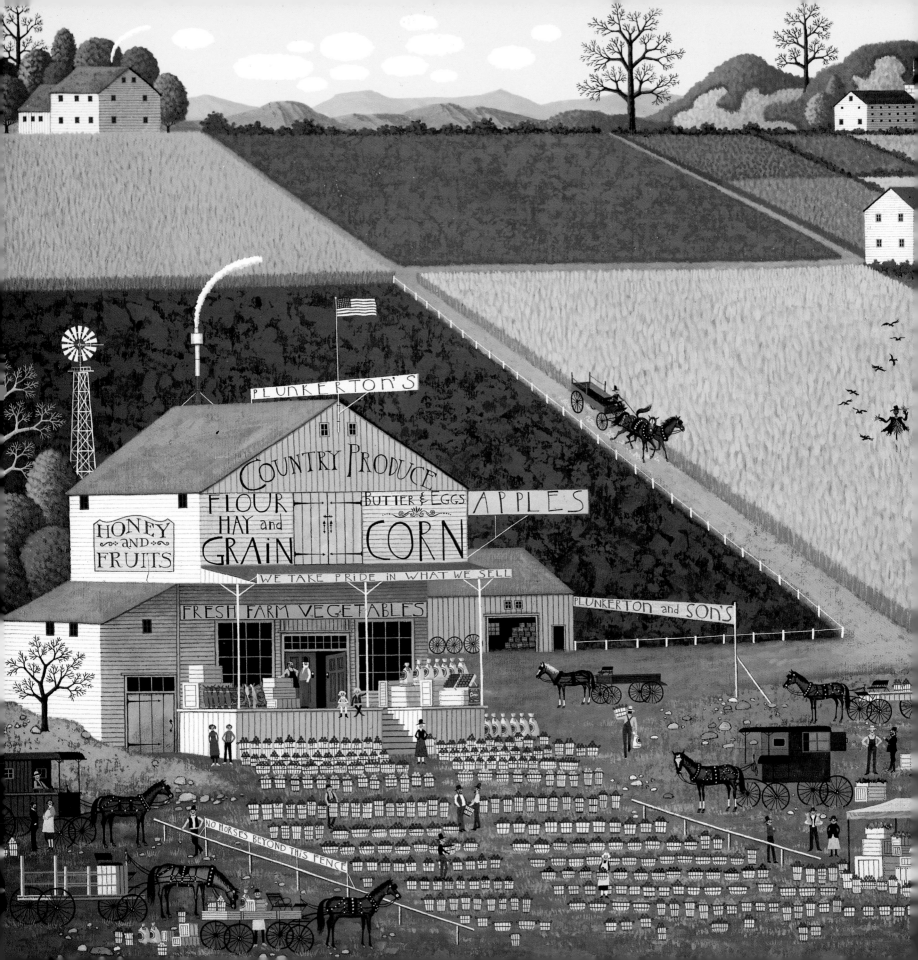

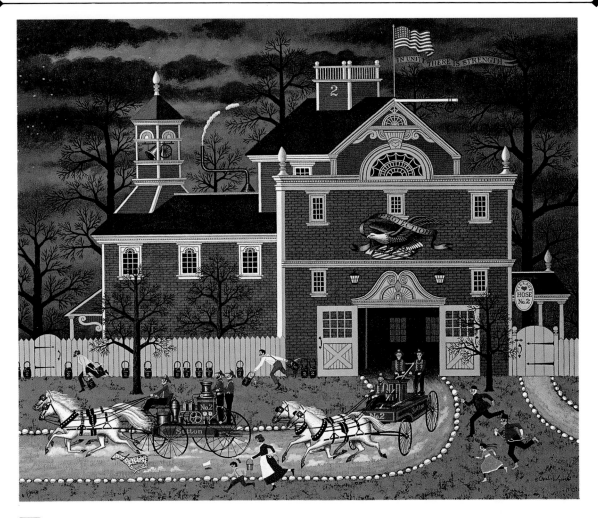

I n small towns, and especially in the cities, there were some things only horses could do. Fire companies cherished their gallant animals and relied on them to help save lives. Firehorses were a large, strong breed, calm in the face of panic, always trailing crowds of spellbound onlookers as they pounded their way to the rescue. Their reward was loving care and a populace that cheered with special affection when the great beasts, brushed and glossy, took their proud and shining place in every holiday parade.

Left: PLUNKERTON'S COUNTRY PRODUCE *Above:* FIRE!

[129]

PUMPKINS & CORN

If the crisp air of fall always brought out the best in horses, it was also a high point for the farm, a rich and lush time when the lessons learned from America's original inhabitants bore bounteous fruit.

The pumpkin, the pumpkin—the glorious pumpkin! A strange, invaluable vegetable first introduced to the pioneers by the Indians, it was destined to become a staple of the farming community—and a design

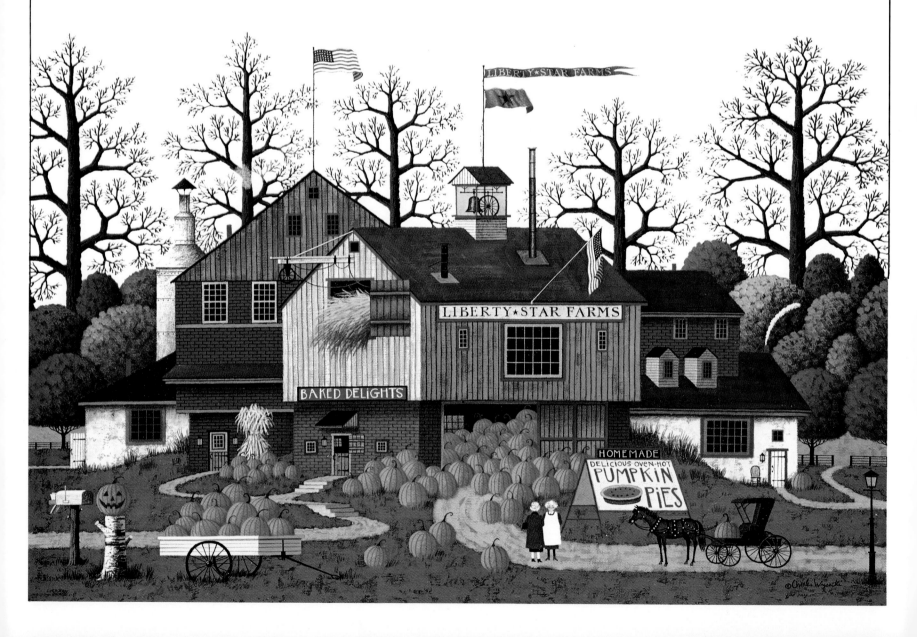

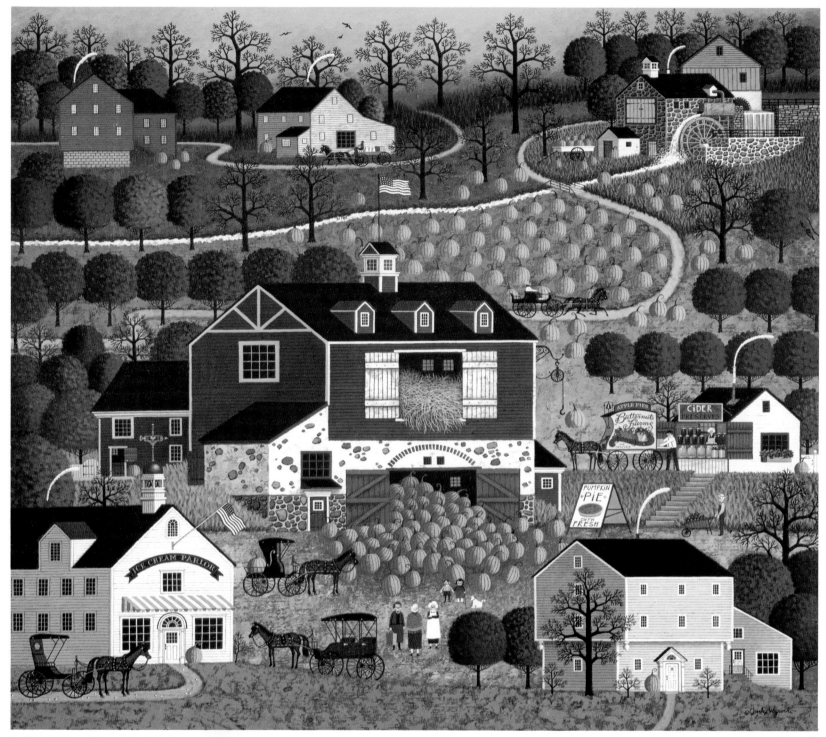

Left: LIBERTY STAR FARMS

BUTTERNUT FARMS

shape favored by artists, a delight to
generations of Jack-o'-Lantern carvers, and
the source of untold delicious pies, pickles
and preserves.

[131]

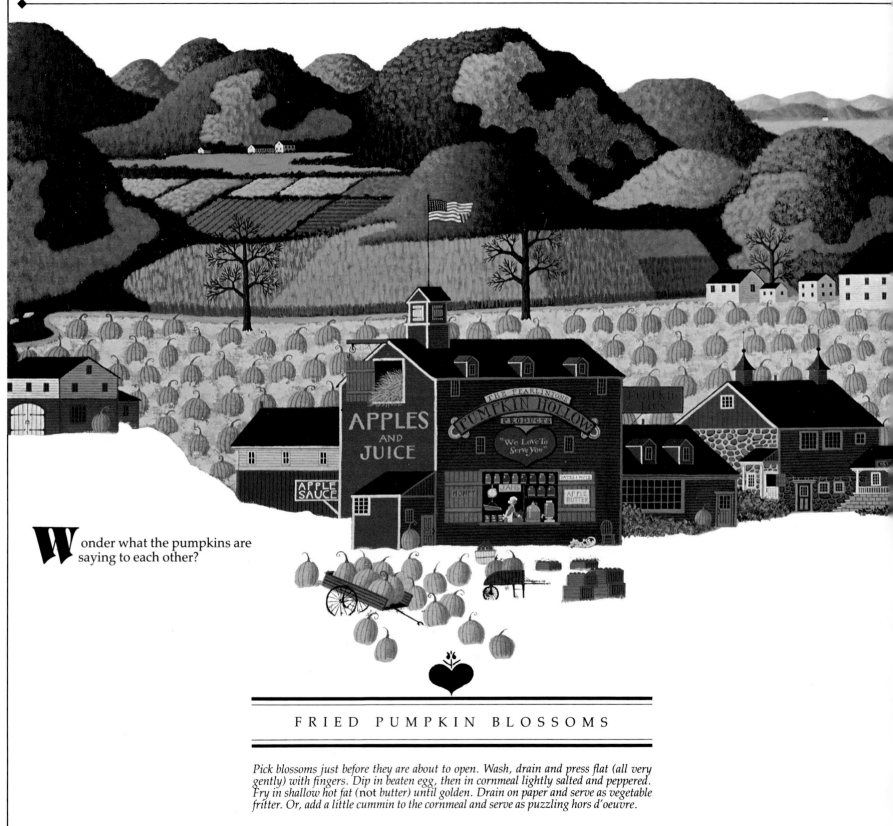

Wonder what the pumpkins are saying to each other?

FRIED PUMPKIN BLOSSOMS

Pick blossoms just before they are about to open. Wash, drain and press flat (all very gently) with fingers. Dip in beaten egg, then in cornmeal lightly salted and peppered. Fry in shallow hot fat (not butter) until golden. Drain on paper and serve as vegetable fritter. Or, add a little cummin to the cornmeal and serve as puzzling hors d'oeuvre.

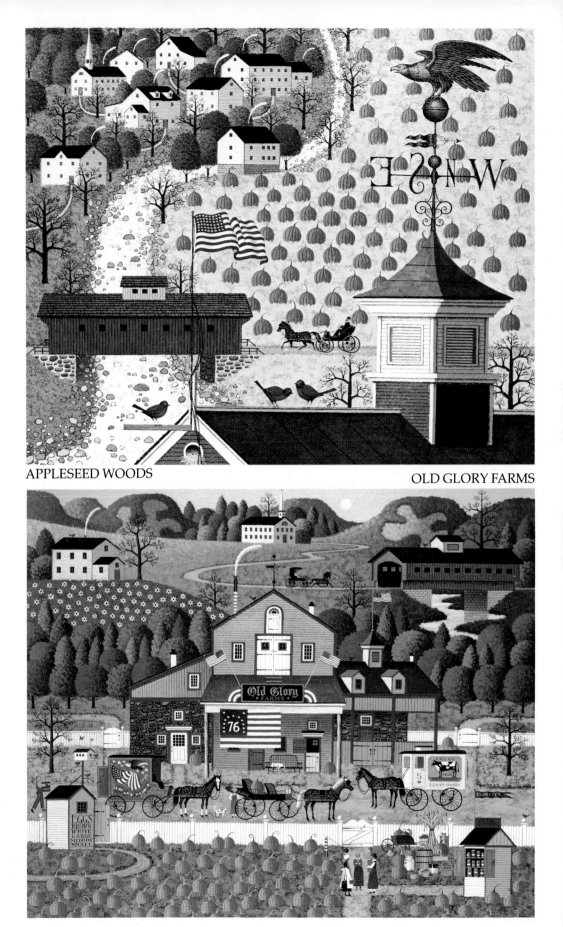

APPLESEED WOODS

OLD GLORY FARMS

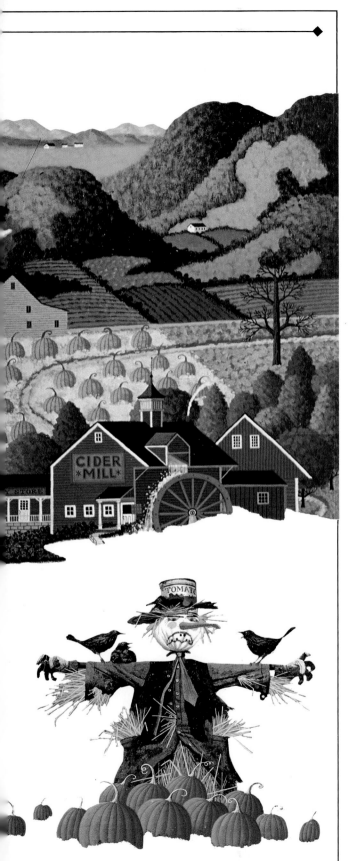

Above: PUMPKIN HOLLOW #1
Below: Detail from MR. SCAREFELLOW

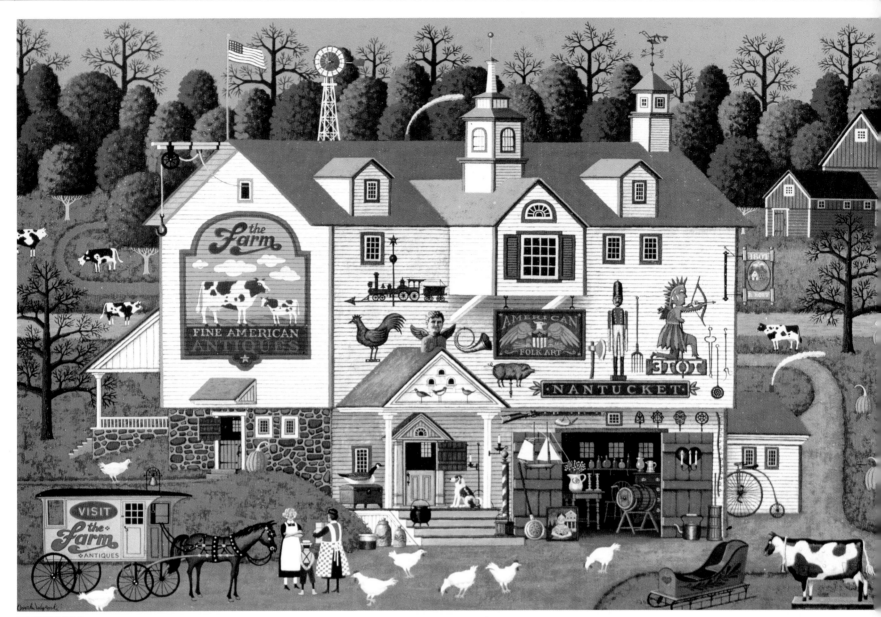

THE FARM

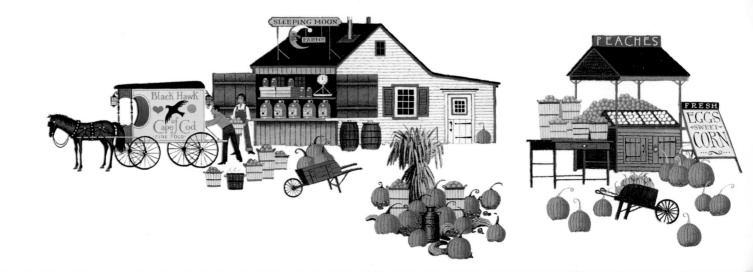

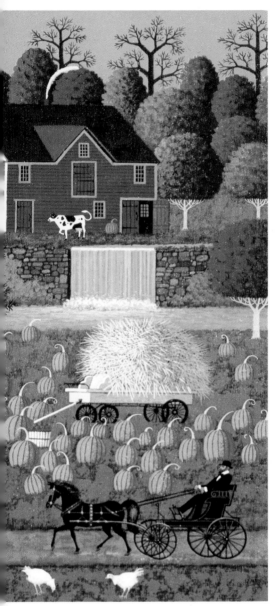

Below: Detail from
SLEEPING HOLLOW FARMS

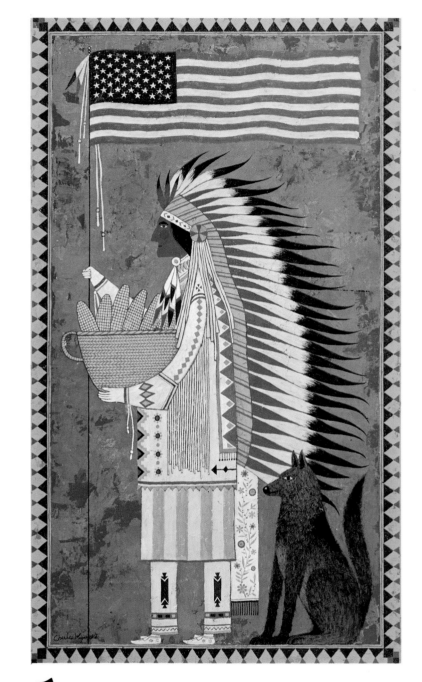

Another gift from the Indians was sweet corn, the source of syrup and flour and oil; one of the most delicious, fresh-eating taste delights ever devised by God and man; eventually to be puffed and popped and crunched into many forms—certainly as rich in its possibilities as its good neighbor, the pumpkin.

THE CHIEF

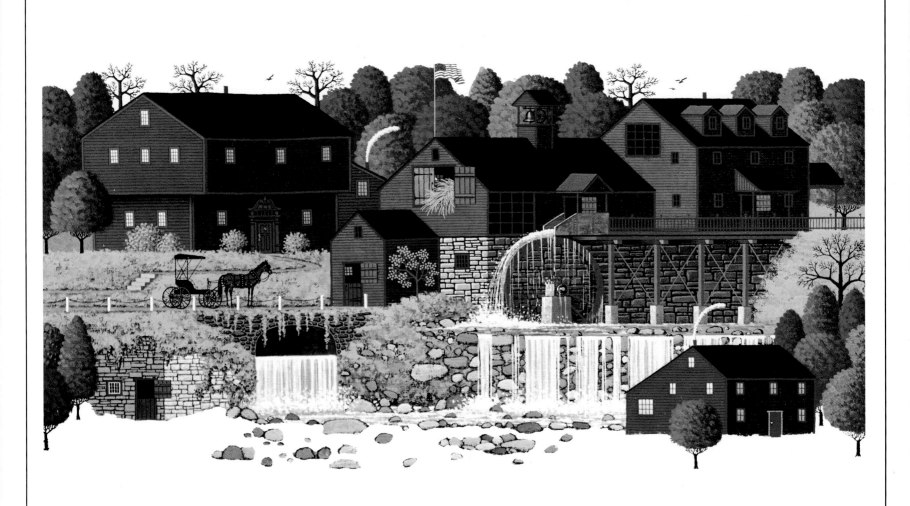

LAND OF SWEET WATERS

If pumpkins and corn and horses were important to the farmer, water was vital. Indeed, it was not only necessary for crops and stock, but furnished the power that gave the miller a central role in the community, was an integral part of tanneries and wood mills, and finally, via the famous Erie Canal and other waterways, provided a means for the farmer to get his produce to market.

Besides all of that, the clear upper streams wandering through woods, frothing over rapids and dashing down miniature waterfalls to make deep, quiet pools, provided a haven for fishermen and ice-cold swimming holes for the young or hearty.

America's hills and valleys and mountains ran with water, gushing and gurgling and chuckling in a seemingly boundless flow of lakes and streams and rivers

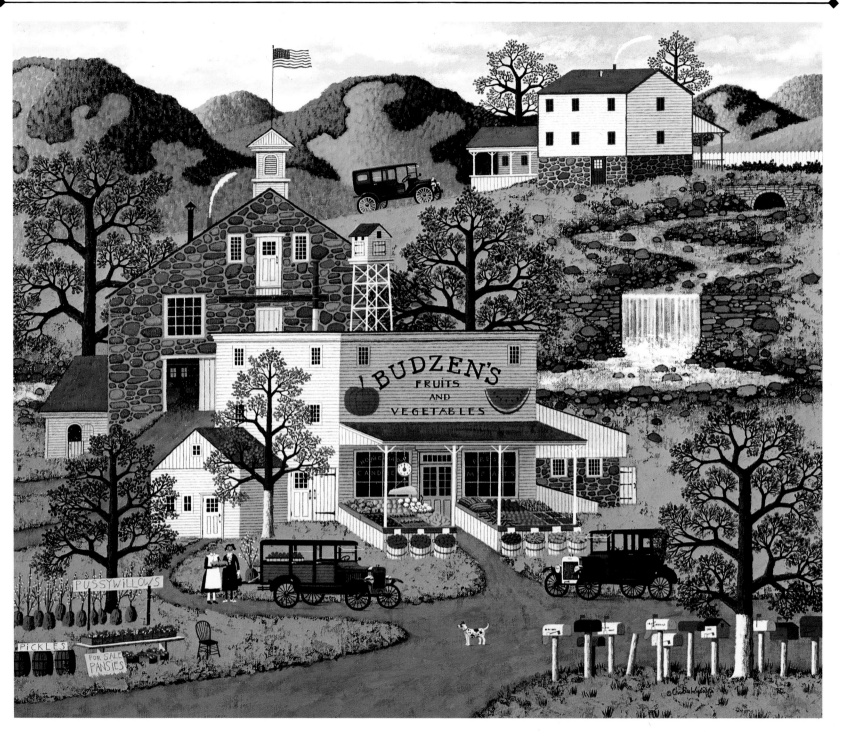

that were a tremendous source of power, a solace, a joy, and home to millions of bass, trout, perch and a dozen other varieties of fish; while the marshes and ponds nurtured vast flocks of waterfowl of every description.

BUDZEN'S ROADSIDE FOOD STAND
Overleaf: BUCK'S COUNTY

[137]

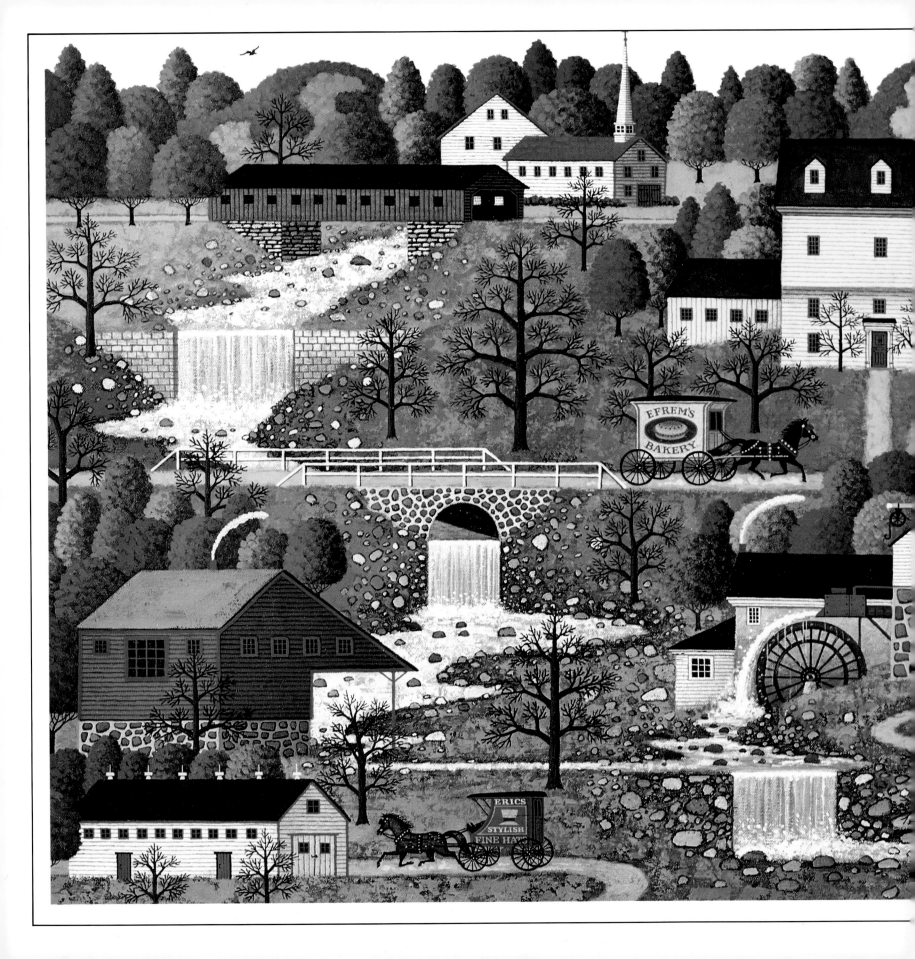

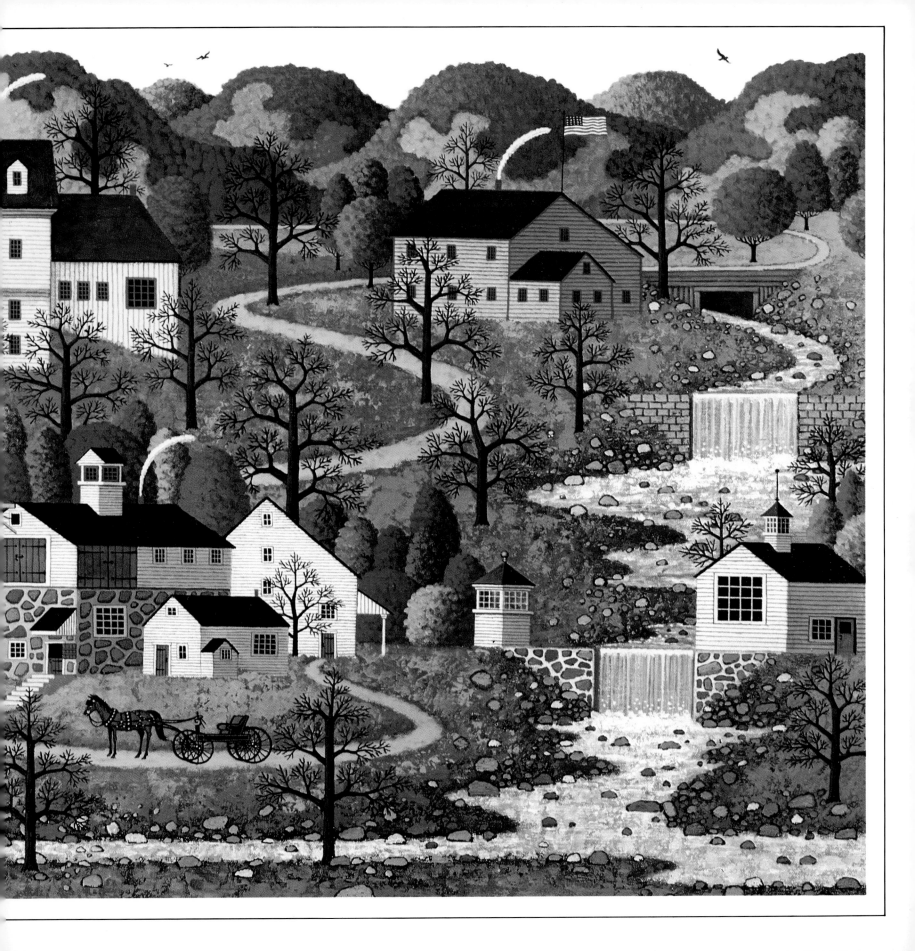

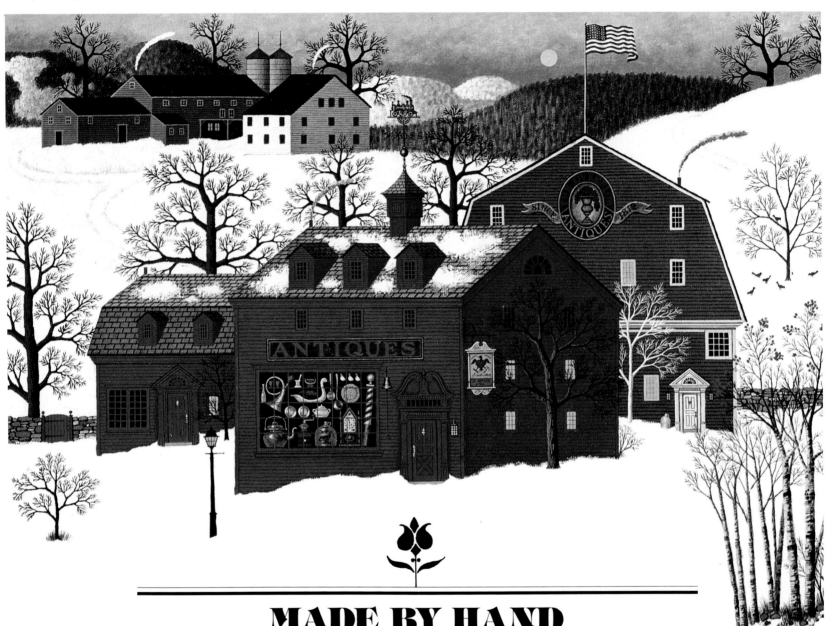

MADE BY HAND

Originally the carving of decoys and the creation of artificial birds was a necessary part of hunting America's bounty of waterfowl. The fact is, the decoys, like so many other workaday tools, were one of the artistic expressions of people who had little time for "art" per se, or who were perhaps forbidden by religious conviction to waste their time on such fripperies. But the urge to beautify, to improve, to embellish, is basic. The decoys were a prime example of art serving life.

No one is immune to the need to create. The Mennonite ladies stitched intricate explosions of color into their glorious quilts, while their more conservative Amish sisters made traditional patterns, rich in strong design.

Early potters, using the salt-glaze method, and not content with simply firing vessels to contain various foods, decorated their thousands of products with blue birds, or flowers, or simple designs; storage in the handsome, heavy crocks of cider, vinegar, oil, salt, butter

Detail from EVENING RACE

and other necessities made an everyday chore a pleasure. And the potters progressed to more complex work, to the lovely warm browns, ochres, golds and greens of Mochaware, and eventually produced highly evolved tableware that rivaled in popularity the imported English china and Chinese porcelain.

The very first glass factory in the new land made beads for trade with the Indians. But the need for glass containers quickly became evident. Thousands of small, rectangular bottles served to contain medica-

tion. However, a collection of such medicine bottles could be used to serve a genuine purpose in pioneer cabins. Welded or cemented together, flat side to flat side, they made a window that let in no air but created an interesting aqueous light—a form of stained-glass window, with built-in insulation!

The storing of whiskey, an obvious necessity, prompted creation of exquisite glass flasks in every size and shape and color that became a unique American art form. Glassmakers learned how to emboss

OLDE AMERICA

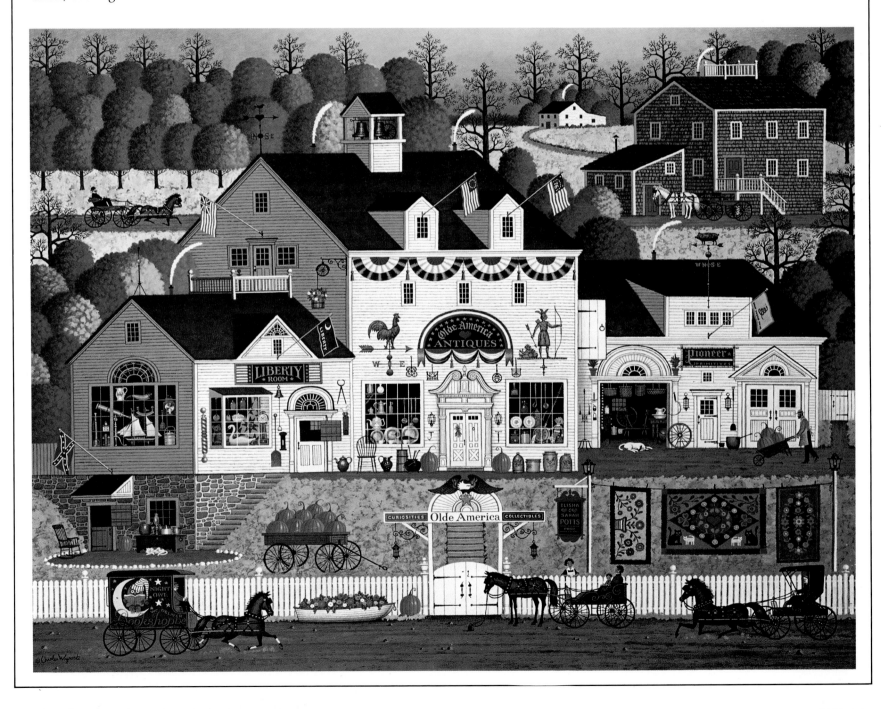

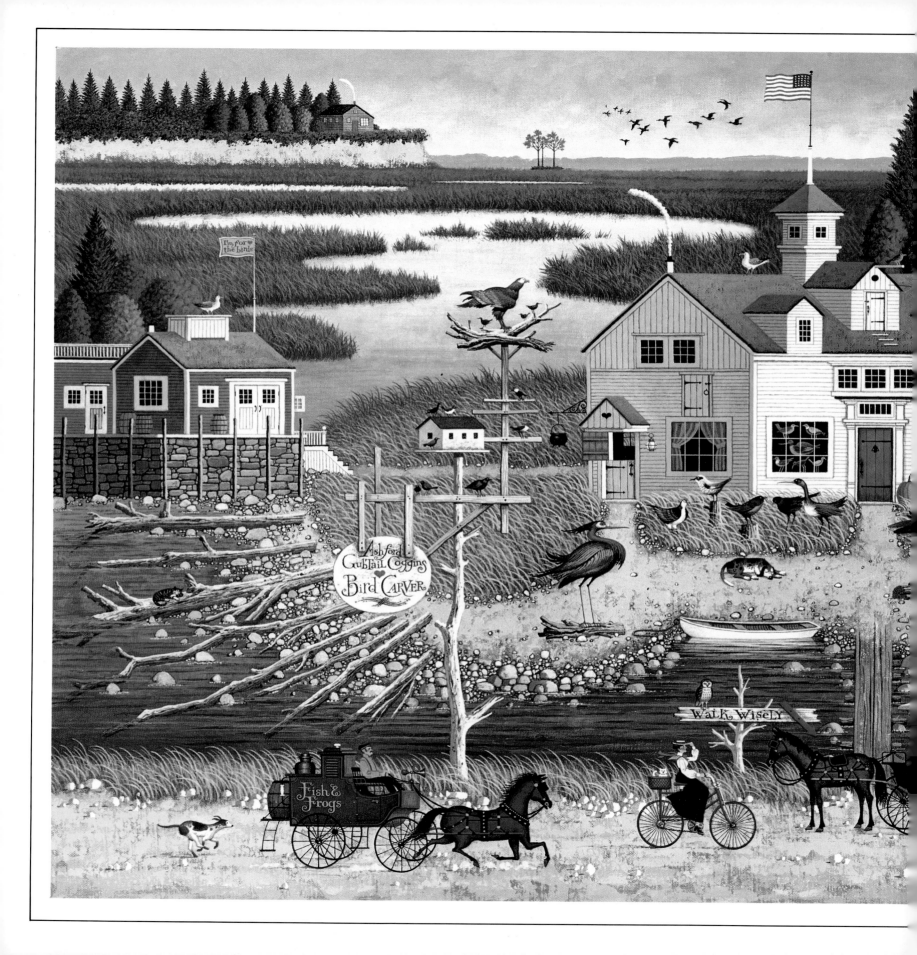

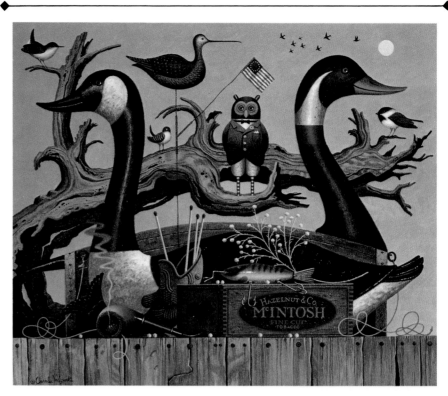

hand-blown pieces, using designs of grape leaves, eagles, flags, and even likenesses of famous people. In political campaigns, Andrew Jackson, Thomas Jefferson, John Adams, and others, dispensed whiskey-filled bottles bearing their images. While the robust outlines of actress Lillian Russell penetrated every corner of the land in this delightfully bibulous form.

However, everything had to be bottled, crocked, boxed, sealed, protected and preserved for use another time, or even by another generation. Japanned tin boxes replaced leather, and were made impervious to termites, mice and mildew. The boxes were not just painted with flat oil paint, but were over-painted with pretty designs to protect the surfaces from rust— and became objects of beauty that enhanced the rooms they helped to furnish. So metalwork, starting with the humble tinsmith and the forge, became an art in the form of decorated boxes, convoluted wrought iron, repoussé brass and

tin lamps, and molded bronze; to say nothing of the intricate mechanical banks invented by workers in cast iron, a fancy that provided children with an attractive incentive to save.

Scrimshaw, the carving of whalebone, served an important purpose. It was a result of the effort to fill the long, lonely months at sea. And, of course, among the oldest of handcrafts were wickerwork and weaving. Each had function. Each had beauty. Each provided a rich outlet for artistic endeavor. Indeed, all across America, people not trained as artists combined need and pleasure and pride in craft to create a history in artifacts—the Americana that have become today's museum pieces and collector's items.

The carvers, the weavers, the potters, the workers in iron, tin and glass, did not know they were creating the precious coin of antiques. But their own lives, too, were enriched by the exuberant product of their hands.

Left: CARVER COGGINS *Above:* HUNTERS LURES

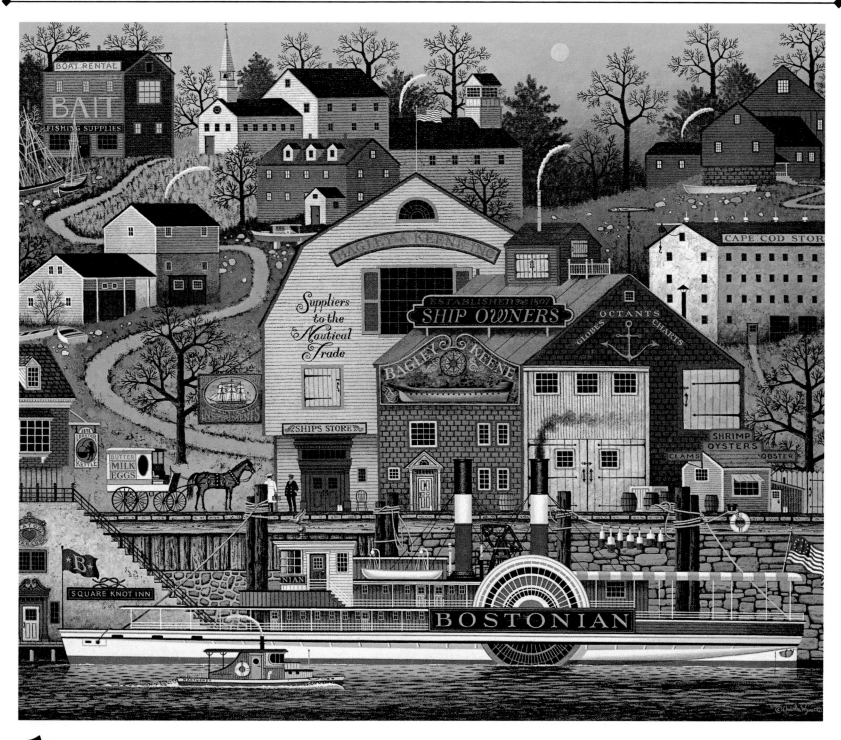

America's artisans created a rich heritage of ship's crafts in buoys and brass, lobster pots, intricate nets, scrimshaw, and specialized tools. In the hands of watermen the knotting of rope became an art in itself.

Even the smaller craft carried their share of ingeniously devised tools for special jobs, and clever dual-purpose devices to circumvent limited space. For on the inland waterways men lived on their vessels, carrying raw materials to industrial centers and farm goods to the cities, taking finished products back to the river towns and via canal up into the farm heartland, there to load up the harvest and start downstream again.

THE BOSTONIAN
Right: PUMPKIN
HOLLOW # 2

HARVEST FESTIVAL

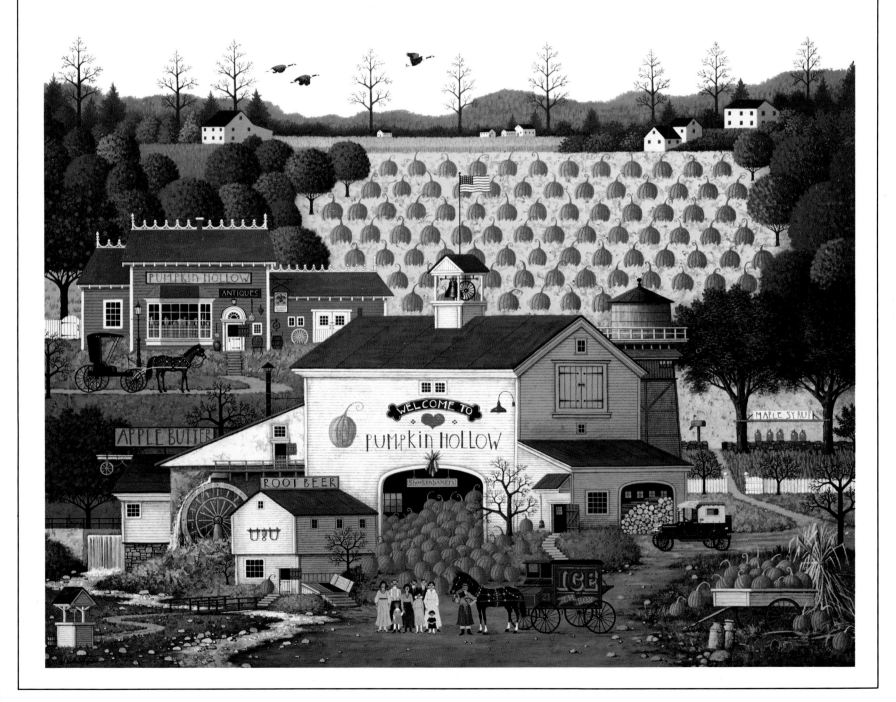

For the farmer, harvest was the real climax of the year. Everyone would be working—the hands, the farmer, his wife, the part-time help, and the kids who were bringing in baskets of beechnuts, hickory, butternut, black walnuts and chestnuts from the woods. The farm's own hedges provided hazelnuts. All would be left in the shell, nature's perfect storage system, until long winter evenings allowed time for hulling or roasting as the family needed. The root cellar already held a lot of hard fruits and ground vegetables packed away in barrels of sand. Dried peas and beans, millet and grains were stored in crocks in the attic, its rafters hung with herbs and strings of onions. Delicious smells from the smokehouse rivaled those of the kitchen, where a great flurry of preserving and the making of various jams was going on. Earlier the cellar had accommodated dozens of quarts of bottled soft fruits and vegetables—peaches, pears, berries, tomatoes and green beans, corn and pickled cabbage.

The farmer himself, field work finished, is laying in feed sacks for the stock and winter wood for the cookstove, carefully selected, properly sized and aged. Not just any old wood will do for baking and cooking. While to heat the house for the entire winter the woodlot must yield, literally, a house-size pile of cut wood.

Once the harvest was in, the frost properly on pumpkin and quince, and the fields fallow, some folks could indulge themselves in certain outdoor activities they found pleasurable, such as formal foxhunting. Most country people didn't have time for such shenanigans.

Farmers the nation over, though, hated foxes—and usually devised more practical methods of protecting their chicken coops from the wily marauder which, in this painting, is clearly going to give his hunters the slip.

Above: CROCKS AND CORN *Right:* THE FOXY FOX OUTFOXES THE FOXHUNTERS

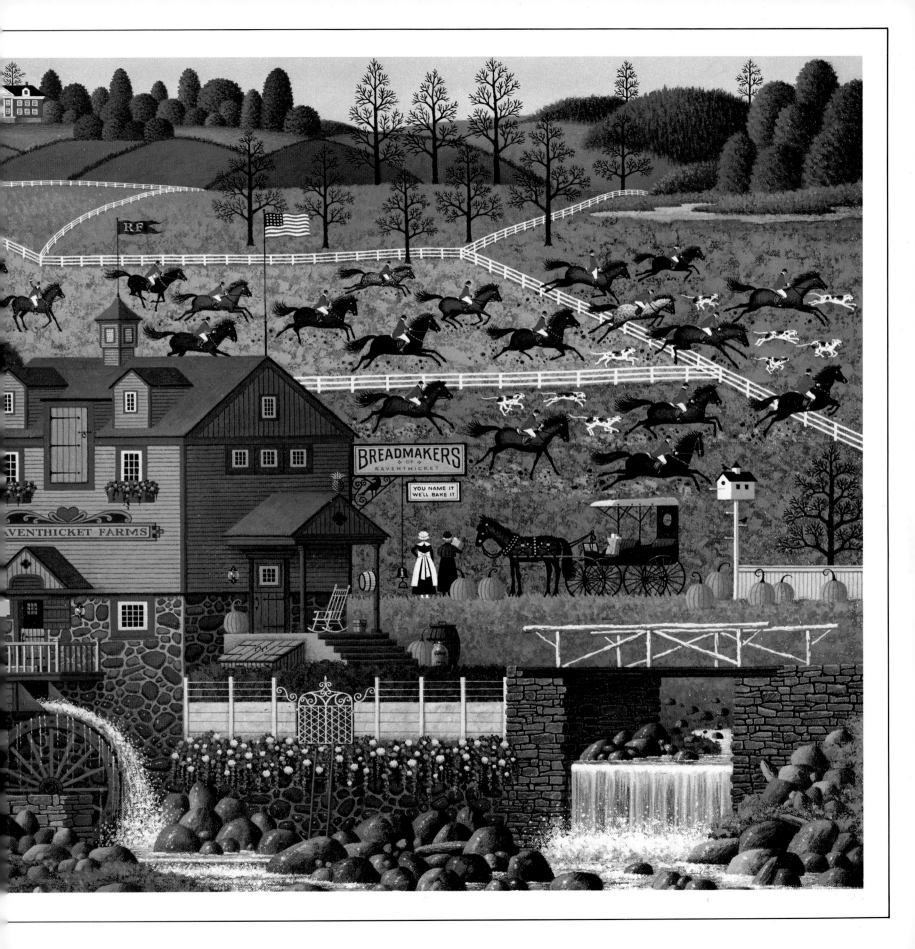

America's love affair with the apple started in New England with a man who used to collect his seeds from fallen wildlings in the woods of Pennsylvania, giving them and the saplings he cultivated to many settlers headed west. Eventually he, too, wandered inland, leaving Pennsylvania and half the East Coast full of hundreds of his plantings. He traveled slowly to Ohio, putting in seed as he went. Then, for forty years, he drifted up and down Ohio and Indiana, planting crops of seedlings all over the landscape, always giving young trees to others who passed by on their way farther west. His name was John Chapman, but he is lovingly remembered all over America as Johnny Appleseed.

Each fall sees a bounty of the crisp, sweet-tart crop, to be preserved intact for many months into the winter or put up as applesauce, apple butter or dried apple; and served as delicious Apple Brown Betty, apple cake, apple strudel, apple pie—and not least, by any means, as cider. Applejack, or apple brandy, used to be made by freezing hard cider down again and again during the course of winter until it became a potent liquor.

And every spring there is delight for the eye as the delicate apple blossoms explode in a froth of pink and white to presage next year's harvest.

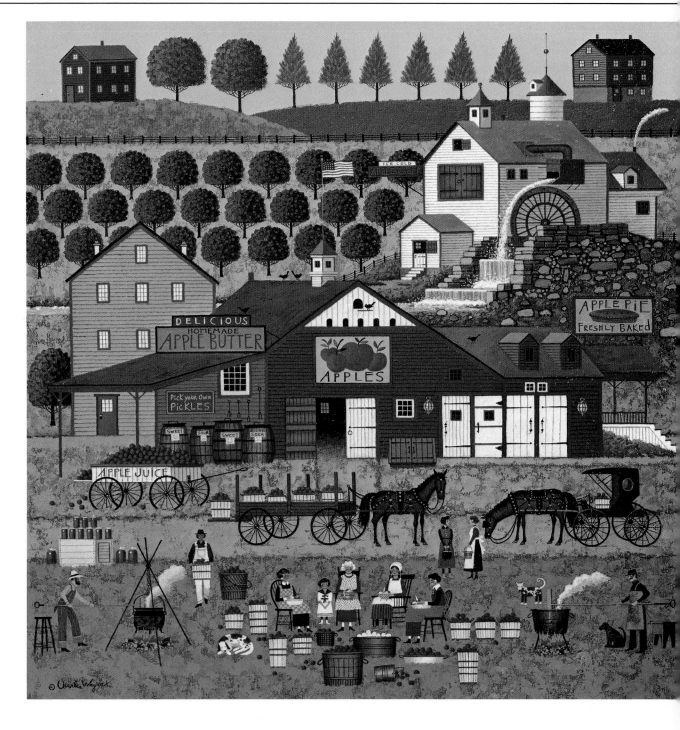

APPLE BUTTER MAKERS

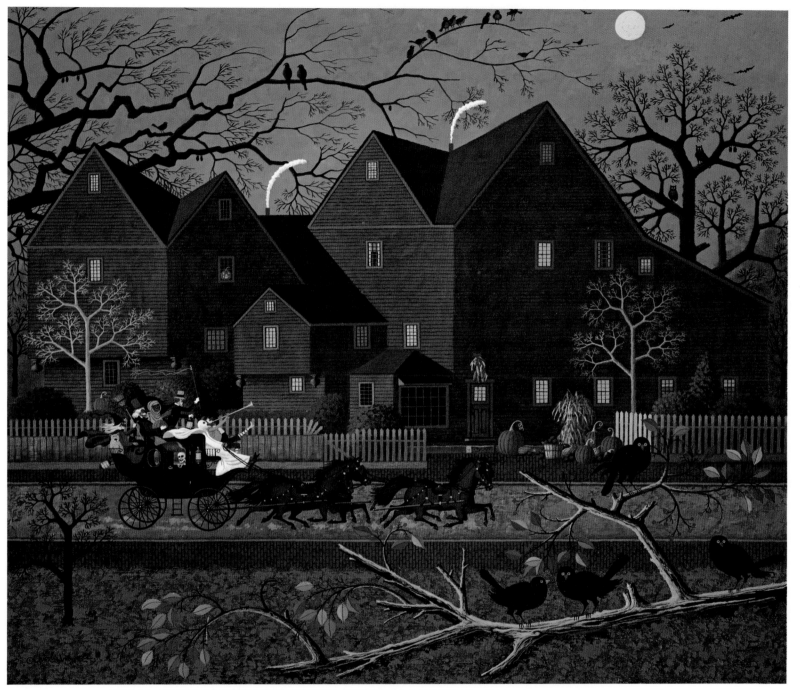

HELLRAISERS PASSING THE HOUSE OF SEVEN GABLES ON HALLOWEEN NIGHT

All Hallows' Eve has its origins in very ancient rites: this was the time, long and long ago, when fires burned all night, witches streamed out over the land, and weirds of many kinds haunted the living. Literally, all hell broke loose.

Translated down through several centuries and many countries, Halloween became the occasion for an outburst of fun and games, for telling ghost stories, dancing around bonfires, bobbing for apples, and trick-or-treating. One of America's most popular traditions that saw many an over-turned privy greet the new day.

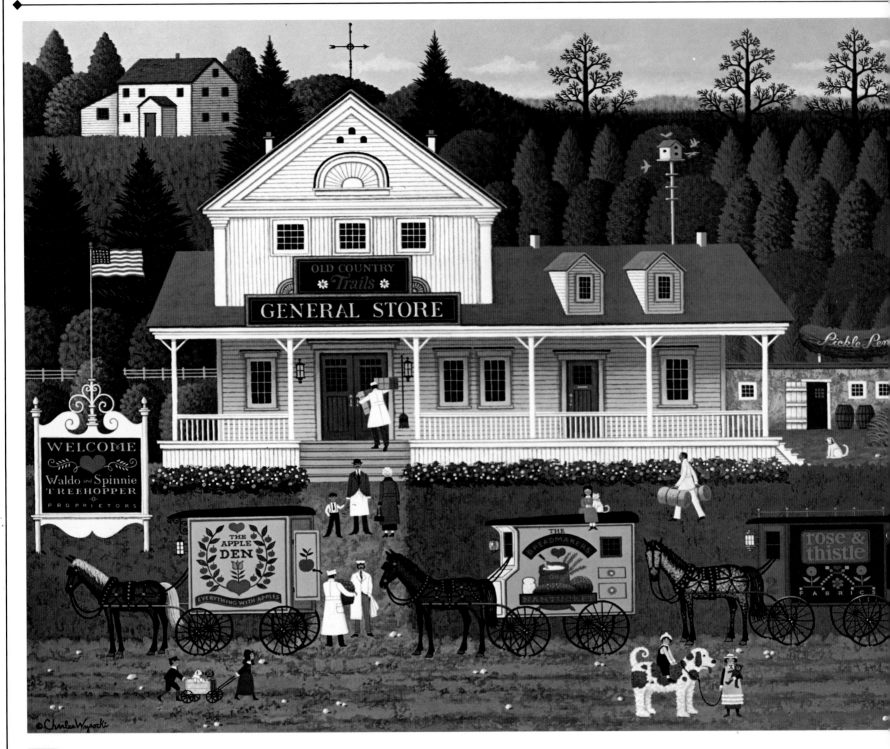

Before snow and ice pretty well closed down the muddy country roads, at least up north, it was wise to lay in a stock of store supplies—kerosene for the lamps, and flour, sugar, salt, oil—the staples, along with the fruit, vegetables and cheese down in the cellar, and the hams, bacon and smoked meats hanging from the rafters, that would keep the winter table covered with rich and plenteous fare.

Folk in small towns laid by stores for the winter, too. Jaunting daily to the shops wasn't much fun in sleet and snow, so once again the all-purpose cellar would be loaded with tubs of butter, a barrel of flour, candled eggs, and other goodies. (Actually, with flour, butter and eggs you could make just about anything.) But the goodies were important and abundant. It made for a real snug feeling.

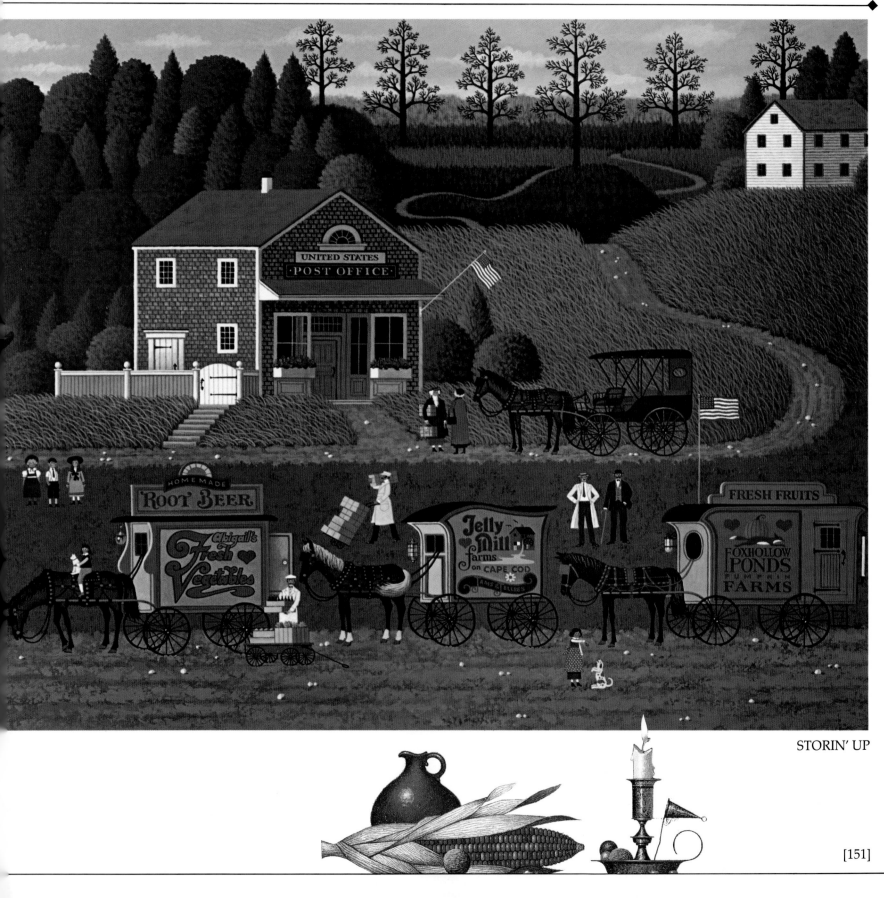

STORIN' UP

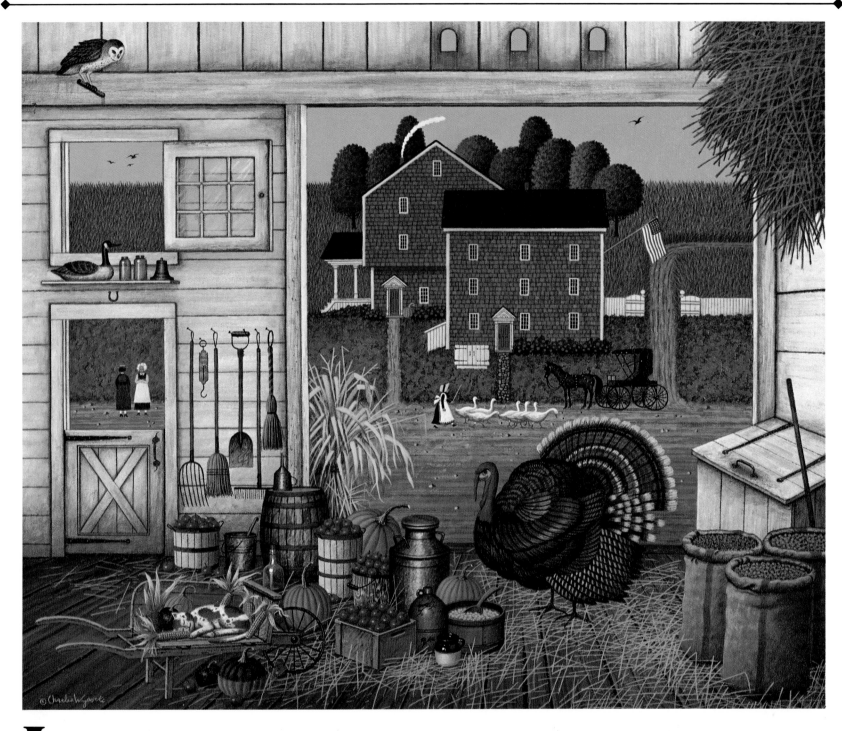

In every home in America, there was one final eating extravaganza in which the turkey, strutting out in the yard, would become the star turn. When properly stuffed, he would require a supporting cast of clams, cabbage, carrots, sausage, ham, rice, squash, sweet potatoes, watermelon pickles and cranberry sauce; and mince, huckleberry or pumpkin pie, all to be washed down with gallons of cider.

This would be the last gargantuan meal before Christmas—a banquet to stuff the stomach and stun the palate, one of America's favorite family get-togethers that celebrates the First Thanksgiving.

TURKEY IN THE STRAW

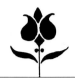

SMALLTOWN, U.S.A.

Right up to the 1890s, even in major urban centers, most people lived as families in individual homes. And most still had privies and stables out back. Universal indoor plumbing was a relative latecomer, while the common mode of transport was still the horse-drawn carriage.

But inside, at least in the towns, there was increasing comfort and unlimited richness in decoration. From strongly designed carpets carefully covered in "wearing" areas by Oriental rugs, papered walls rose, gay with festoons of flowers, fat cupids, rampant ribbons and bows, to dadoed ceilings sculptured in bas-relief—an appropriate setting for the heavy wood furniture carved and knobbed and twirled and turreted with rosettes, acorns, wooden fruits, flowers, leaves and other more exotic artistic profusions, upholstered with studded plush or brocade, tufted and tasseled, and all heavily protected by antimacassars, various embroideries and throws.

These were just the basics. For proper elegance,

Mr. Partridge wiggles, jiggles and fluffs
and also huddles, cuddles and stuffs
for to nest himself on the heart
is a graceful and delicate art

1918

MR. PARTRIDGE

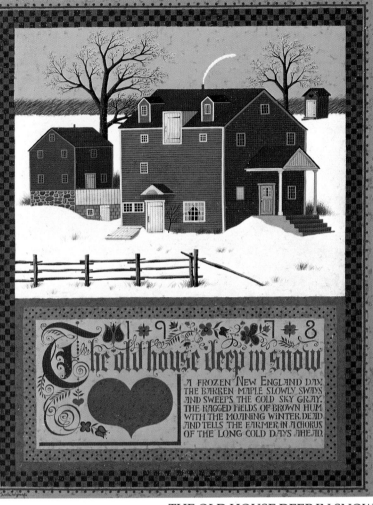

THE OLD HOUSE DEEP IN SNOW

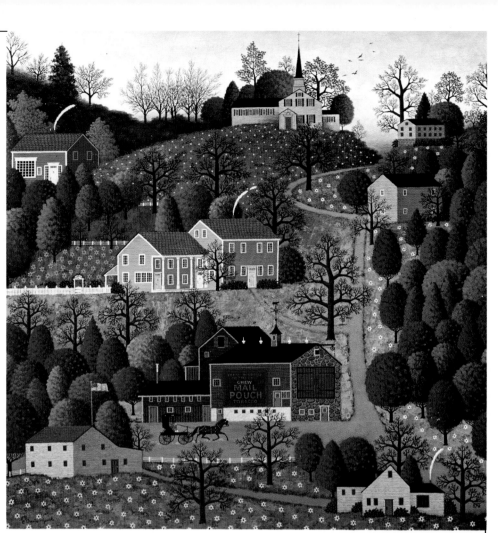

AUTUMN MORNING

there were lamps of wrought brass and painted glass supporting lace shades threaded through with satin bows; footstools, sidetables, rocking and easy chairs, curved and fretted couches and love seats, spindly whatnots loaded with busts and boxes and vases set on doilies, cupboards to display china and glass, a pianoforte buried under photographs, its polished surface protected by mats of crochet and tatting; and display shelves, ferns arrayed on brass plant stands, books, pictures, wall hangings, curtains, mantels tastefully draped with shawls, every nook and cranny lovingly crammed—all reflected in several ornate gilded mirrors. And often, incredibly managing to dominate the whole, an astounding, melodramatic wood stove. Where the stove was replaced by a more elegant tiled fireplace, the mantel would achieve the same commanding position by climbing in several spindle-pillared tiers to the ceiling, each level displaying statuary, shells, porcelain

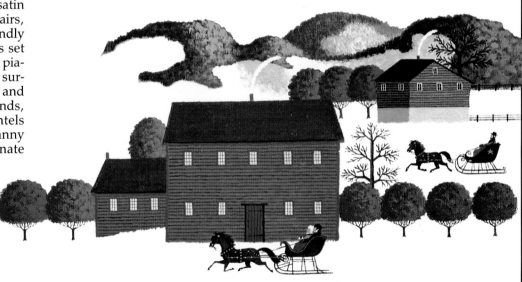

Opposite and above: Detail from PASS THE RED FOX TAVERN

[155]

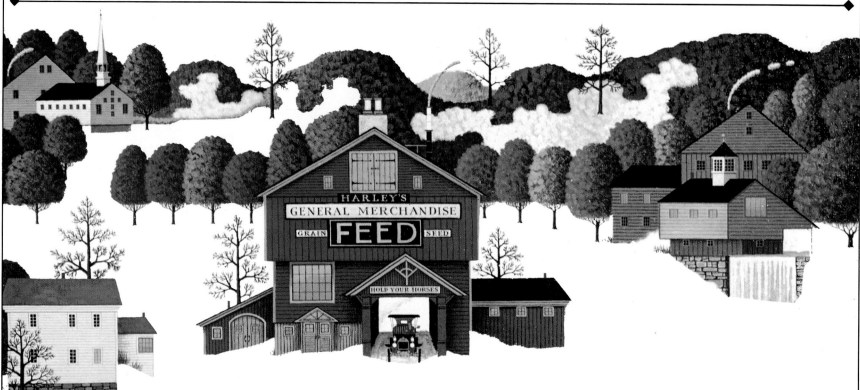

Above: Detail from HARLEY'S FEED STORE *Below:* HOTEL SLATT'S MUSIC ROOM

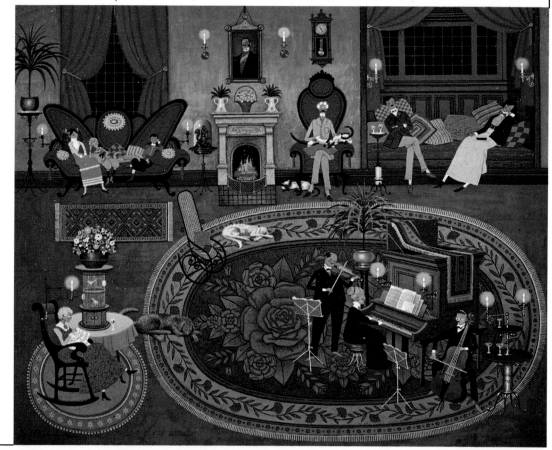

figurines, china fruit and the like, thus gracefully retaining the authority of the obligatory focal point.

This was a time of proud acquisition and extravagant display, an explosion of embellishment upon decoration upon design. And a dusting nightmare.

By comparison, the music room at Slatt's is relatively austere.

A few daring folks had invested in Mr. Ford's new horseless carriage, but it was held to be very unreliable, especially in inclement weather. In winter not only would the machine very likely refuse to start, but give it a couple of inches of snow and it would develop a mind of its own and skid off the road.

The only way to be sure of getting to where you wanted to go was to use a sleigh or a buggy, drawn by a horse that was a whole lot friendlier than any machine, and smelled better, too. So there were a great many horses around, and they ate a great deal more than humans. Summer or winter, the feed store did good business.

[156]

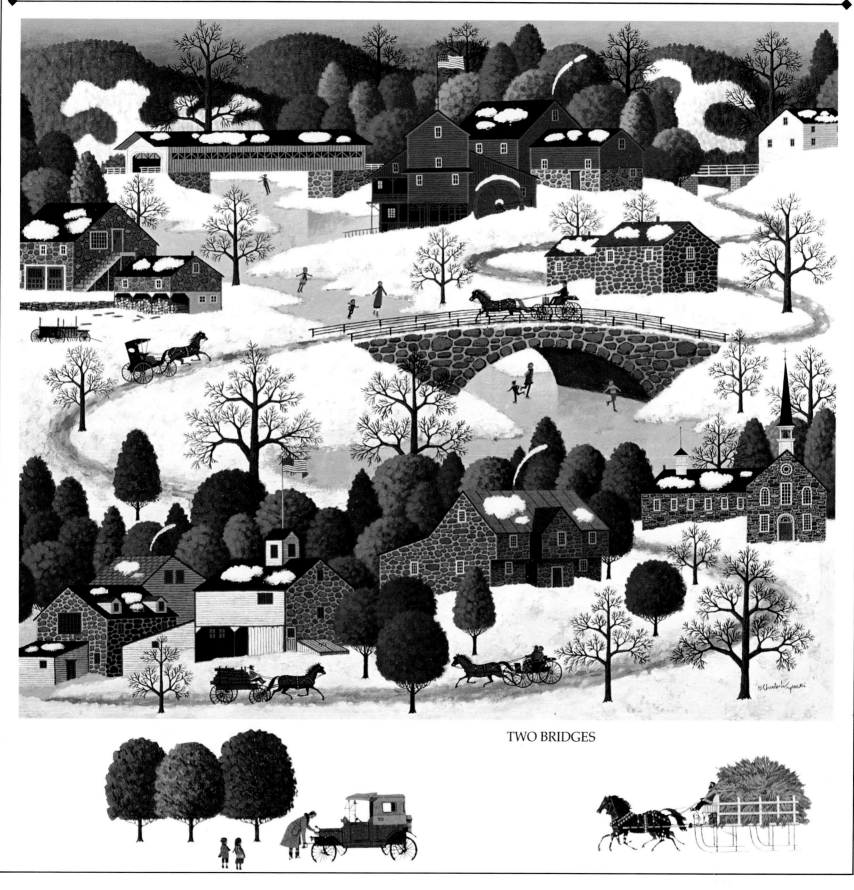

TWO BRIDGES

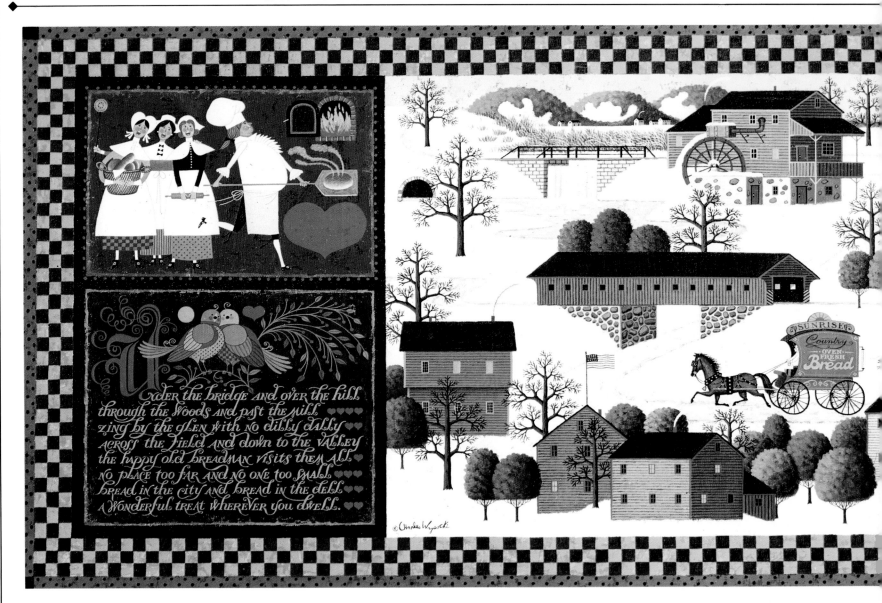

Under the bridge and over the hill
through the woods and past the mill
zing by the glen with no dilly dally
across the field and down to the valley
the happy old breadman visits them all
no place too far and no one too small
bread in the city and bread in the dell
A wonderful treat wherever you dwell.

Although a lot of baking was done at home, for families with large numbers of mouths to feed, the baker was a great convenience. Besides, there were many particularly desirable baked goods that were not bread. The baker could be counted on to provide special kinds of rolls— and doughnuts, cream-cakes, pastries, and worse—a feast to seduce the taste-buds and ruin the figure.

Of course, for anyone living on their own, perhaps in a roominghouse (as opposed to a boardinghouse, which generally provided meals), purchasing fresh-baked bread was a necessity. For this lucky person, the delectable smells of the bakery were a familiar daily delight.

Indeed, a town without a baker was a town without a heart.

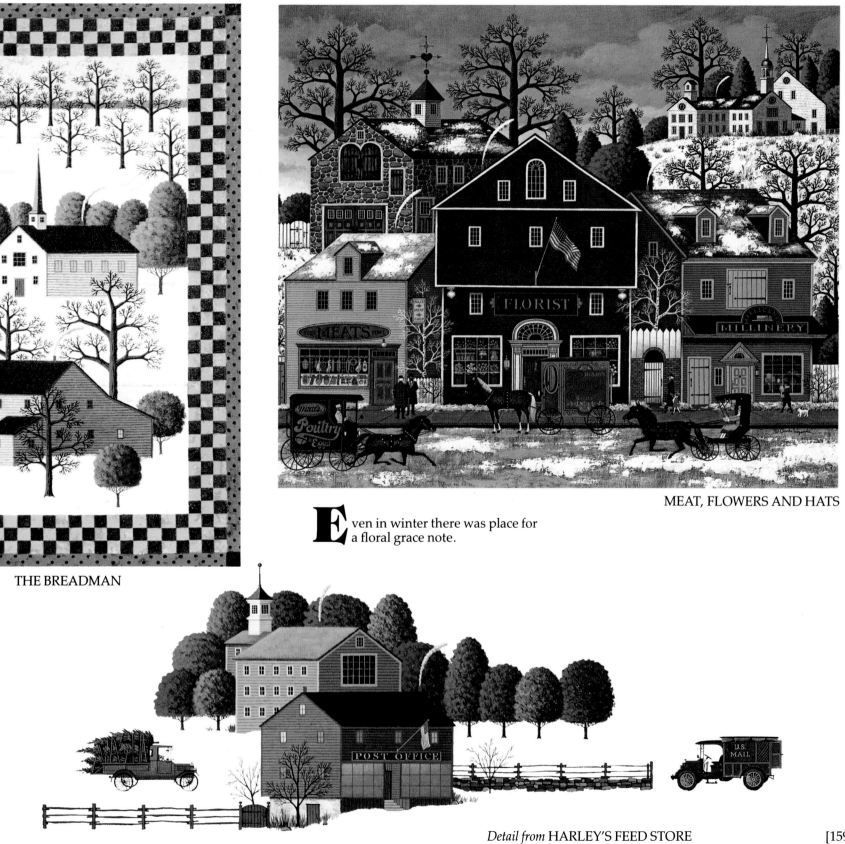

MEAT, FLOWERS AND HATS

Even in winter there was place for a floral grace note.

THE BREADMAN

Detail from HARLEY'S FEED STORE

[159]

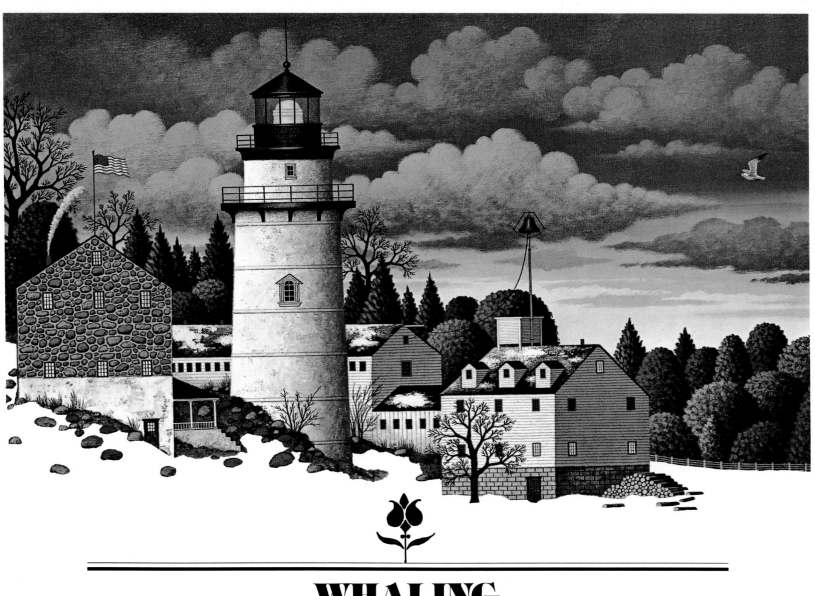

WHALING

Whaling was a summertime occupation—at least, that was the season when the ships started out. Originally, American whalers sailed north out of Long Island and Cape Cod, headed for the frigid Arctic waters in search of the right whale. Later, Nantucket and New Bedford became the main centers for the hard-bitten men and the patient, courageous women whose husbands followed this demanding profession. Eventually, New Bedford would become the greatest whaling port in the world.

But it was a Nantucket man who captured the first sperm whale, with oil far superior to that of the right, and thus set the whole industry on a new path, searching south to the Antarctic home of this behemoth and journeying at last clear round Cape Horn to hunt in the Pacific, on trips that sometimes ran three to four years.

Oil was not the only product the great water mammal supplied. Generations of Victorian ladies grew up laced into the armor of whalebone corsets. The bone was used also for everyday items such as knitting nee-

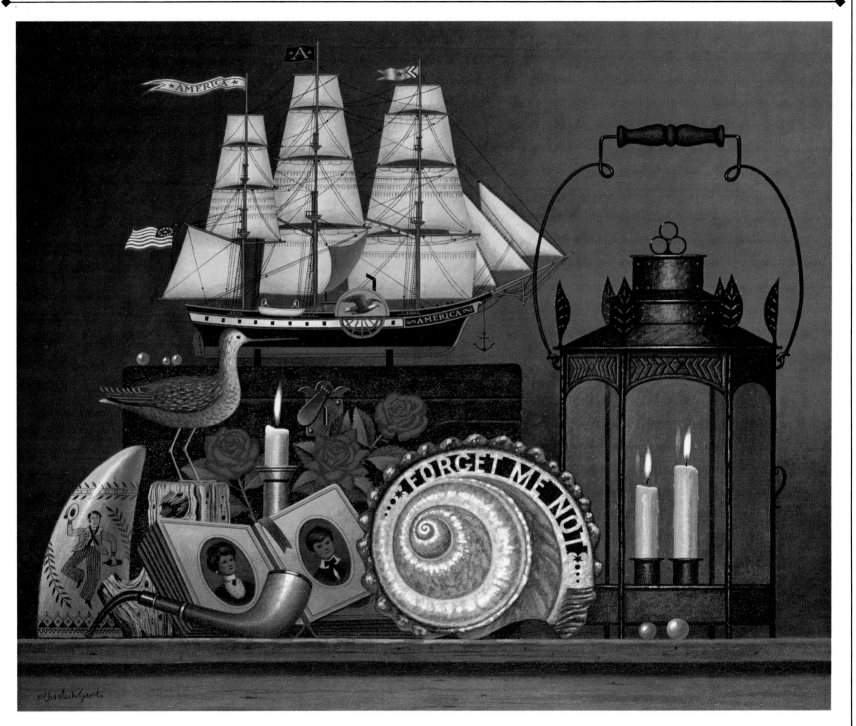

dles, ladles, spoons, and even carved jewelry. Fortunately, the need for whale oil was displaced by the development of mineral fuels; while the corsets, if they did not entirely disappear, became formidable constructions of steel and rubber.

Meanwhile, the hunt for whales would continue. Eventually, restrictions would control the number and kind taken. But the great whaling ports, and the tradition of the men who made them great, remain a proud part of the American heritage.

FORGET ME NOT

[161]

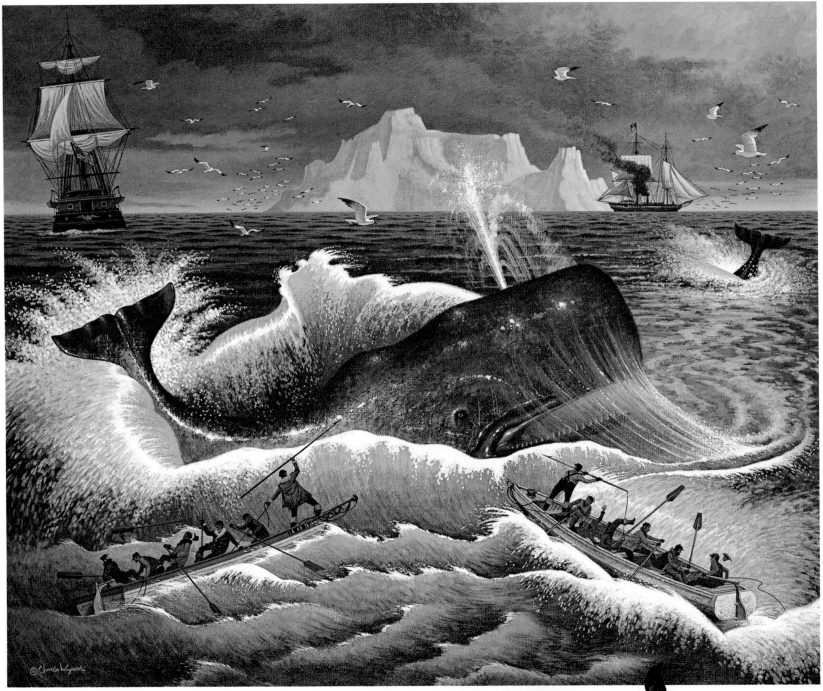

THE WHALERS

There was supreme danger in hunting whales in the early days, when all a man had was a hand-thrown harpoon.

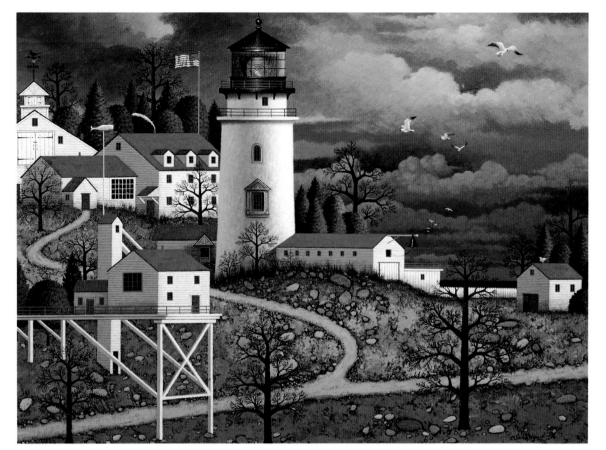

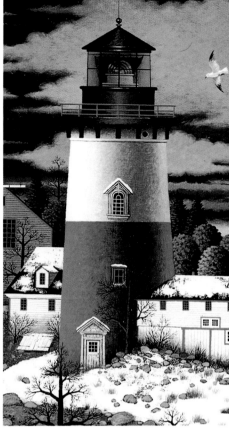

The very earliest of lighthouses, all the way back to Egypt, were tended by priests. Ancient Egypt believed guiding the ships home was important enough to be a sacred function. Their wood beacons, set close to the water's edge, signaled and warned with smoke by day and fire by night.

Many more modern lighthouses were built on rocky points out at sea, built to withstand the lash of gales and the thunderous crash of enraged waters—unapproachable except on the calmest of days.

Early lighthouses used tallow candles, coal fires and oil lamps for illumination, requiring constant attention. In fog or storm, whistles, horns and drums were employed to warn ships of danger. Sometimes, if relief could not get out to him, a keeper would be immured out on his rock for an entire winter without seeing another living soul. It took a special breed of man to cope with the lonely, demanding, endless task of lighthouse keeper, but it was a job that saved the life of many a sailor.

THE EDDYSTONE LIGHT

*Me father was the captain of the Eddystone
 Light,
Slept with a mermaid one fine night,
From this union there came three,
A porgy and a porpoise and the third was
 me . . .
 Yo-ho-ho, the wind blows free,
 Oh for a life on the rolling sea.*

*One night while I was a-trimmin' of the glim
A-singin' a verse from the evenin' hymn,
A voice from the starboard shouted "Ahoy!"
And there was me mother, a-sittin' on a buoy.
 (Chorus)*

*"Well, what has become of me children three?"
Me mother then she asked of me:
"One was exhibited as a talking fish
And the other was served on a chafing dish."
 (Chorus)*

*Then the phosphorus flashed in her seaweed
 hair,
I looked again, and me mother wasn't there:
A voice come a-echoin' out of the night,
"To hell with the keeper of the Eddystone
 Light!"
 (Chorus)*

CAPTAIN'S LANTERN

Detail from **TWILIGHT SENTINEL**

WINTER ON THE LAND

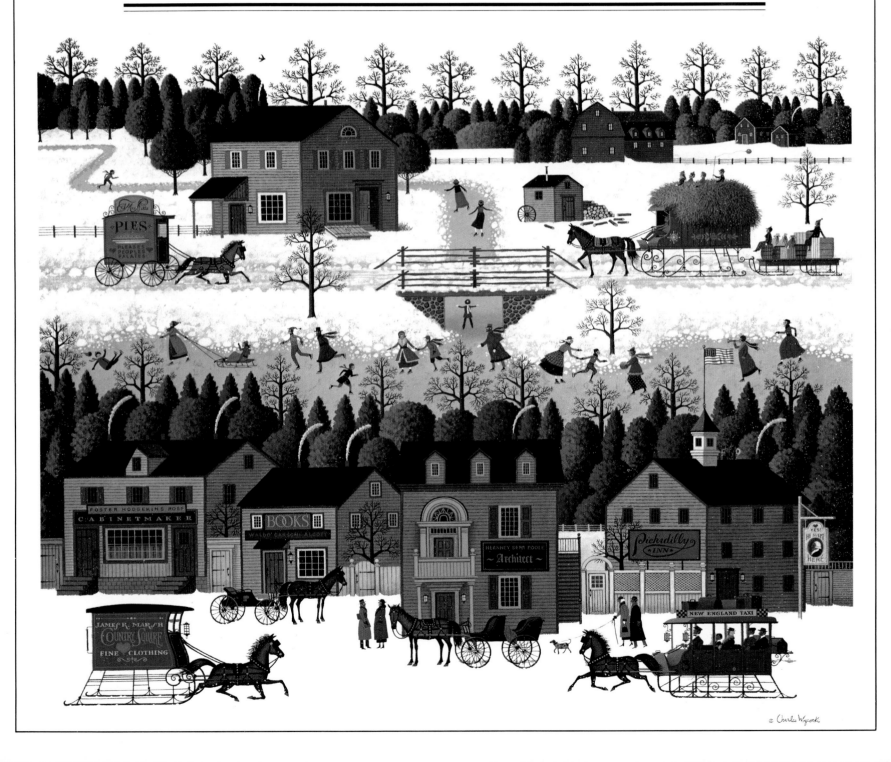

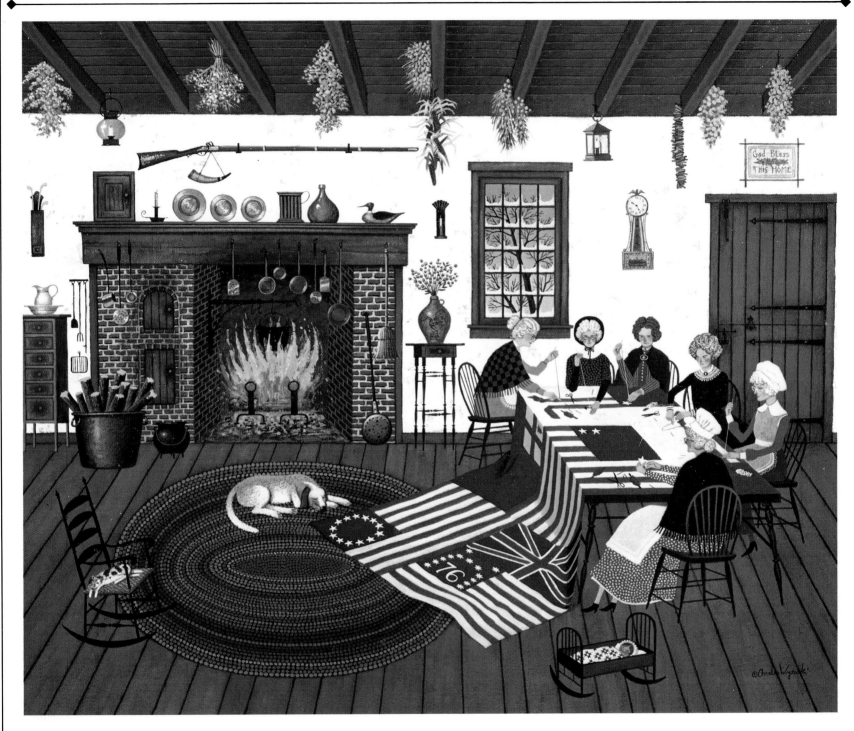

Winter was the time for indoor activities, among the most popular of which was quilt making. Quilting bees were occasions for much chatter and laughter—and even some entertainment, for once in a while a member of the group would be delegated to read to the others, or perhaps sing a song or two, espe-cially if her stitching was not of the best . . . but that was rare. Most ladies prided themselves on their nee-dlework, with good reason, and the more usual prod-ucts of such friendly get-togethers were delightful gossip and a beautiful, lasting piece of work that might well be handed down for several generations.

THE QUILTMAKERS
Left: WINDJAMMER
CANAL

[165]

OLD CALIFORNIA

While the East and the North froze, Californians hugged their climate
and enjoyed all the many diversions it offered.

The benign warmth of California was all very well, but it takes a real snap in the air to bring out the best in hot toddies, roasted chestnuts, steaming clam chowder and the like. So in wintry ice and snow, taverns were havens to many, offering good fellowship as warm as the cheer they served. There are distinct advantages to living in the kind of climate that demands such comforting consolations.

Below: Detail from PASS THE WICKET TAVERN *Above:* BEAVER HAT TAVERN

Home entertainment, important at all times of the year, positively burgeoned in winter. Most folks could play an instrument of some kind, or recite, perhaps do a few card tricks, or tell a good story.

But song was the heart and core of a jolly occasion. And there is something about a warm hearth, a plenitude of good food and, above all, good company that brings out the lark in all of us.

THANKSGIVING
DINNER MUSIC
Right: BENJAMIN'S
MUSICAL TOOLS

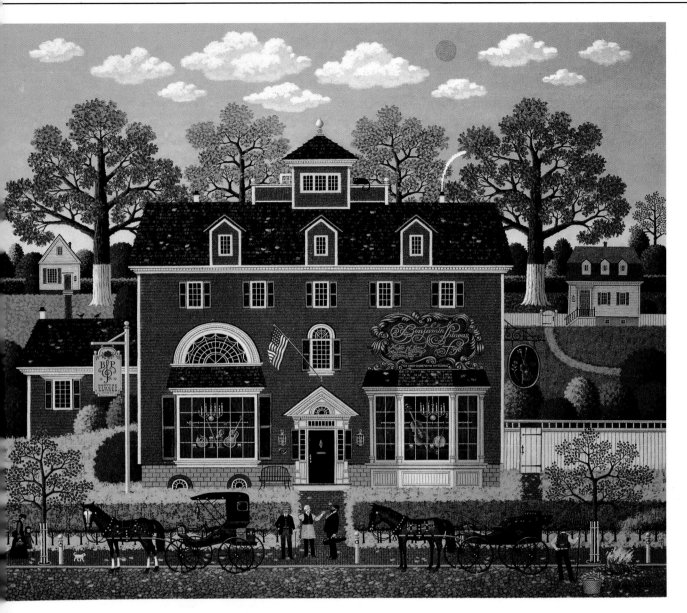

There was a time when any musical instrument you came across had to have come from one of the old countries. Concertinas were the most common, being easily portable and a favorite among sailors. There'd be an occasional violin, too, although these didn't like sea air and the strings were always chancy. Flutes and whistles of one kind or another were also easily carried, and there were always drums—well, things to bang on, anyway.

But music was much too important to remain a poor relation for long. People began to make their own instruments—sweet dulcimers and even violins. A good fiddler was welcome everywhere. Meanwhile, successive waves of immigrants brought more and more complex musical tools—banjos and other sophisticated devices for making a joyful noise.

Then Montgomery Ward and the U.S. mails put the possibility of music, among other things, into every corner of the country. From then on, American homes resounded to the twangs, tweets, tootles and tinkles of everything from mandolin to organ—a joyful noise indeed.

[169]

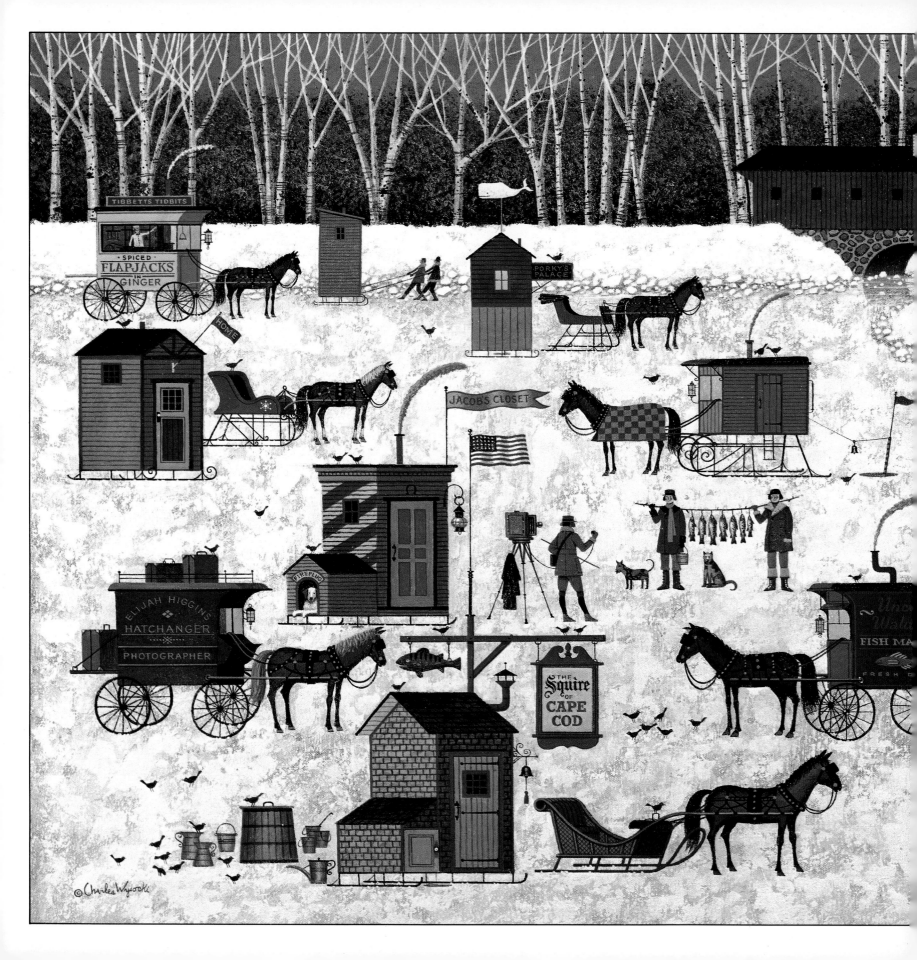

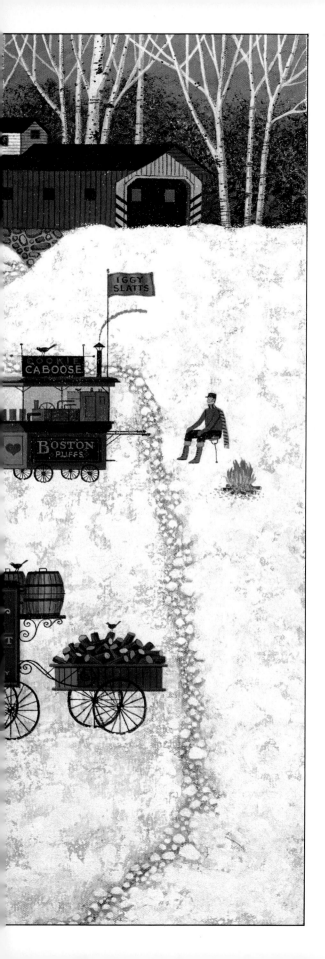

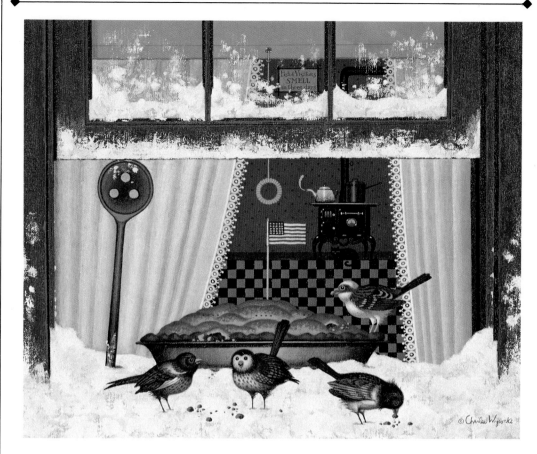

Really deep winter saw some folks ice-fishing. This was considered a sport, and obviously it must have been something that folks enjoyed doing since it was largely a weekend activity: also, proud fishermen decorated their ice shanties with quaint personal designs and sayings. These are not the actions of serious-minded men forcing themselves to sit or stand in below-zero conditions for the noble purpose of hunting victuals. They really were having fun.

Of course, there had to be all kinds of good ways to keep the inner man warm. And every now and then the actual catching of a fish could also call for celebration. In fact, it seems possible, even likely, that ice-fishing was a highly convivial sport.

It would be hard to begrudge such charmers their share, but the unwary housewife probably didn't feel that way. Actually, most winter birds were thoughtfully provided for, and the bolder ones—sparrows and robins particularly—would come and tap impatiently at an accustomed window. The bird feeders in the yard would also be kept replenished, often taking care of whole populations of avian friends. Indeed, sacks of birdseed were usually among the winter stores laid up in most cellars and sheds.

Above: BIRD PIE
Left: CAPE COD COLD FISHING PARTY

[171]

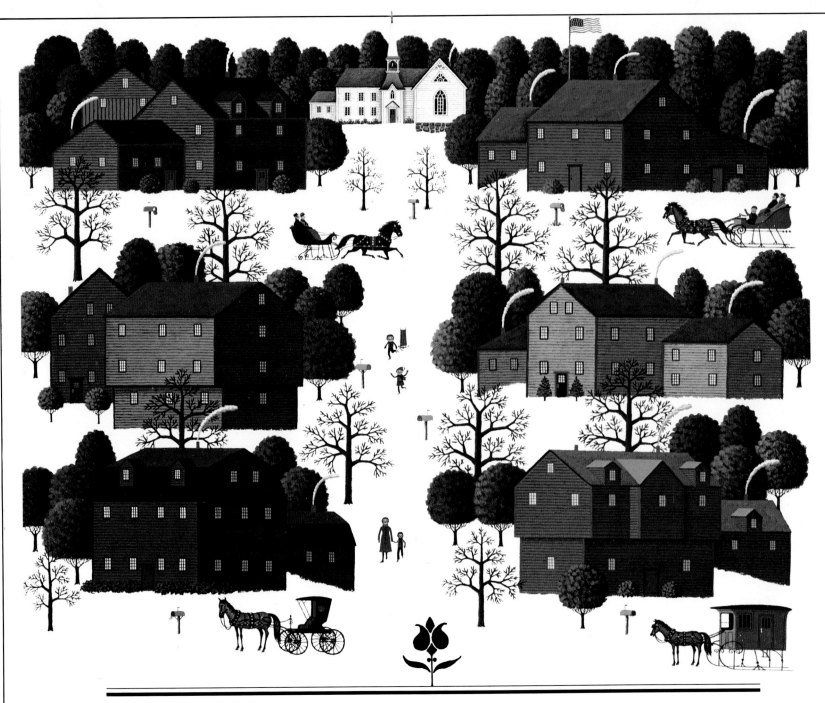

FUN IN THE SNOW

Ice-fishing was probably winter's coldest sport, and even with the help of spirits, was indulged in only by the very hearty. Sleighs were much used to get from one place to another, more reliable (and a whole lot sweeter-smelling than the newfangled horseless car-riage). But sleigh-riding for the sheer fun of it was popular, perhaps for a winter picnic, or simply to get out and see the fairyland a fresh fall of snow could make of the countryside.

For most folks, however, crunch-cold snow and chilly

SANDY BIRD RIVER JUNCTION

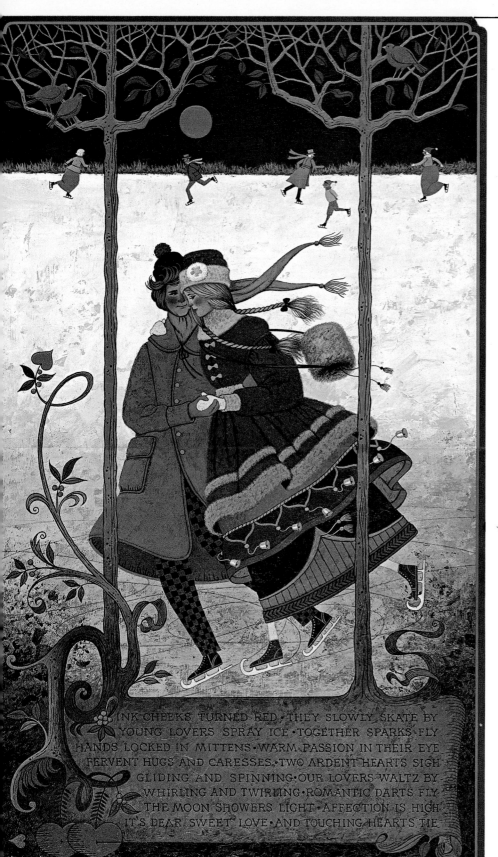

INK CHEEKS TURNED RED · THEY SLOWLY SKATE BY
YOUNG LOVERS SPRAY ICE · TOGETHER SPARKS FLY
HANDS LOCKED IN MITTENS · WARM PASSION IN THEIR EYE
FERVENT HUGS AND CARESSES · TWO ARDENT HEARTS SIGH
GLIDING AND SPINNING · OUR LOVERS WALTZ BY
WHIRLING AND TWIRLING · ROMANTIC DARTS FLY
THE MOON SHOWERS LIGHT · AFFECTION IS HIGH
IT'S DEAR SWEET LOVE · AND TOUCHING HEARTS TIE

air induced a need to move fast themselves. So skating and sledding were common (if any activities as exhilarating can be so described), the former enjoyed by adults and children alike, the latter largely by small-fry—often "assisted" by a high-spirited grownup unable to resist an equally high-speed rush down a snowy hill.

Building snowmen, of course, was a happily clammy occupation (the snow had to be of a special wet consistency to really stick together) and in some small towns could even take on the nature of a competitive sport,

Above: Detail from VICTORIAN CHRISTMAS
Left: SWEET LOVE

[173]

every front yard boasting a formidable creation. Cold and snow, and especially ice, made winter a magic time.

With a rug or heavy blanket over your lap and toes to keep out Jack Frost, a ride through the early violet shadows of a winter evening could be highly romantic. And whether sleigh-riding or skating, there was always the welcoming warmth of a hospitable tavern to look forward to, or a glowing hearth ready and waiting at home.

EVENING SLED RIDE
Right: CHESTNUT VALLEY

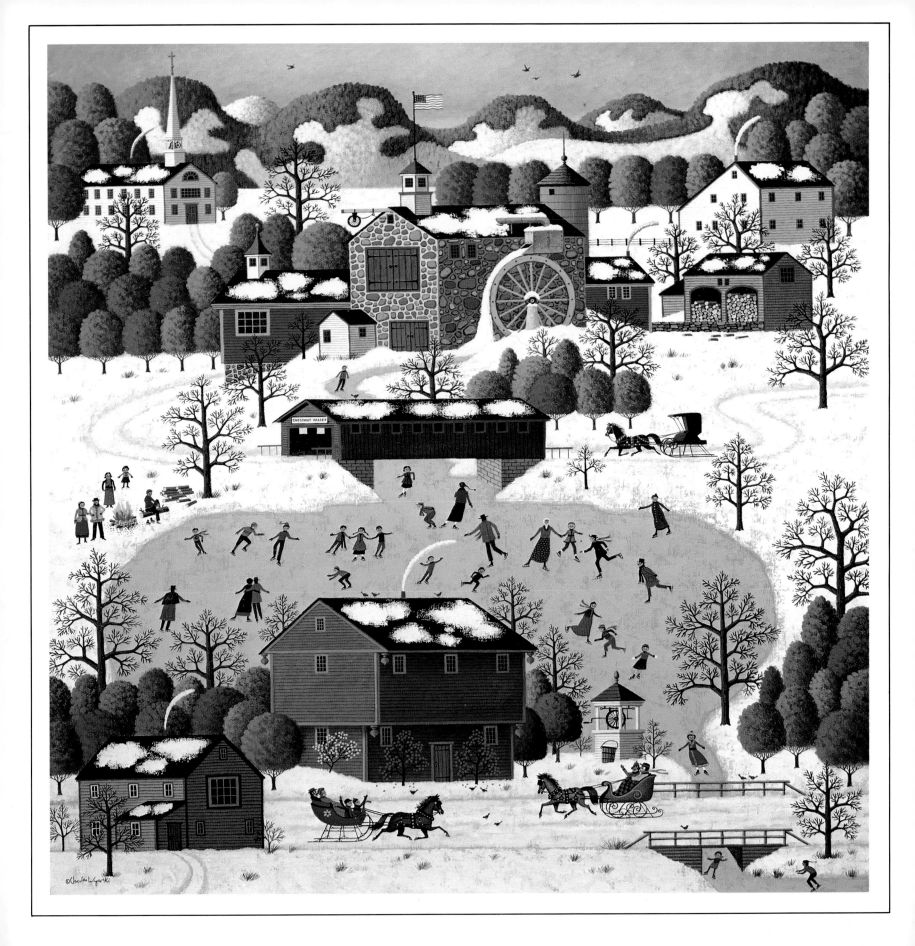

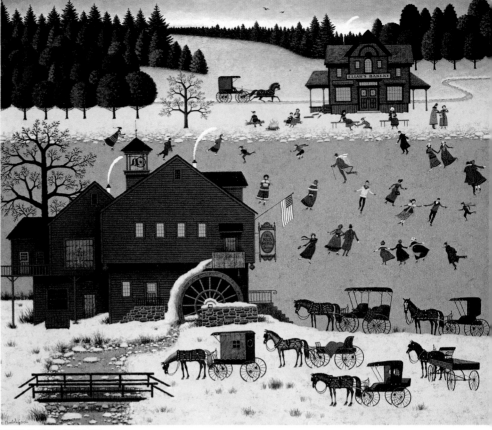

RED MILL POND

NEW ENGLAND SKATING PARTY

Winter's joys included dance-skating, gliding along on the ice in the crisp evening air, preferably with a partner. Sometimes there was music ringing out across the ice, a delightful complement to the rhythmic flow of the graceful dancers. For those needing to warm the inner man there might be the grateful cheer of a waffle wagon, good for a delicious hot snack and steaming drink.

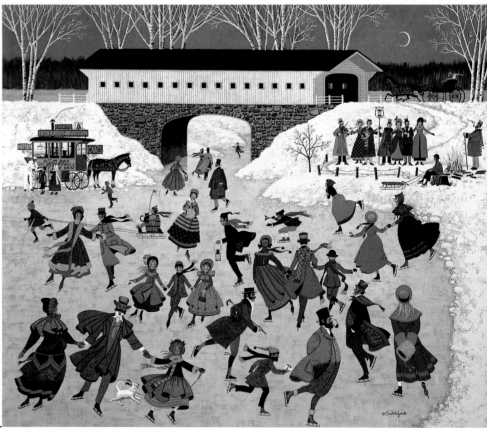

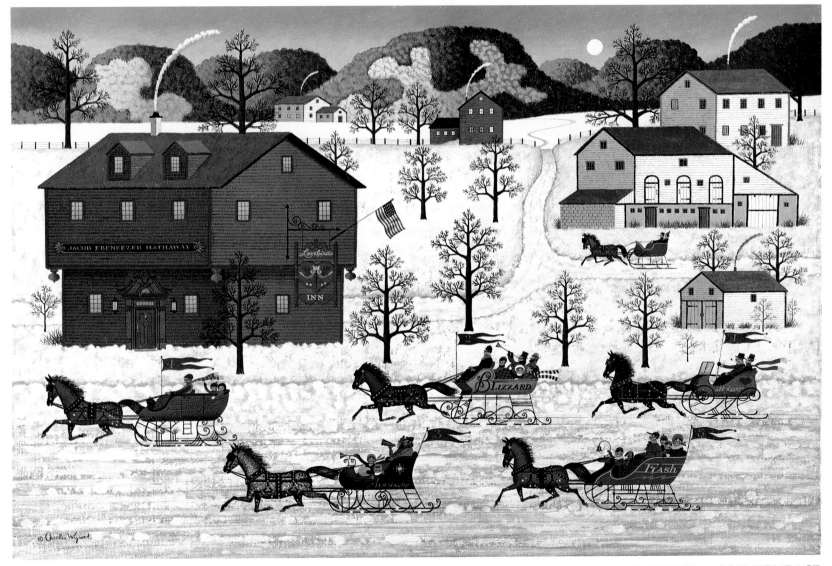

Below: MOVING ALONG COUNTRY RACE

Keen competition in sledge designs resulted in a wide variety of excellent vehicles that could slide easily and gracefully over the crusty snow.

And once in a while neighbors would wrap up warm and set out hellbent-for-leather to see whose horse-drawn sleigh was the fastest one in town.

Nothing could beat that feeling—the merry jingle of harness and bell, the warm, steamy breath of the horses as they proudly settled into a fast-paced trot, the crackling cold air streaming by, bringing tears to the eyes, and above all, the smooth, effortless glide as one sailed triumphantly past a laughing rival, the horse snorting his pleasure at being in the lead.

Only winter could gift the world with such delight.

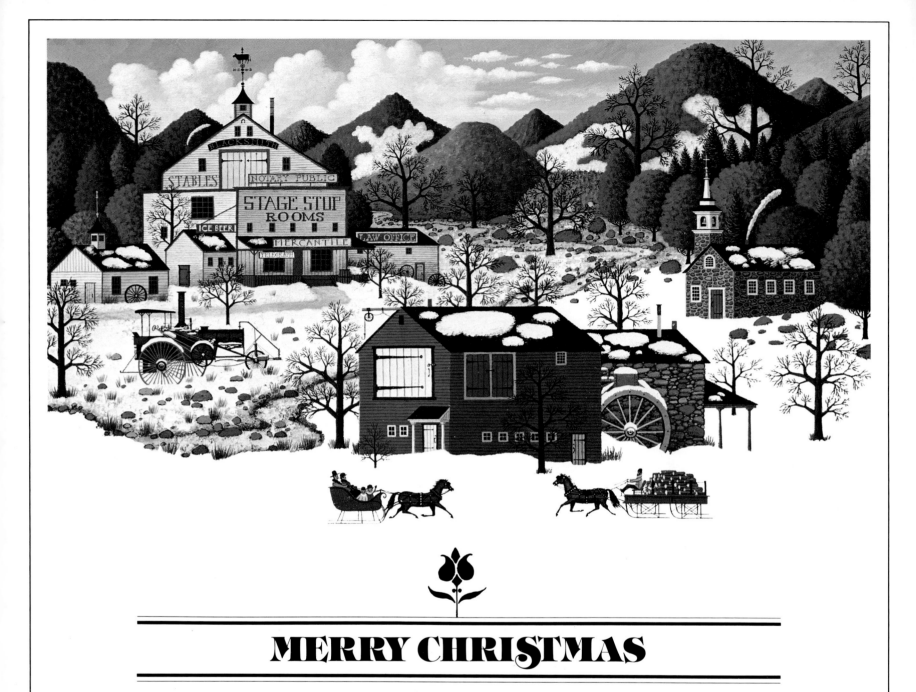

MERRY CHRISTMAS

As Christmas got closer, distant members of families started thinking about going home. And if home was more than a day's journey away, the stage stop would take care of them, keeping them warm and fed overnight, or helping them on their way with a good meal and a hot drink.

Way stations of this kind dotted the countryside and were generally fairly large establishments. They often had many folk to accommodate, and usually all at once. But the care and feeding of the horses was at least as important as the well-being of the human travelers and took up a good deal more space. Often such inns, on a regular run, would stable animals under contract, to provide a change of horses.

And, especially at Christmas, it must have seemed to the bustling innkeepers, the maids, the hostlers and the many helpers who kept the inn going that the whole world was on the move, valises bulging with gifts and holiday finery, hearts high, and every last one impatient to move on despite ice, sleet or snow.

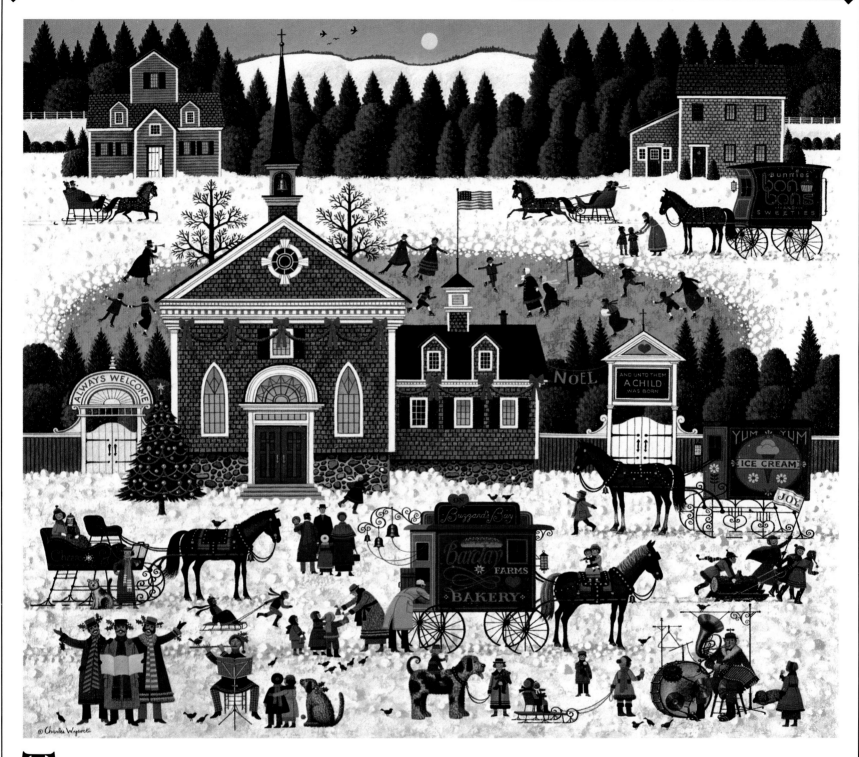

Throughout the length and breadth of the land, preparations for Christmas keep people busy—knitting, sewing, cooking, building, carving, working in leather, cutting trees. Cherished ornaments are examined, packages are stashed in unlikely places; the kids are gathering greens for decoration, attending choir practice, tuning up instruments, working over carefully studied pieces, and rehearsing plays, songs and noble efforts at elocution.

A bustle of plans is moving toward a joyful day, Christ's Mass, the celebration of a very special birthday.

CHURCHYARD CHRISTMAS

With Christmas just around the corner, young heads are wondering if Santa will visit them this year. There is a sudden flurry of angelic behavior.

Teddy Roosevelt, that famous fightin', roughridin' President, never dreamed, when his name was bestowed on a toy bear, that generations of cuddly, furry critters would make his name famous and gladden the hearts of thousands of kids. But he would have loved it.

Top: THE GANG'S ALL HERE

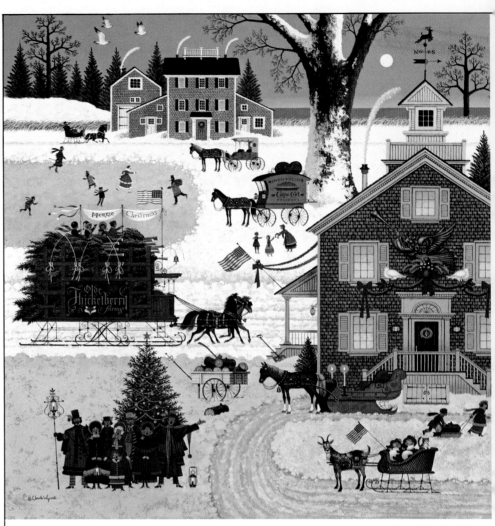

Below: Detail from CHUMBUDDIES CAPE COD CHRISTMAS

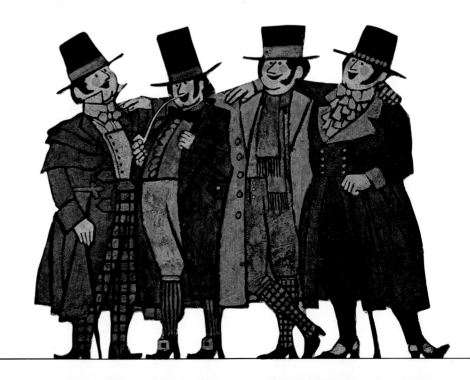

MR. CARDINAL

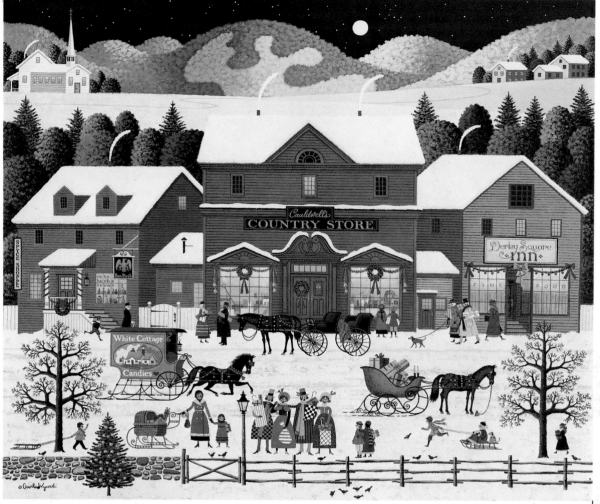

Left: THINGS I LOVE MERRY CHRISTMASMAKERS

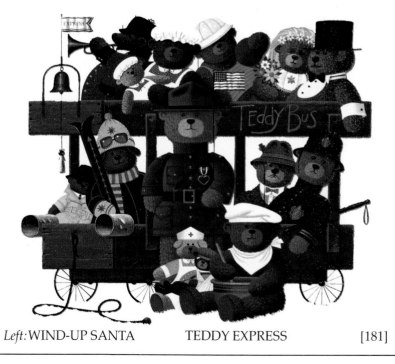

Left: WIND-UP SANTA TEDDY EXPRESS [181]

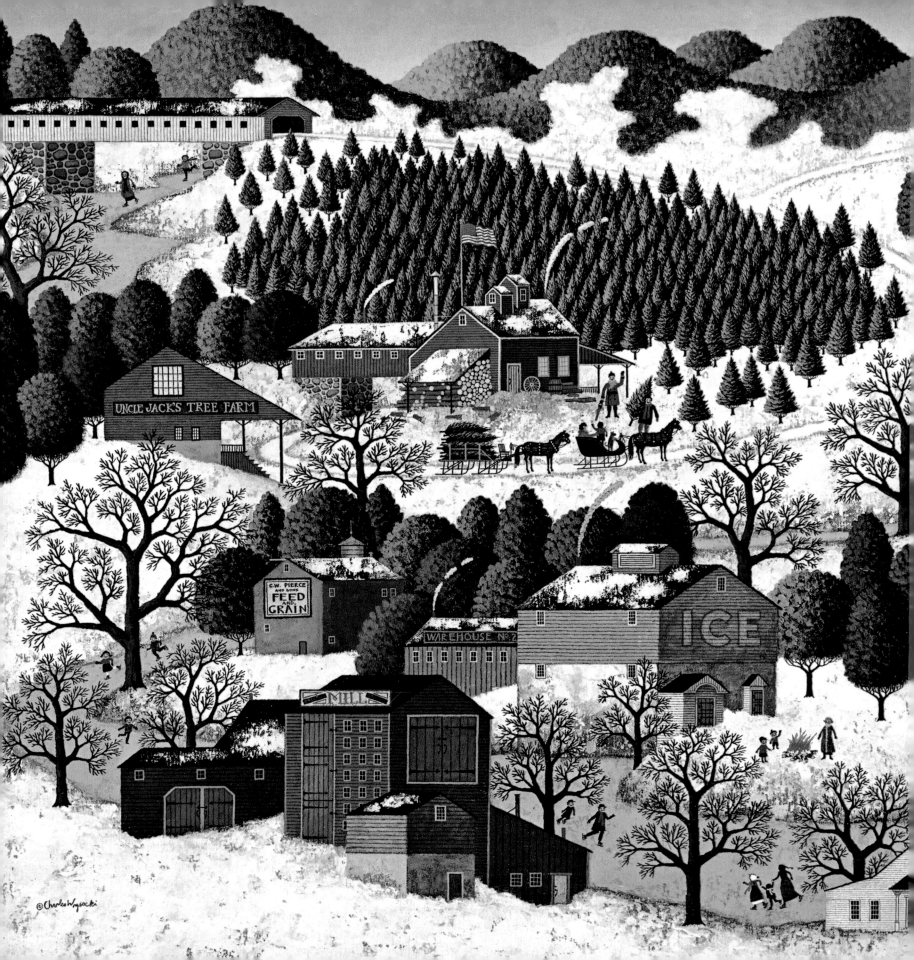

F or weeks, and indeed months, preparations have gone forward. And now it is Christmas Eve. The children have decorated the whole house, inside and out, with greens and hundreds of tiny lights and paper chains and frostflake cutouts, ably assisted by Uncle Harry, home from the sea for the holidays. An incorrigible bachelor, Uncle Harry has also secretly hung bunches of mistletoe in unsuspected corners.

In the dining room, all the spare leaves have been added to the big table, the silver has been polished to a fare-thee-well, the best china service has been taken out and is washed and ready, and trays of shining crystal ranged around the punchbowl wait in the pantry to be wheeled in for the party tomorrow.

In the living room, the great tree holds command, verdant and stately, glimmering with tinsel and beloved ornaments in countless shapes and forms and colors—exquisite sequined birds, shining stars, delicate snow-crystals (a new decoration made every year by each child in the family)—all hung with scallops of strung popcorn and cranberry chains, and topped with a shimmering angel.

Beneath the tree the children have already placed their presents. Concealed in extraordinary wrappings are many lovingly embroidered handkerchiefs, hand-made slippers, an assortment of knitted scarves and caps, wallets wrought by small fingers, belts, clay vessels of uncertain shapes (handy as vases or ashtrays), a pipe patiently bored out and glued together (the recipient will heroically ignore what kind of glue), and several more artifacts made of wood, wax, leather, and lace—all with very much love.

The Christmas cards have long been sent off, each carefully made of heavy white paper on which suitable scenes were drawn and watercolored, the paper pierced and threaded with vari-colored ribbons, and at last painstakingly inscribed with affectionate sentiments and good wishes. Similar cards, received from friends, decorate the mantelpiece, now also hung with sturdy socks, fully worthy of being filled to the brim with goodies.

At last all is ready, the lights are doused (except for the fairy Christmas bulbs), the grown-ups retire and the house gives a concerted sigh of relief. While late, very late, a patter of bare feet and some giggles and gasps indicate that someone (or two or three) has made sure Santa has indeed visited.

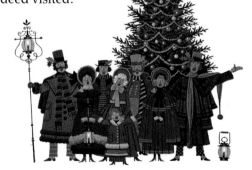

Left: UNCLE JACK'S TREE FARM *Above: Detail from* CHRISTMAS EVE

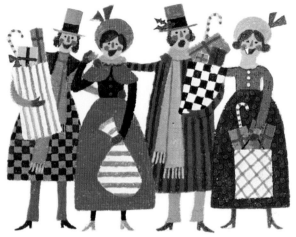

Christmas Day! It starts at dawn. The children are gathered in the living room, wild with excitement as they unstuff their stockings. This happy activity holds them just long enough to get most of the family down and assembled.

While coffee and doughnuts and nut bread are passed around, the opening of presents begins, and continues for the next two hours amid gasps of pleasure, squeals and cries of joy, laughter, and exclamations of amazement. The ladies are in raptures over the brocaded Chinese silk gown

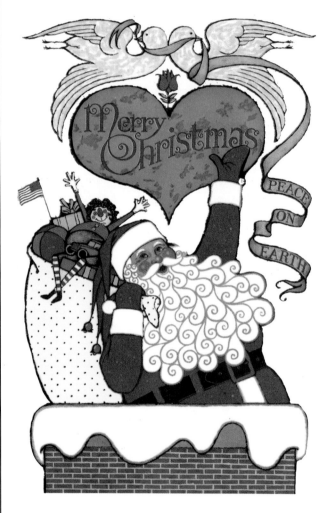

not one for mere babies. The youngest is filled with pride, and fairly bounces with eagerness to get out and try it.

The assembled company sits in happy satiety amid drifts of colored papers and tumbled boxes (most of which will be saved for next year). Mama insists now that the children abandon toys long enough to have some breakfast before getting dressed to go out. And at last, around eleven o'clock, the children, the young people, most of the men, and three hysterical dogs stream out into the snow to try the new sled and the new skates, to refurbish the snowman, to flop about amid gales of laughter on a pair of newfangled wooden slats that Uncle Harry claims are genuine Norwegian skis. Someone suggests a snow battle, and immediately sides are picked. A man-made blizzard of feather-light missiles ensues to the accompaniment of screams, shouts, and the excited yipping of the dogs. At last, gasping and somewhat hoarse, Papa announces it is time to return for Christmas dinner.

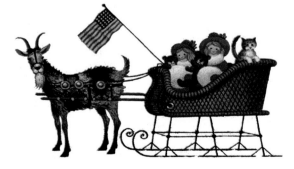

Uncle Harry has brought for Mama. But the *pièce de résistance* (and the most anxiously awaited object) is Papa's gift to the youngest—an absolutely perfect, beautiful, super, bright red sled with real metal runners. This is a serious sled,

Left: CHEERIO *Top:* HOLIDAY CAROLERS *Right:* A MERRY CHRISTMAS STREET

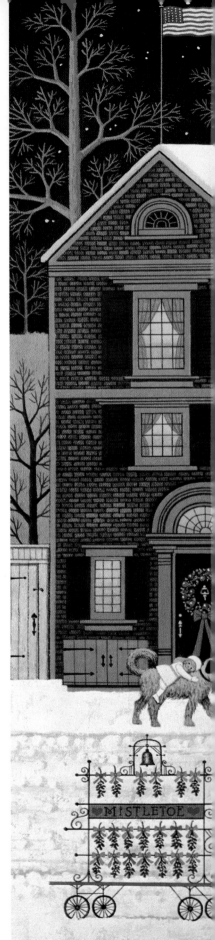

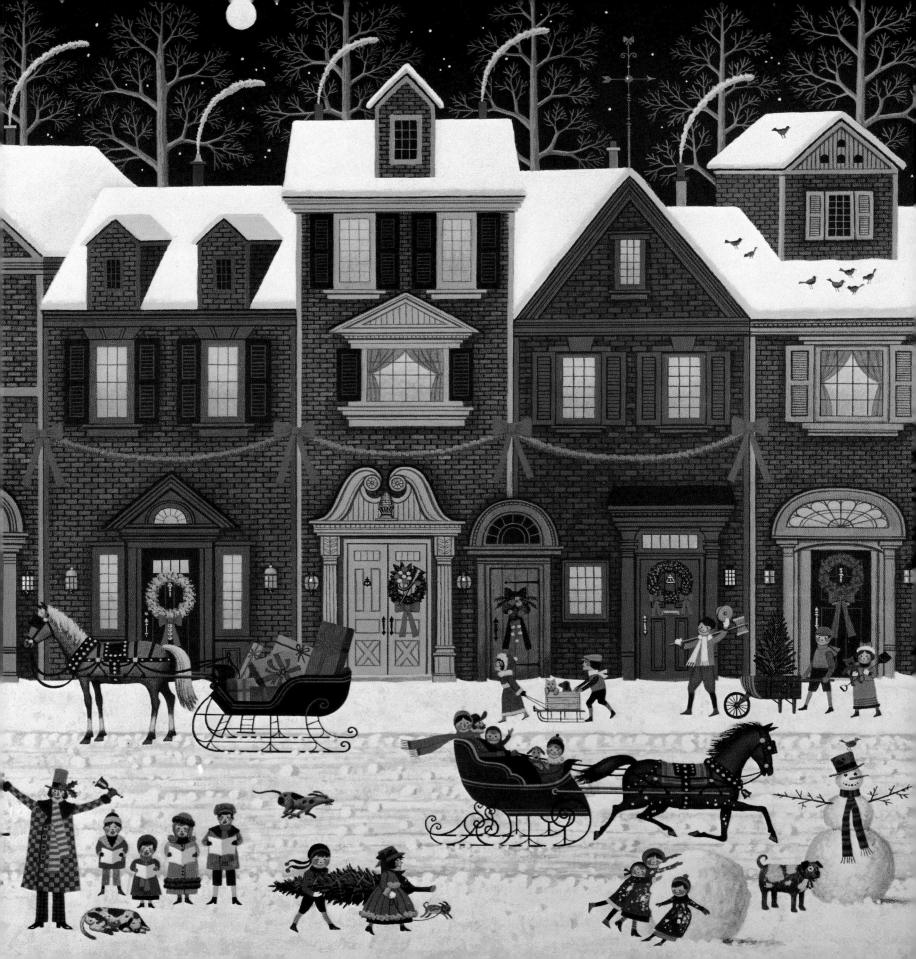

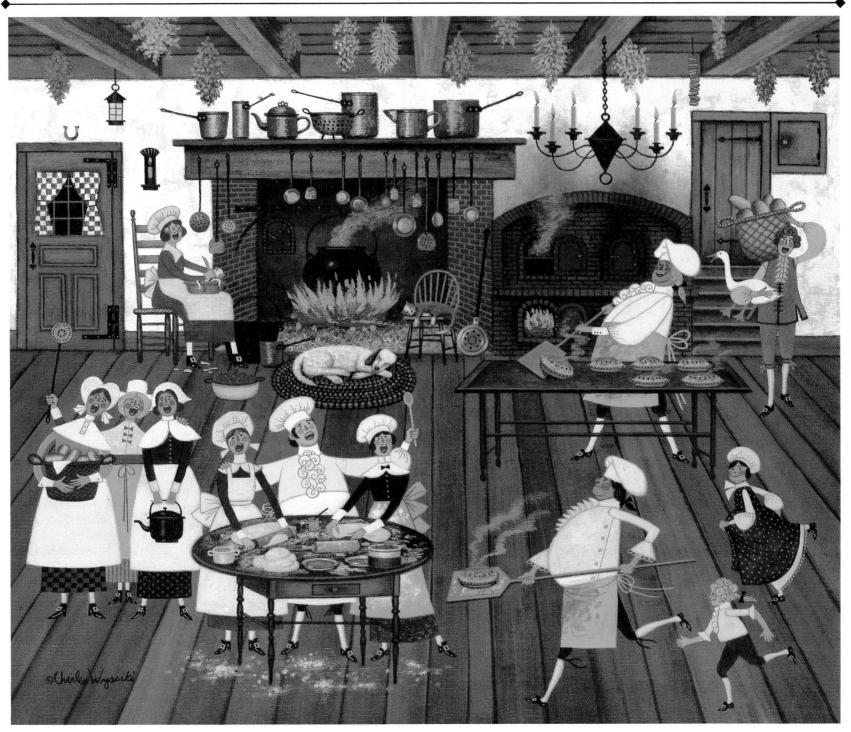

The long table is clad in white damask, with a bright scarlet silk runner down the middle bearing small silver dishes of nuts and candy. Bowls of fruit are interspersed with red-ribboned bottles set in silver holders, and a great centerpiece of holly and brilliant berries surrounds a fat red candle. Two sideboards and an additional table are loaded with steaming dishes and platters.

When everyone is seated, Mama rings a bell, and Cook enters carrying a gigantic turkey, to cheers and clapping. Flushed and proud, she places it on the sideboard and waits. Now Papa stands, and the room is quiet while he thanks the Lord for all His bounty. All murmur amens, and several hands help to pour the wine (lemonade for the littlest ones, but in real wineglasses). Everyone stands to toast the beaming Cook.

SINGING PIEMAKERS
Right: A WARM
CHRISTMAS LOVE

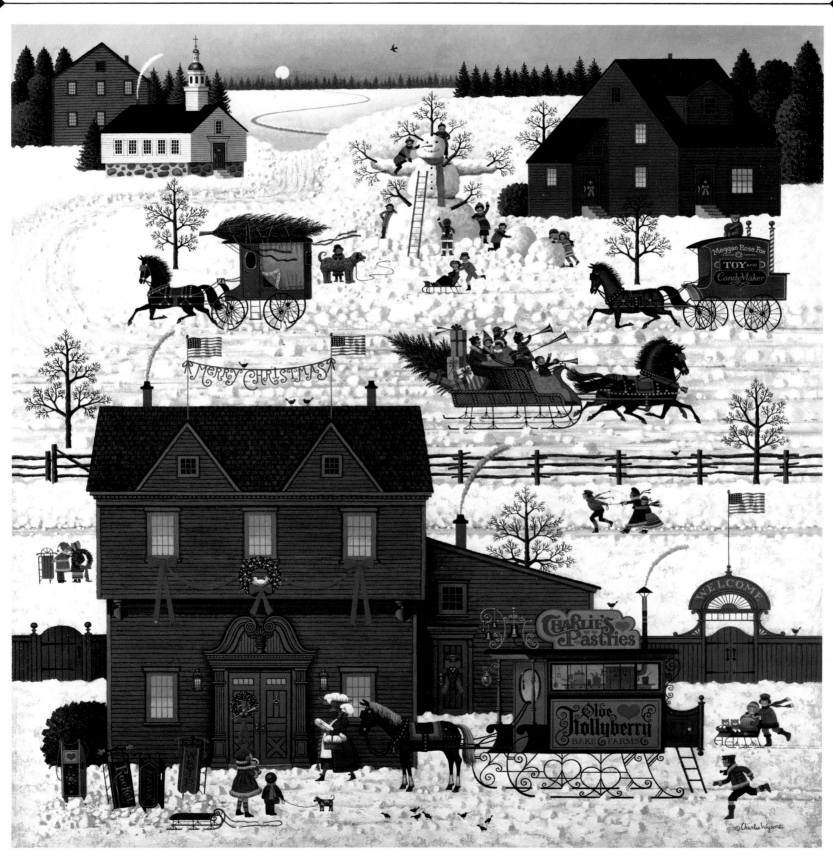

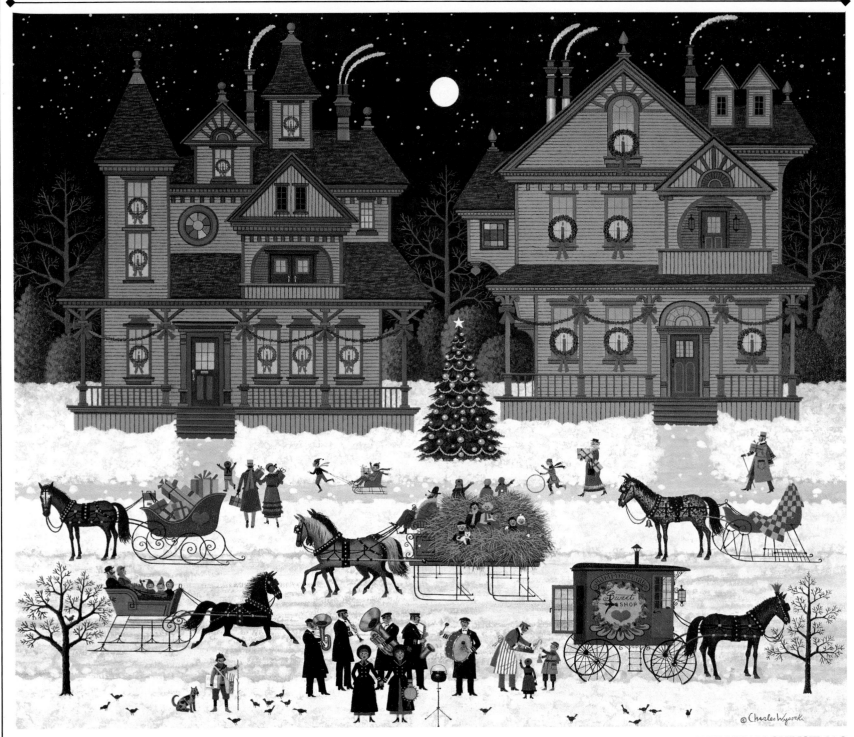

VICTORIAN CHRISTMAS

The feast . . . twice-stuffed turkey (sage-and-sausage in the neck cavity, chestnuts-and-thyme and who knows what else in the middle), tiny white onions in bread sauce, precious summer peas with fresh mint, wild rice, Brussels sprouts, carrots, cranberry sauce, hot Christmas pudding with hard sauce, mince pie and whipped cream, fondants, nuts, fruit, cheese, wine, and coffee . . . takes long to serve and longer to eat. There is hardly time to retire, nap, and prepare for the evening's festivities.

No one can stand even the thought of another meal before the guests arrive. The children, in any case, are much too excited about the forthcoming performances they have been rehearsing, and (once again assisted

by the indefatigable Uncle Harry, who has all kinds of tricks with ropes up his sailor's sleeve) they rig a stage and curtain, just barely in time for the arrival of the first buggies bringing the neighbors. The entertainers remain "backstage," costuming, primping, taking a last look at their lines. Meanwhile in the living room, hallway and through the double doors into the dining room, chairs are

arranged, punch and tidbits are served, and a buzz of anticipation terrifies the thespians.

The dinner gong announces the opening of the show; a horrified voice is heard from behind the curtain, "Oh *no!*", but the young lady of the house seats herself at the piano and commences the grand march, prelude to incredible marvels. The curtain goes up (well, sideways, actually) and the show is on. A magnificent drama takes place, to shouts and cries of encourage-

ment from the audience. Appreciative silence greets individual performers when they come on, one in particular drawing a murmur of approval—the youngest

Peace 1702

Voices sing in yuletide cheer
Happy Mr. Partridge Bird is here
To warble so mellow, a "hello"
Our Christmas guest, this fellow.

Love

daughter, posed as a shepherdess within an enormous gilt frame from which she daintily steps to perform a charming dance, coming to rest at last back within the frame—really very clever—and the audi-

ence thoroughly enjoys a duet by the two older sisters, a light tenor soulfully rendering "I Did But See Her Passing By . . .", Uncle Harry's rumbled sea song (lots of power and rhythm there, if a bit off-key), Uncle Alec's magic passes with the cards and coins, several piano pieces, and one swooping violin.

The whole company then joins in for carols, and having sung their lungs out, all

are very ready for more punch and a light repast. The neighbors also have brought offerings and Christmas specialities for this light buffet supper, enjoyed by all for the next hour or so.

Fed and wined, the group turns to music and dancing. The chairs are all moved back and away (the mistletoe doing land-office business during this operation), and the house resounds to the rhythms of the polka and the square dance while feet tread out a fitting climax to the Best Day of All.

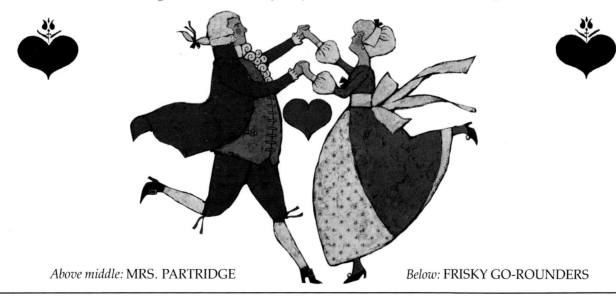

Above middle: MRS. PARTRIDGE *Below:* FRISKY GO-ROUNDERS

THE ARTIST AT WORK

Born of Polish parents in Detroit, Charles (Chuck) Wysocki grew up in a neighborhood where much of the influence was still "foreign." Perhaps it helped to give him perspective and a special feeling for America. His was an active and happy boyhood, with all of boyhood's pleasures and anxieties. He remembers always wanting to draw but his parents did not share his enthusiasm for the arts, their concern for him directed toward more reliable sources of earning income. But young Charles' interest in art continued all through high school (Cass Technical) and even through his two-year hitch with the Army.

Service duty over, Wysocki returned to the Polish community in Detroit and found a job making drawings of tools, nuts, bolts and other car parts for manuals and catalogs. It was not at all his idea of pursuing a career in the arts. Then his brother, also an artist, convinced Chuck to enroll in the Art Center in Los Angeles. Partly on the GI Bill and partly with the help of his parents, Charles Wysocki attended art school where one of his most influential teachers was Jack Potter, an illustration instructor whose twin gods were creativity and individualism.

On graduating from art school Wysocki again returned to Detroit, but two years there convinced him that he needed the sunshine of California. In Los Angeles he worked successfully, and happily, as a free-lance commercial artist for three years. He first met his wife-to-be, Elizabeth, in an advertising agency. They began dating immediately, and were married six weeks later. In the years that followed, they produced three lovely children—David, now twenty, Millicent, seventeen, and Matthew, fifteen. They also, in the course of time, moved up into the San Bernardino mountains and made their home there.

Elizabeth was to become a very strong influence in Chuck's life. A graduate from UCLA with the highest honors in art, Elizabeth had much in common with Chuck and was able to fully appreciate the talents of the man she had married. Her family, one of the oldest to settle the San Fernando valley, had always been farmers and she, in contrast to Chuck, had grown up in the country. Her parents welcomed the young man and he was deeply impressed with the open gentleness, the willingness to work, the cheerful unity of Elizabeth's family. When he began to evolve a style of his own in painting, he found it was linked to his sympathetic feeling for the values of simplicity and warmth that he observed in his wife's background.

"To this day," he says, "I feel the serenity of this life, and it became enhanced on our vacations to New England. We fell immediately in love with this section of our country because the pace so closely resembled our way of thinking—a love for the very small personal closeness of each other's company and being content with 'little' things, happy in activities city folks might find boring."

New England remains the source for many of Wysocki's favorite subjects. As for other influences, he says of himself, "I was and am probably still greatly influenced by the paintings of Rousseau, Winslow Homer, Andrew Wyeth, Edward Hopper, Ben Shahn, Norman Rockwell and, of course, Grandma Moses. But mostly, I believe, by Clara Williamson and Joseph Pickett. I do not think of myself as being either 'folk' or 'primitive.' I consider myself simply a painter of early American life with a wide mixture of influences and with a love for the old-fashioned values. If some naiveté appears in my paintings, it is because I planned it that way. And that is undoubtedly because I would like to live that way myself. I feel that my relationship to older American folk and primitive art is like myself. Their simple approach to unsophisticated shapes of pattern which seem to dominate their paintings is at the same time rather abstract in quality."

In fact, all of Charles Wysocki's paintings are abstracts in the sense that none of them is a rendition of an actual place. Just as an author of fiction will take aspects of many people he knows and meld them into

one realistic whole, so Wysocki utilizes pieces of many scenes and threads of many feelings, and weaves them into a symbolic and realistic whole. His paintings express feelings just as strongly as the imaginary scenes they depict—the quirky humor, the warmth, romance, sentimentality, the complex organization, the delight in pattern and, above all, the love he feels for America, appear again and again in his richly detailed, brilliant compositions that celebrate various aspects of American life from the early 1800s on through the 1920s and '30s. If the scenes never existed in actuality, one has the feeling they certainly should have. Moreover, they are so rich in inventive detail that one can come back to them again and again, each time delightedly discovering something new.

Wysocki's method of working is painstaking and methodical. When he gets a concept for a painting, he first draws the various elements on small pieces of tissue paper. There might be two or three or as many as dozens of such mini-pieces. These are moved around, or changed, or developed, or all three, until he is satisfied that he has a balanced composition. He might then do an overall drawing on tissue and then embark on color. If the color is not going properly, he will start all over again to redesign. Sometimes a painting will take weeks to develop. Sometimes all the many elements fit easily and everything seems to fall into place.

Of his painting methods Chuck says, "I received most of my training as a 'painter' in my own studio under my own plodding direction. I took painting classes but the time spent in these classes was limited and just covered the basics. Time, and what seems like thousands of brush miles later, I still feel I have just scratched the surface. Another influence that has affected my personal style is my love for pattern. Fitting patterns together piques my interest."

This is abundantly clear from the home in which Chuck and Elizabeth live. The house is filled with Americana—dozens of beautiful antique bottles (Elizabeth's collection), jars, jugs, crocks, carvings of birds and other animals, textiles, lace, western bronzes, paintings, old-time artifacts, dried flowers, baskets—and unobtrusively comfortable chairs and sofas, tables and lamps in the right places. The walls are covered with original art by Chuck and other artists, including portraits of Washington and other presidents, and—look closely!—exquisite needlepoint "paintings" done by Elizabeth. The magnificent quilt in the master bedroom is her work, too. The whole house is redolent of love and care and joy, with every nook and cranny arranged to caress the eye. To say nothing of the six cats who grace the house with their presence.

In Chuck's studio, behind his drawing-board, is a long cabinet along one wall, lined with old tobacco tins (neither he nor Elizabeth smokes) and facing him is a wall of glass cabinets filled with a magnificent collection of art books and books on Americana of all kinds. Yet none of this gives a sense of crowding—simply of comfort and order and endless riches to delight and please, relax and stimulate. Their home, clearly as much Elizabeth's creation as it is Chuck's, is the joint and joyous expression of much that appears in a Wysocki painting. They join in celebrating life, and the world enjoys the gift of that celebration in the work of Charles Wysocki.

Copyright rights for the paintings listed below are owned by AMCAL. Pp. i,xi,179 Detail from Churchyard Christmas (1985); p. iv Gifts, Antiques and Cakes (1985); Pp. v, 98 Flagwaver (1975); p. x Peppercricket Farms (1985); p. 15 Jizzywhiznickel Farms (1983); p. 17 Fawn Dell (1971); p. 20 Confection Street (1978); p. 21 Herkymer (1977); p. 26 Sunflower (1977); p. 30 The Americans (1981); p. 31 The Boat of Life (1971); Pp. 32,63 Beastly Associates (1980); p. 33 Noah and Friends (1979); p. 34 Detail from The Eagle Tavern (1980); p. 35 Lilac Point Glen (1979); p. 38 Quail's Roost (1978); p.41 Stoney Bay (1982); p. 42 Nantucket Winds (1980); p. 45 Detail from Connecticut Town Shoppers (1984); p. 46 Detail from Cattle Drive (1972); p. 47 Cowboy Trappings (1976); p. 48 Oklahoma or Bust (1975); p. 49 Cowboy Treasures (1976); p. 50 The Pony Express (1972); p. 51 Wells Fargo Memories (1980); p. 52 Western Townsfolk (1972); p.53 Pete's Gambling Hall (1983); Pp. 55,56-7 Kirbyville (1981); p. 58 Curtis Mining Co. (1972); p. 60 Peaches (1973); p. 63 The Pig (1980); p. 63 Pump, Pumpkin and a Prayer (1984); p. 64 Cow (1983); p. 65 Old Homestead (1979); p. 66 Amish Autumn (1979); p.67 The Quiltmaker Lady (1973); p. 68 Gingernut Valley (1979); p. 69 Detail from Twins and Tandem (1974); p. 69 Kitty's Treat (1979); p. 71 Doctor Bonkley's Family (1976); Pp. 73,77 The Cambridge (1979); p. 76 Timberline Jack's (1975); p. 78 American Meat Store (1978); p. 78 Fish Seller (1974); p. 79 The Haberdashery (1976); p. 82 Ice Cream and Hopscotch (1974); p. 83 Victorian Street (1976); p. 87 Amish Valley (1983); Pp. 89,133 Old Glory Farms (1984); p. 89 Watermelon Farms (1971); p. 90 Amish Meeting (1973); p. 91 The Barn Raisers (1975); p. 92 Evening Services (1972); p. 93 America, Land of the Free (1984); p. 93 New England Wedding (1975); p. 94 Freewheelers (1976); p. 95 Pleasant Sunday (1974); p. 99 Old Glory (1975); p 101 Roll Call with a Bang (1982); p. 102 Bang, Boom, Bam and Pow (1984); p. 103 The All-American Boy (1973); p. 103 Detail from Young Patriots (1985); p. 105 Cider Brook Farms Ice Company (1979); p. 106 Cape Cod Star (1974); p. 107 Childhood Memories (1981); p. 108 I Love (1982); Pp. 109, 121 Fox Hill Farms (1982); p. 110 Smooth Talker (1975); p. 111 Indian Rugs (1972); p. 113 Warp In The Wind Bay (1983); p. 113 Sunday Sailors (1973); p. 115 Burma Road (1982); p. 116 Mansfield Air Spectacular (1979); p. 116 Windblossom (1981); p. 116 Cloudbusters (1976); p.117 Four Aces Flying School (1981); p. 119 Home for the Holiday (1973); p. 120 Where The Buffalo Roam (1972); p. 121 Railroadiana (1977); p. 123 Waterfall Valley (1974); p. 123 Rooster Express (1981); p. 124 Meadowlark Farm (1974); p. 125 Valley Farm Street (1971); p. 126 Racing at the Greenstar (1973); p. 127 Shops and Buggies (1978); p. 128 Plunkerton's Country Produce (1977); p. 129 Fire! (1975); p. 130 Liberty Star Farms (1976); p. 132 Detail from Mr. Scarefellow (1977); p. 133 Appleseed Woods (1979); p. 137 Budzen's Roadside Food Stand (1974); p. 140 Detail from Evening Race (1983); p. 143 Hunters Lures (1985); p. 144 The Bostonian (1976); p. 145 Pumpkin Hollow #2 (1978); p. 146 Crocks and Corn (1971); p. 149 Hellraisers Passing the House of Seven Gables on Halloween Night (1979); p. 152 Turkey in the Straw (1981); Pp. 156,159 Detail from Harley's Feed Store (1976); p. 156 Hotel Slatt's Music Room (1976); p. 157 Two Bridges (1973); p. 159 Meat, Flowers and Hats (1973); p. 160 New England Sentinel (1971); p. 161 Forget Me Not (1979); p. 162 The Whalers (1976); p. 163 Detail from Twilight Sentinel (1983); p. 164 Windjammer Canal (1984); p. 165 The Quiltmakers (1975); p.166 Old California (1980); p. 167 Beaver Hat Tavern (1978); p. 168 Thanksgiving Dinner Music (1982); p. 169 Benjamin's Musical Tools (1982); p. 171 Bird Pie (1982); p. 172 Sandy Bird River Junction (1979); p. 173 Sweet Love (1977); p. 173 Victorian Christmas (1974); p. 174 Evening Sled Ride (1974); p. 176 New England Skating Party (1978); p. 177 Moving Along (1977); p. 181 Teddy Express (1985); p. 181 Things I Love (1976); p. 181 Merry Christmasmakers (1980); p. 182 Uncle Jack's Tree Farm (1971); p. 183 Detail from Christmas Eve (1981); p. 185 A Merry Christmas (1984); p. 186 Singing Piemakers (1978); p. 188 Victorian Christmas (1982).

© AMCAL.
Photograph p. 191 by Walter Zurlinden
Other photography by Robert Hixon